The Craftsperson Speaks

The Craftsperson Speaks

Artists in Varied Media Discuss Their Crafts

Edited by JOAN JEFFRI

Introduction by Mary Greeley

Sponsored by the Research Center for Arts and Culture,
Columbia University

Contributions to the Study of Art and Architecture,
Number 1

GREENWOOD PRESS
New York • Westport, Connecticut • London

Library of Congress Cataloging-in-Publication Data

The Craftsperson speaks : artists in varied media discuss their crafts
/ edited by Joan Jeffri ; introduction by Mary Greeley ; sponsored
by the Research Center for Arts and Culture, Columbia University.
 p. cm.— (Contributions to the study of art and
architecture, ISSN 1058–9120 ; no. 1)
 Includes bibliographical references (p.) and index.
 ISBN 0–313–27993– 4 (alk. paper)
 1. Artists—United States—Interviews. 2. Decorative arts—United
States—History—20th century. I. Jeffri, Joan. II. Columbia
University. Research Center for Arts and Culture. III. Series.
NK808.C73 1992
745′.092′273— dc20
[B] 91–34696

British Library Cataloguing in Publication Data is available.

Library of Congress Catalog Card Number: 91–34696
ISBN: 0–313–27993– 4
ISSN: 1058–9120

First published in 1992

Greenwood Press, 88 Post Road West, Westport, CT 06881
An imprint of Greenwood Publishing Group, Inc.

Printed in the United States of America

∞™

The paper used in this book complies with the
Permanent Paper Standard issued by the National
Information Standards Organization (Z39.48–1984).

10 9 8 7 6 5 4 3 2 1

CONTENTS

ACKNOWLEDGMENTS

The Research Center for Arts and Culture gratefully acknowledges the contributions of the Andrew W. Mellon Foundation and the New York Foundation for the Arts, which provided resources for the project's research and development, its own Administrative Committee and Advisory Board members, the artists and related experts for their thoughtful guidance, and the members of the staff who carried the project through to completion.

Joan Jeffri, Director
Mary Greeley, Project Coordinator
Dr. Robert Greenblatt, Computer Consultant
Zoe Friedman, Research Assistant
Ruth Loomis and Patricia Pullman, Interviewers

PREFACE

The interviews in this book were chosen from fifty personal narrative histories of craftspeople and "related experts"—museum curators, art historians, critics, managers—from all over the United States. Besides forming an important resource on their own, they constitute an integral part of The Artists Training and Career Project, a study of the training and career choices and patterns of craftspeople, painters, and actors conducted by the Research Center for Arts and Culture at Columbia University. Craftspeople are at the heart of the first part of this study. They have been asked through the interviews and a detailed questionnaire sent to a random sample of 4,000 craftspeople nationwide (garnering a 33 percent response) to describe in systematic ways the impact of training and career choices on their work, their requirements for doing their work over time, and their career development and satisfaction.

Areas of investigation used first in the interviews and later in the questionnaire have been developed through the creation of a multi-stage "validation sequence" from early childhood through mature careers. Questions move from initial influences through education, training and preparation to career entry, peers and colleagues, marketplace judgments, critical evaluation and public response, to career satisfaction and maturity. They also seek information on background and current activity.

By eliciting information about the kinds of validation as well as the kinds of resistances the craftsperson meets, the Research Center for Arts and Culture (RCAC) will begin to be able to describe the training and

career development of craftspeople; will contribute to a growing literature on careers that includes research in the scientific, legal, medical, and law enforcement professions but is lacking sadly in the arts; will provide important information for advocates and funders; will give training institutions a better idea of the points of greatest need for training; will give arts service organizations information about appropriate assistance for craftspeople and when such assistance is most helpful; and will document the position of the craftsperson as an integral member of society.

Also, these interviews will provide pleasurable reading as they humanize a process and a search. Space does not permit us to publish all the interviews, but all the audio tapes are housed at the Oral History Collection of Columbia University and permission to hear them may be secured there. Data and information from the survey can be obtained directly from the Research Center.

Each published interview begins with a brief biography of the main markers in the craftsperson's life and ends with information on where the work itself can be viewed, including corporate and public holdings. Professional affiliations and honors are appended as relevant. One illustration of the artist's work is provided with each interview, courtesy of the craftsperson.

We have tried to include a variety of media in this volume and to represent craftspeople demographically, ethnically, and equally by gender. We have encompassed a wide age range and have targeted craftspeople in three broad career stages—emerging, established, and mature. During the study we have been advised formally by two groups, one of "related experts" and one of craftspeople themselves to help us keep our work relevant to the needs and realities of the field.

From this small sampling and from the larger body of interviews, particular comments and insights have stayed with us. Over and over again craftspeople spoke about respect for their material as if their relationship with the work were a compact and the material somehow had to *agree* to be used in a certain way. Many ceramists have "prayer gods" or small totems they make and put in their workspaces as a hedge against things they cannot control. Fiber artist Jeff Glenn from San Francisco said, "It's never 'how to'; it's 'what if?' "

The investment, at least as discerned from the interviews, seems to be in the work first; one's career comes after. This approach is supported by our data, which reveal that the average age when people began a "professional craft career" is twenty-nine, much older than one might expect. Steven Maslach, a glass artist whose interview appears here, said, "It's the exploration, the journey, not the destination." This exploration and the

tenacity to work in craft were reinforced by glass artist Mary Kay Simoni, "If there were no glass, I'd be an artist with mud, or sticks, or twigs, or dirt."

Craftspeople mentioned the lack of real critical dialogue about their work and the importance of peer review. Seventy-one-year-old June Schwarz, a West coast enamelist, referred to "the good opinion of people I respect" as "signal lighting." Others talked about isolation and the non-linear paths they followed in their careers.

Several saw the craftsperson in relation to the larger whole. Nancy Corwin, an art historian now living in Washington, DC, said, "I do think that a belief in what you're doing and a belief in its importance and its necessity in the world is the greatest gate-opener; and a belief that if you are doing what you need to do the universe will support you, in a sense, is the greatest gate-opener there is." Basket maker Kari Lonning viewed her work as a craftsperson as a responsibility to the world: "Somebody's got to take care of the world and that's part of why I am doing what I do because somebody has got to keep their hands on materials, not just doing key punch and computer stuff."

The interviews were conducted by Research Center staff members Zoe Friedman, Ruth Loomis, Patricia Pullman, and Project Coordinator Mary Greeley, who also wrote the following introduction, which offers a brief history of the craftsperson in the United States. I am most grateful for their good work and conscientious interviewing. They were aided by Ron Grele of the Columbia University Oral History Collection, who gave everyone important pointers in technique. This work would not have been possible without the substantial aid of the Andrew W. Mellon Foundation and the continuing support of the New York Foundation for the Arts. Mostly, it would not have been possible without the cooperation of craftspeople and experts nationwide, who have given generously and willingly to make this project happen.

We hope this work has something of what we heard from many of our interviews, the belief that one can actually see the love that craftspeople put into it.

INTRODUCTION

While much of the available historical information describes the object rather than the object maker and his or her role in society, our intention here is to describe the environment for training and career development for the craftsperson at different periods of American history up to the present day.

In their earliest forms, all crafts were made by hand to accomplish a specific function of use (tools), adornment (ornaments), or worship (ritual objects). They included vessels, dishes, clothing, furniture, wall hangings, jewelry, and tools. Their makers were family members. Today, while a few crafts may still be made completely by hand without the use of machinery, most crafts now require the use of large, often complex, facilities and machinery; wheels and kilns for pottery, glass blowing equipment, looms, and other supporting structures necessary for large fiber pieces and surface design, and wood and metal working machinery such as power saws, sanders, and lathes.

Throughout the centuries these household objects have become art objects. Some still include a function; many do not. The contemporary view of the process of creation is one in which the creator uses hand, eye, spirit, and mind to control the design as well as the manufacture of the object. Those who view craft as art, or "craft art," also understand that the work of the craftsperson, or "craft artist," makes a personal aesthetic and philosophical statement, one that is an integral part of the work produced, as does the work of other "fine" artists.

American crafts have largely followed the traditions of Western European culture. There has been occasional impact from other cultures, in the form of adaptations of Native American, Hispanic, and Asian decorative elements and forms during the twentieth century. Motifs were used as early as the 1920s in architecture, ceramics, and furniture; but the greatest impact has been in work since the 1950s, as seen in the incorporation of Native American, Asian, and African themes in all of the craft media.

BACKGROUND

The history of crafts is one of slow development until the 1500s, when the impact of technological discoveries of the Middle Ages, especially the printing press and the clock, radically changed the course of culture. These discoveries affected the nature of work, man's relationship to his work, and the entire social structure by establishing new conceptual frameworks and methods of communication. The Industrial Revolution followed, setting up a profound reorientation of society, one that continues today. It initially produced both great swings of enthusiasm for, and then rejection of, the miracles of technology and mass production. The contemporary craftsperson deals with these issues of technology, production, and relationship to society, as they both affect and are affected by the kind of work the craftsperson produces, the educational needs of the craftsperson, and the ways in which the craftsperson markets the work.

BEGINNINGS

The earliest craftspeople worked by necessity, not by selecting a career. There were very simple divisions of labor and training; the allocation of daily tasks concerned the acquisition of food and shelter and was done according to physical attributes such as physical strength or ability to care for children.

With the advent of cities and increased masses of population, more complex divisions of labor developed, as did social hierarchies. The first distinctions were made between those whose work was primarily physical and those whose work was largely intellectual. Craftspeople, as manual laborers, were usually at the lowest end of the status hierarchy and were often slaves, a status that remained even after they had become extremely valuable as skilled producers of luxury objects. As the higher social classes demanded finer, more "artistic" or richer versions of the objects, made of more valuable materials and with higher degrees of skill, the more casually

made, coarser objects were relegated to the lower classes. Craftspeople themselves remained an integral part of the working class.

As a social and economic middle class developed during the Middle Ages, crafts objects and the processes by which they were made became increasingly sophisticated. By the end of the sixteenth century new heights had been achieved in Venetian glass and German and Italian goldsmithing. Furniture making had moved to complex systems of joinery and veneer treatments. Ceramics incorporated new glazes and glaze techniques from the Middle East and Spain and historic and narrative scenes for decorative elements. Cloth became sumptuous, with fantastic embroideries and complicated garment design; tapestries were important both for their function as wall coverings and for their portrayal of mythological and historic scenes. New distinctions between country craft and town craft further developed the social/economic levels at which craftspeople functioned in society.[1] The relationship, however, was still one of service, rather than one of social equality.

During the period 1500–1750, craftspeople developed certain powers through the formation of crafts guilds, which served two purposes. First, they established and maintained standards of craftsmanship for a particular medium, effectively confirming and protecting a hierarchical division of labor. Second, they set up tightly controlled systems for entry and movement through the profession. Such systems brought increased legitimacy to the crafts and formed the early roots of "professionalism," as well as setting up social and economic divisions within the craft field itself. Today there are no guilds with such power, but as the crafts world seeks greater professionalism and recognition the issues again arise.

THE UNITED STATES
1650–1750: COLONIZATION

The first 100 years of European settlement in North America maintained a solid Eurocentric orientation, one that paid little heed to the many Native American populations already here. Native American crafts existed as objects of daily functional and ritual use and were viewed by their makers and users as such, similar to the views of the early settlers towards the crafts they brought across the Atlantic with them. There was little interchange between the two groups: Native Americans and immigrants maintained their own separate societies, interacting primarily in battles over land ownership. Native American crafts were largely unknown to the early settlers, and those that were known were viewed as "heathen" and therefore outside the cultural limits of respectability.

During the early years of colonization the crafts were based on knowledge, traditions, and technology from Europe. Crafts objects were functional: tools of metal and wood for household use and agriculture, household furniture and furnishings, and clothing. Every person was, generally speaking, still a craftsperson; work was done at home or in the village, distribution was local, and much of the work was bartered. Production methods depended on the availability of materials and the complexity of the process of creating them. Tools requiring metal, ceramics, and glass items had to be imported until forges and furnaces of various kinds were established.[2] Wood for furniture, dishes, and tools, and fibers for cloth, particularly wool, were available locally, so these items were made at home. Training was simply part of the household education of the children by parents and other adults, without concern for occupational specialty.

As the first settlements in America were fairly homogeneous socially, so were their crafts. As time went on, however, and the populations increased in number, social classes emerged, followed by distinctions in the quality of the crafts produced: the coarser goods made for and by the lower classes and the finer goods made for the upper classes, usually by middle class artists/craftspeople. In furniture, architectural detailing, and metalsmithing, the work became much more sophisticated; families of craftspeople developed identifiable bodies of work, and specific technologies were passed from one generation to the next. As these more sophisticated decorative elements were developed, greater social prestige was attached to the possession of finer, more expensive goods. However, there was not yet a clear distinction between objects of daily use and objects as fine art.

1750–1850: INDUSTRIALIZATION

During the next 100 years the colonies became the United States, and the population grew rapidly and society grew more complex, influencing both production and use of crafts objects. The East coast population became sophisticated in taste and production methods and affluent in purchasing power. Other segments of the population moved west after 1800, and differentiations in social structure and in the production of goods took place according to geographic location.

In the East, manufactured goods became more plentiful, cheaper, and more available, and the need for families to produce their own goods decreased. The need for Everyman to be a craftsperson decreased, and those who continued work as craftspeople became more specialized.

Training was still largely learning by doing either within the family or by apprenticeship. In addition, the middle and upper classes slowly developed an interest in "fine art" in terms of portrait painting and portrayals of historic scenes,[3] resulting in the recognition of painting as a valuable occupation. This prestige did not carry over to the work of craftspeople as there was little conscious recognition of any links between the artist and the craftsperson, although such links existed. The general attitude towards craftspeople was as honest laborers serving a vital but not professional function. Craftspeople content with their status in life, such as Paul Revere, felt no need to upgrade that classification, either because their own needs for recognition and success were filled or because they agreed with it. Others who had started out working with their hands at whatever craftwork was available or in demand, then graduated from what they considered a lower form of work to the higher work of painting, an occupation viewed as conferring higher status.

Frontier societies continued to focus on the craftsperson as Everyman. Craftwork remained divided along traditional lines of strength and capabilities, with men doing the larger heavier tasks and women the less strenuous ones. The objects made were still primarily functional. There were, of course, some specialties, depending on the medium; major forge work, for instance, needed a permanent home, but there were many itinerant blacksmiths and tinworkers who travelled from city to town to farm doing work as needed. Most products involving wood and fibers were still made locally. Mills were available for the manufacture of cloth of all kinds, and factories were producing chinaware, distributed by commercial retail stores in the East and by the travelling salesmen in rural areas, especially in the West. Technology was increasing, but the major disjunctions created by the Industrial Revolution were just beginning.

1850–1920: THE ARTS AND CRAFTS MOVEMENT

By the second half of the nineteenth century, societal views towards art itself had also shifted in two complementary directions. The first view, coming out of the Transcendental ideas of the glory of man and the universe with the self as the central source of knowledge and reference, was that art, rather than inciting evil and depravity (an earlier view held by the Puritans), could be used to uplift society and to provide moral regeneration. The artist could therefore serve as an active agent of moral and social welfare and provide pathways to Truth. The second view, an extension of the first, held that there was an identifiable utility for art and a specific use for the artist's talents. Artists would serve as a rallying force

for the disparate and disjointed elements of society by portraying, through monuments and public buildings, a government of strength, dignity, beauty, and worthiness. Artists then were considered useful to society, and opportunities for both artists and craftspeople to create major works for public spaces increased, which advanced the value placed by society on both the artists and their works.

However, despite the view that art should be highly valued for its uplifting moral force, the economic value was still dependent on the work's utility as a redeeming force, not its inherent aesthetic qualities. This emphasis on utility was also reflected in attitudes toward the function of work itself: the motivation for work was the need to earn a living not a concept of the glory of work for its own sake. The prestige of the craftsperson reflected this: work was valued for its utility, although one could increase its value by using more luxurious materials, more complex decorative treatments, and more highly developed skills, thereby increasing its monetary value. The craftspeople who created the finer goods were ranked higher socially than those who used coarser materials, but all were still considered part of the service population who traded a clearly defined product for money.

The arts and crafts movement that had begun in England moved rapidly to the United States. The movement, based on concepts developed by John Ruskin (1819–1900), the first professor of art history at Oxford, and carried forward by William Morris (1834–1896), an English fabric, furnishings, and book designer, espoused the philosophy that work should be the core motivating force of life: ". . . the creative and joyful essence of daily life rather than a mere act of sustenance."[4] If work was to be valued above and beyond the paycheck it brought, then it should be restructured to allow the individual maximum involvement and control over the entire process of manufacture, from beginning to end, which assumed that individual control of one's activities made a crucial philosophical difference to one's sense of being valued. There was a rejection of the lavishly decorated furnishings of the recent past, especially the impersonal, smoothly finished surfaces of the machine-made product. There were new proclamations of the aesthetics of asymmetry, roughness, and irregularity, of reference to the simplicity of medieval times. The movement struck responsive notes in English and American society and generated many guilds, workshops, and schools dedicated to the promotion of the craftsman ideal.[5]

The arts and crafts movement in the United States followed slightly different patterns than in England. One segment was more interested in the socialist aspect of craft ideas as they related to the labor movement. It

had a goal of restructuring the manufacturing process and designing a system where the production process itself would be both artistic and educative and where the products of labor would be both useful and beautiful.[6]

A second segment felt that the primary mission of the movement was to promote the ideals of good taste, thereby raising the cultural level of the entire population. The goal here was to elevate the aesthetic, to reform the tastemakers, and to beautify daily life through museums, schools, and crafts societies. It espoused the cause of "the universalizing of art, and the ennobling of labor."[7] This segment, which included people who were both profit and anti-profit and both for and against the use of machinery, then split into subgroups.

The movement, begun as an approach to aesthetics and production, became a way of life as well, often duplicating earlier historical examples of communal living from the first half of the nineteenth century, such as the Transcendentalists and Utopians, who held an idealized view of man and his individual bond with nature.[8] The craft colonies were equally idealistic and shortlived and often centered around furniture making (Roycrofters Community, East Aurora, NY; Byrdcliffe, Woodstock, NY; Rose Valley, PA), except for Ruskin (TN), which produced chewing gum, suspenders, and commercial printing.[9] The movement, however, spoke primarily to a small segment of the population, those sufficiently affluent to have the education, culture, and money to have had exposure to "good taste" and therefore the desire to pursue its presence in their lives.

During the latter half of the nineteenth century, other important cultural changes were taking place as well. The separation of "fine art" from "popular art" continued, recognizing the different tastes of different audiences. It was particularly promoted by the upper classes because it established and preserved their position in society as the leading arbiters of good taste as well as the decision makers for the social good of all classes.[10] This division affected the crafts directly; there now was a body of work that was formally established as "fine art," a realm outside their own.

As the realm of "fine art" was moving away from the crafts, especially on the East coast, there was a blossoming of the crafts (still known as the "handicrafts"), particularly ceramics, in the Midwest in the 1880s and 1890s. It began with the enthusiasm of various women's clubs and guilds and was carried out by the establishment of "art potteries" in Cincinnati, St. Louis, and New Orleans. Two of these were led by women, the Rookwood Pottery founded by Maria Longworth Nichols in Cincinnati, Ohio in 1880, and the Newcomb Pottery founded and shaped by Mary G. Sheerer, in 1886 at Sophie Newcomb College of Tulane

University, New Orleans. These women, along with several others, became very successful, both with their potteries as businesses and with their work in competitions.

The American Ceramic Society was founded in 1899 by Charles Fergus Binns, and Pewabic Pottery opened in 1903 in Detroit as an art center and commercial tile works. There were also several journals devoted to ceramics that came and went during this period. The "art potteries" declined after 1915, but they had been very successful and served as a catalyst for the later growth of the studio potter, a different form of working that was more academic and exploratory in nature without the commercial emphasis. The New York School of Clayworking and the Ceramics Department at Alfred University, both of which opened in 1900, were early leaders in the studio movement. National and international competitions and exhibitions were held from Chicago to New York and New England, along with international exchanges of exhibitions.

Education

The arts and crafts movement also endorsed the teaching of art, including drawing and design, as part of the regular school curriculum and as a part of the education of the whole child. While the motivation reflected a patronizing attitude held by the upper classes toward the lower classes, particularly the immigrant population, educational theory was being developed as a significant area of study. The inclusion of art as a useful and therefore integral part of the curriculum established important groundwork for the future. The introduction of the "minor arts" were to help teach the child "to think . . . to prepare children for labor, curb idleness, and promote morality."[11] As early as 1869, textile magnates and the Jordan Marsh department store petitioned the state of Massachusetts for publicly financed drawing classes. Subsequently the state passed a law requiring towns with over ten thousand inhabitants to provide free mechanical or industrial drawing classes for persons over fifteen.[12] In turn, the objects so produced were to improve and beautify daily life for all levels of social classes and to improve the general state of art for the nation.

Settlement Houses and Vocational Schools

Another catalyst for promulgation of the crafts were the settlement houses, such as Hull House in Chicago, the South End House in Boston, Henry Street Settlement, Greenwich House, and Rivington Street in New York. In league with the public school philosophy of the importance of art

in teaching general educational skills, the settlement houses were also interested in Americanizing the immigrants and providing them with useful vocational skills. Another educational development of this period was the appearance of vocational schools, which served both the industrial crafts and, to a lesser extent, the nonindustrial crafts. The Industrial Revolution had demolished the old apprenticeship program, and vocational schools were developed to take their place; a significant shift was made by the American Federation of Labor, which came out in support of vocational education in 1910.[13]

Societies, Guilds, and Schools

Between 1896 and 1915, arts and crafts societies and guilds were founded across the United States.[14] Major cities each had formal Arts and Crafts societies, along with the many groups formed within a specific medium. Societies were designed to teach and make art and arts and crafts objects, to discuss, exhibit, and sell work. Members of these societies came from both the professions (artists, craftspeople, and architects), and amateur groups, such as ladies' clubs, the public school system, and the social welfare planners. Again the members often held divergent views as to whether their mission was to improve society at large or deal primarily with aesthetics and taste. Both professional and amateur groups, however, established craft shops to sell the works, thereby providing a venue for distribution and relieving the craftsperson from sales responsibility.

Boston held its first craft exhibition in 1897, displaying nearly 1,000 items from 108 distributors related to home and church furnishings: carpets, embroideries, furniture and woodwork, jewelry and metalwork, pottery and decorated china, wallpaper, stained glass, bookbinding and printing. One third of the exhibitors were craftspeople; another third included six art patrons, nineteen commercial manufacturers and retailers, six applied art industries, four art schools, and a decorative art society.[15] The Boston Arts and Crafts Society, founded the same year, held exhibitions, established a sales room in 1900, and a monthly journal of the arts and crafts in 1901. (The membership closely resembled the upper class orientation of the founding groups of the Boston Symphony Orchestra and the Museum of Fine Arts and included leading crafts artists and architects. It did not, however, include many members from the working classes, while other medium-specific guilds did.)

The development of vocational schools during this time also reinforced the connecting link between crafts and the building trades, especially in

the Midwest. This mutual interest and cooperation laid the foundation for the later American acceptance of the industrial orientation of the Bauhaus in Germany, which in turn fed the continued growth of the craft movement here in the late 1920s and early 1930s. Frank Lloyd Wright was one of those espousing intelligent use of the machine to further the design process and wished to unite craftspeople and manufacturers, a concept backed by Jane Addams of Hull House and John Dewey, a major aesthetic and educational theorist. Manufacturers were investing in industrial education. Sears, Roebuck founded the Art Craft Institute in 1900 with classes in cabinetmaking, printing, sewing and weaving; the short-lived Industrial Art League was founded shortly thereafter.[16]

Also at the turn of the century, we see the development of the first art schools and art departments within universities, such as the Cincinnati School of Art (Cincinnati, OH) in 1871, the California School of Design (San Francisco, CA) in 1874, Washington University Department of Art (St. Louis, MO) in 1879, the Cleveland School of Art (Cleveland, OH) in 1882, the Philadelphia College of Textiles and Science (Philadelphia, PA) in 1884, Pratt Institute (Brooklyn, NY) in 1887, the Department of Design at the University of Kansas (Lawrence, KS) in 1890, Ohio State Department of Engineering Ceramics Program (Columbus, OH) in 1894, New York State School of Clayworking and Ceramics (Alfred, NY) in 1900, and the Rhode Island School of Design (Providence, RI) in 1901. Many other schools followed in the next twenty years, with programs in clay, metalworking, and textiles. Many Arts and Crafts Societies, such as the Oregon School of Arts and Crafts, founded originally in 1906 as The Arts and Crafts Society, also carried out strong programs. While these programs did not state the preparation of professional craftspersons as a specific goal, the academic recognition and interest in the crafts provided one of the early validation points for the crafts as a professional field.

During this period, moreover, we see the first recognition by the dominant white population of Native American arts and crafts, reinforced by the development of anthropology as a field of science and the tourist trade to the Southwest. Efforts were made to help native populations by providing economic returns for the sale of their work to the non-native population. With the founding of the Indian Industries League in 1889, work that had served religious and functional needs for its makers up to this time became commercial. Native American design elements also found their way into the early work of architect Frank Lloyd Wright in his household furnishings and Louis Comfort Tiffany, the glass designer, although these design elements remained identifiably Native American.

1920–1945: THE CRAFT SYNTHESIS OF TECHNOLOGY, INDUSTRY, AND ART

The period between the wars saw a decline of the crafts communities and an emerging interest in the technical and aesthetic aspects of the crafts. Communal idealism, so much a part of the American arts and crafts movement of the first decade, was brought to a close by World War I. The war provided a definitive break with the nineteenth century in terms of philosophy, culture, and living styles, and it opened new arenas for technological and industrial development. Most of the idyllic colonies closed or moved to private ownership. They were unable to maintain a working community for an extended length of time, although a few continued life briefly as summer artists' colonies. Art was still taught in public education but primarily as an exemplary vehicle for learning, not as a valid discipline in its own right. Craftspeople had to redefine their niche both philosophically and practically. Fortunately the alternative arena of academia was developing, which provided strong centers of energy, often with close ties to industrial technology. Meanwhile the financial crash of 1929 affected the entire society ushering in a period of doing without or using only materials available close to home.

The Craftsperson/Artist/Designer

The first two decades of the twentieth century in Europe had seen major stylistic developments such as Art Nouveau, Art Style (France), Stile Liberty (Italy), and Jugendstil (Germany), all having grown out of the British arts and crafts movement. Elements of the arts and crafts ideals of the craftsperson/artist, such as control of the design, production process, and quality, were incorporated in these movements, but they also embraced the use of machinery as an integral part of production. The *Staatliches Bauhaus*, founded by Walter Gropius in 1919, was a combined academy of art and school of arts and crafts. It became the leading proponent of designing for and with industry. Gropius's famous statement set the tone: "Architects, painters, and sculptors, we must all turn to the crafts. Then there will be no 'professional art.' There is no essential difference between the artist and the craftsman; the artist is a craftsman raised to a higher power."[17] The curriculum included painting, sculpture, three dimensional and industrial design and used contemporary craft media to design household and commercial furnishings. The role of the artist/craftsperson was that of the controlling force, shaping the future environment, consciously using the newest technology to its fullest. From here the role of the

craftsperson/artist quickly expanded to include architecture, urban design and planning, roles that assumed an affective power within society. These concepts served to promote the idea of professionalism for craftspeople and validated the idea of training that focused on professional development.

These ideas from Europe reinforced those mentioned earlier of the American architect, Frank Lloyd Wright, who had been working along these lines, designing all the furnishings for his buildings as well as the buildings themselves. An immigration of talent and energy moved to the northern Midwest, such as the Finnish architects Eliel Saarinen and his son Eero, who settled near Detroit, Michigan. Other ceramic, fibers, and metals artists immigrated with the Saarinens, plunging into life in America with vim and vigor, bringing with them a sense of intensity and professionalism, and pushing the crafts media further into designing for industry. The Cranbrook Academy, in Bloomfield Hills, Michigan, founded in 1927, represented a confluence of interest in art, in crafts, and their relationship to industrial and architectural design.

Another school/center for the arts was Black Mountain College in North Carolina, founded by John Andrew Rice in 1933. A later version of the idyllic educational/communal/artistic community, it focused on artistic achievement in both visual and performing arts. Black Mountain College demonstrated an affirmation of the creative artistic spirit and created a public acceptance, at least by a significant portion of the art and academic worlds, of the active and legitimate activity involved in the production of art, using all media. The school offered a home to Joseph and Anni Albers after they left the Bauhaus, as well as to many American visual and performing artists in various stages of their careers between 1933 and 1956. This promotion of art, including the crafts, was part of the dynamic groundwork for the growth the art world experienced at the close of World War II.[18]

A second center of energy was the West coast, especially in ceramics and fibers. Ceramics departments were opened during the 1930s at the universities of Idaho, Montana, Oregon, and Washington, as well as at UCLA. UC Berkeley also expanded its Anthropology Department to include a Department of Decorative Arts, whose initial studies focused on early Peruvian textiles and in the 1940s developed the country's first MFA degree in Weaving. There was also a strong fibers program at the California College of Arts and Crafts, initiated by Trude Guermonprez, who had come from Europe via Black Mountain College, and supplemented by Ruth Asawa, a Black Mountain College graduate.

The work in both ceramics and fibers incorporated much of the European enthusiasm for purity of form, use of industrial technology, and other

decorative styles as well as new directions in sculpture. This influenced the work being done, particularly in ceramic sculpture, and moved it more toward abstract expression. It also brought in a host of well known "fine" artists, such as Alexander Archipenko, Reuben Nakian, Isamu Noguchi, Elie Nadelman, and Jackson Pollock to experiment with clay, expanding the boundaries of traditional vessel forms.

Venues for artists to show their work increased during the 1920s and 1930s as national and international exhibitions were held across the country. Titles of exhibitions included such phrases as "arts and crafts," "designer/craftsmen," "modern and industrial decorative arts," "contemporary decorative arts," "native decorative arts," and "women artists," as well as specifying the media shown. Ceramics was the dominant medium, and in 1928, the American Federation of Arts organized the first International Exhibition of Ceramic Art, opening at the Metropolitan Museum of Art in New York and showing the best of American and European ceramic art. Upstate New York soon became a center for the ceramic world with the founding of the Ceramic National Exhibition in 1932 at the Everson Museum in Syracuse, dominating East coast ceramic art for the next four decades. The first exhibition showed New York artists only, but it became a national show the second year and within three years, included international exchanges. It was also in this arena that the first national recognition of Native American work in ceramics took place with the inclusion of the work of Maria Martinez and other Pueblo Indians in the Everson exhibitions in the 1930s.

Outside the academic arena, the groups founded as arts and crafts societies hung on and provided moral support and venues for distribution through various crafts guilds, but these remained tiny in number, local in orientation, and consisted primarily of avocational artists. The work coming out of such centers, although technically acceptable, was viewed as old-fashioned and out of step with the times, both to the industrially oriented workers of the Midwest and to the academic artists. In addition, many of their members still philosophically opposed mass production and preferred to ignore new technologies.

Artists in both arenas were also aided by the federal Works Progress Administration, established in 1934, which set up 3,000 specific crafts projects. Other New Deal programs were also of benefit, such as the Farm Security Administration, which initiated many projects in handicraft production, and the Department of Agriculture, which set up the First National Rural Arts Exhibition.

Other major projects featured commissions for outdoor sculpture and the crafts in the interior and exterior decoration of public buildings, such

as Timberline Lodge, a ski lodge on Mt. Hood, in Oregon. These projects were finite, however, and highly labor intensive; they failed to firmly tie the crafts to the surge of growth beginning to take place in industrial production. Neither did they take into account the negative reaction of unionized labor, which had firmly established itself as a political and economic force and opposed the use of non-union workers. This method of commissioning, did not continue, therefore, as a strong force in the employment of craftspeople.

The Field Begins to Organize

To summarize, in the first third of the twentieth century, the crafts movement had become divided between the academic arena, which had moved in the directions of technological exploration and fine arts, and the crafts guilds and societies. The academic base provided a framework of legitimacy, a supportive environment, and a steady salary for the artists, as well as a national network of colleagues. The crafts guilds and societies remained intact, limited in focus, and often reflected the inevitable rumblings found in all groups where strong personalities are the driving force. These guilds also often represented the folk art traditions, frequently including the traditional work of newly "Americanized" immigrants. While they maintained themselves throughout the country, and grew modestly in numbers, they did not match the energies found elsewhere.

The groups persisted, however, and in 1939 the Handcraft League of Craftsmen was founded by Aileen Osborn Webb at a conference of craft groups from New York, New Jersey, and the New England states. In 1942 it merged with the American Handcraft Council, forming the Handcraft Cooperative League of America, and in 1947 the American Craftsman's Educational Council was formed out of several local handicraft leagues. This institution was chartered by the New York Board of Regents with recognition of permanent status in 1948. Its purpose was to serve the cause of American craftsmen by stimulating them to a greater understanding of their role, and helping them fulfill their capacities as creative individuals. It encompassed educational programming both for craftspeople and the public, reviving refrains from the original arts and crafts movement.

The Council was accompanied by two allied enterprises. The first was a marketing agency, America House, also founded by Aileen Osborn Webb as a sales outlet for participating craftspeople; it was located in Manhattan and remained in business until 1971. The second, the publi-

cation *Crafts Horizons*, was founded in 1941, to cover all aspects of the crafts and related activities such as exhibitions, educational programs, and craft fairs. The Council, now the American Craft Council, and the magazine, now *American Craft*, still exist, serving a diverse membership of craftspeople and providing both marketing services and exchange of information.

During this time both folk arts and Native American arts received increased attention. There was a revival of interest in the folk arts, especially in the South, and programs were designed to teach and promote the local crafts and to provide income for the underemployed. A series of craft exhibitions was held in schools and social halls all over the country between 1918 and 1932, celebrating the traditional craft work of the immigrant populations. The Museum of Modern Art hosted an exhibition of Native American Art in 1941, the result of interest aroused by the increased awareness of the commercial potential of the tourist in the Southwest and the Western national parks.

1945–1960: AFTER THE SECOND WORLD WAR

Post-WW II years saw tremendous growth of the craft world as it currently existed and as part of the larger national and international art world. The country had gone through a period of industrial growth, which, no longer needed for war production, could now focus on consumer goods. The surviving male work force came back home with the G.I Bill to help pay for college tuition, a factor which allowed many men to pursue college training for a career in art previously unaffordable. For the first time there were sufficient students and jobs for teachers to create an atmosphere charged with energy, looking to the future instead of fighting to survive.

As seen above, the two divergent craft groups each had its own focus, audience, and infrastructure. The academic centers within art schools, colleges, and universities focused on aesthetic and technological explorations, appealed to the student seriously intent upon becoming a professional artist, and organized curricula accordingly. The craft societies and arts and crafts centers were organized towards the part-time avocational student, offered loosely organized classes and workshops not part of a formal curriculum, and addressed a wide spectrum of students at all ages, all levels of proficiency, skill, and seriousness of intent. Occasional hostilities arose between the two groups over perceived differences in prestige or "professionalism." They were closely linked, however, through shared interests in the craft medium, and shared faculty. Teachers from

academia often taught the workshops and summer classes at the arts and crafts societies and centers, and the students themselves moved from one arena to the other following favorite teachers. The craftspeople who established their base within the academic world now viewed themselves primarily as artists using crafts media rather than as craftspeople.[19]

Further exploration of both familiar and new materials, the expansion of sculptural ideas, and the development of American Abstract Expressionism[20] all moved the art world, and as part of it, the craft world further away from the tightly functional categories that had served as earlier standards, although these categories continued as legitimate areas of study. In painting, Abstract Expressionism involved intense interaction with the surface of the object and the action of painting itself; it focused on color, form, and texture, concerns that were easily translated into the crafts arena. This adaptation by the craft artists of the dominant movements in the academic art world began a relationship to the marketplace similar to that of the "fine artist." While craft artists still exhibited and sold their work through craft fairs and craft shops, they began actively to seek gallery representation and museum exhibitions and purchase.

Many new centers were founded during this time, such as the Haystack Mountain School of Crafts in Deer Isle, Maine (1950), the Archie Bray Foundation in Helena, Montana (1951), and the Brookfield Craft Center in Connecticut (1954), which offered classes and studio work in several media. New, media-specific organizations also came into being, including the Michigan Silversmiths Guild, the Seattle Clay Club, the New Jersey Designer Craftsmen, the Metal Arts Guild (San Francisco Bay area), the Midwest Designer-Craftsmen, the Midwest Weavers Association, the National Woodcarvers Association, and the Minnesota Crafts Council. The opening of these new crafts centers and organizations reflected the energy generated among craft artists during this period and their needs for more sophisticated educational resources.

Individual Craft Media

The development of the different media which all progressed during the next fifty years differed markedly in pace due to variations in technological development, complexity and cost of materials, and personal energy and chemistry of the leaders in each medium.

Ceramics remained one of the most active crafts. A strong Zen Buddhist influence, led by the visiting English potter Bernard Leach and the Japanese potters Shoji Hamada and Soetsu Yanagi, affected both the traditional and experimental work across the country, especially in aca-

demic settings. One of the most adventurous ceramic departments in the country, characterized by strong camaraderie among students and faculty and respect for the individual as arbiter of his own art, was set by Peter Voulkos at Otis Art Institute in Los Angeles.[21] He later moved to the Archie Bray Foundation in Montana and then back to California, establishing new concepts of nonfunctional ceramic sculpture, a dramatic shift still strong today. Other centers of energy were the State University of New York at Alfred and Black Mountain College, where there was exciting interaction among artists in all fields, moving far away from the quiet ceramic studios of the past.

The same energy was also evident in the fibers world. Internationally, there had been a resurgence of interest in fibers with some marked changes during this period. Explorations during the 1920s and 1930s had focused on designing for factory reproduction. The new work, later designated "Art Fabric" by Constantine and Larsen, consisted of work still made of fiber but created on or off the loom; it was designed to express the artist's personal experience and explorations.[22] Much of the major fibers activity in the United States before 1950 had been on the West coast, but due to effort by Aileen Osborn Webb, New York's Bertha Shaefer Gallery finally hosted an exhibit of fiber work. This exhibition introduced fibers as a serious art form to the East coast and was later followed by a cooperative venture by the Merchandise Mart of Chicago and the Museum of Modern Art in the Good Design Program. In 1956 the Museum of Modern Art held an exhibition entitled "Textiles, U.S.A.," which included Art Fabrics as well as industrial fabrics and home furnishings. Major industrial designers such as Jack Lenor Larsen and Dorothy Liebes both moved to New York in the early 1950s.

The 1950s also saw a blossoming of work in glass as an art form in the United States. The first part of the century saw close association among the industry, artists, and architects in Europe, begun by three artists, Emile Gallé, Louis Comfort Tiffany, and René Lalique. Each exemplified the artist-designer-manufacturer, serving as designer for both functional and sculptural pieces and developing a substantial business that lasted until the late 1940s. Other examples of European artist/industry collaborations were the use of artists to manage the manufacturing process as well as design for both sculptural and functional work in a Swedish glass factory in 1917, then close working relationships between the glass industry and architectural firms in the Netherlands, and the production of well-designed industrial glass for the huge Milan Triennales from 1933 to 1968. In 1954, Egidio Costantini, an Italian studio owner, commissioned original glass art sculptures from leading artists such as Alexander Calder, Pablo Picasso,

Max Ernst, Joan Miro, Mark Tobey, with copies for himself, Peggy Guggenheim, and one for each originating artist.

In the United States, there had been little work in studio glass outside the factories. Corning Glass was established in Corning, New York, in 1903, and it opened the Corning Museum of Glass in 1951. The other major factories were Libby and the Johns-Manville Fiber Glass Corporation. Many American glassworkers of this period had been trained in ceramics; they were used to working with kilns and glazes, but there was little general interest in glass until the early 1950s. At that time Harvey Littleton, a ceramic artist who had grown up at Corning Glass, began experimenting with blown glass in his studio, a process previously restricted to large scale glass production due to the complexity of the equipment required. Littleton persisted and in 1959 gathered together the first panel of glassworkers at the Third Annual Conference of the American Craftsmen's Council at Lake George, New York, to discuss glass as a contemporary craft medium. The movement continued to gather strength and in the 1960s became a full-fledged and fully recognized part of the craft world.

The field of metals has always been divided between jewelry and household and architectural furnishings. Jewelry had consisted of three mainstreams: the traditional "fine" jewelry of precious metals and stones, costume jewelry, often of plastic and other synthetics, and a much smaller segment of one-of-a-kind handcrafted pieces made by craft artists. During this period traditional work in jewelry continued, with growing attention to the third stream as metals departments were opened in art schools and universities and several major metals exhibitions were held.

Wood developed largely outside the universities and reflected continuations of the traditional work in furniture, household, and architectural furnishings. The primary avenues of distribution and sales were the traditional ones of shops within the craft centers and commission work. Craftspeople in these two areas were generally not yet in the mainstream of aesthetic exploration, and there was not the striking growth witnessed in the fields of ceramics, fibers, and glass.

1960s-PRESENT: INTEGRATION AND EXPANSION

The rapid growth in the numbers of activities, participants, and crafts institutions between 1945 and 1960 has continued at an even greater rate in the last thirty years. The expansion has been at all levels and in all directions, reflecting the increasing complexity, specialization, and segmentation of society at large. The meaning of the word "crafts" is still

often problematic and depends on the context in which it is used; it can refer to work ranging from the potholders, casserole dishes, and candles found at the popular commercial craft fairs to the "fine arts" sculpture found in upscale galleries and museums.

The field has also advanced in professional sophistication. Professional business procedures, such as formal contracts with galleries, suppliers, buyers, and employees, inventory systems, and formal marketing techniques are used by many craftspeople. Formalized marketing procedures and channels have been established for both craftspeople and buyers on a much larger scale, such as the professional craft fairs, the American Craft Retailers Association, and books such as *The Guide* by Kraus Sikes Inc. Monthly publications such as *The Crafts Report*, founded in 1975 by Michael Scott, provide information on marketing, business practices, and health hazards. In addition, the administration of craft organizations, both general and media-specific, have responded to the needs of the field by providing a more business-oriented approach to internal organizational structure and to business and professional information available for members.

Formalized systems of resource support have developed in areas of health, financial, and legal needs, such as the American Craft Council-sponsored group insurance plans (including major medical, hospital indemnity, life, and studio policies), the Crafts Emergency Relief Fund, which provides emergency loans to crafts people, and the various local and regional Volunteer Lawyers for the Arts groups. There is the recently established endowed Chair of the Crafts at the University of the Arts in Philadelphia. Such organizations, along with the craft-sponsored regional and local organizations and public support at national, state, and local levels, indicate a coming of age of crafts generally, embracing the entire range of work within the field.

Historically, the period includes the turbulence of the Vietnam war and its aftermath, the relative financial prosperity of the 1970s, and the growth of "high tech" in the 1970s and 1980s. It reflects long-term economic dislocations resulting from the shift from a manufacturing to a service economy, new waves of immigration from Southeast Asia, and the decline of urban capacity to deal with problems in education, health care, and public safety. Social movements include the "Hippie" counterculture of the 1960s and early 1970s, the increased politicization of minority groups, the rise of feminism, ethnic awareness, and ethnic pride for Native Americans, African-Americans, Hispanics, and recent immigrant groups. These movements are both social and political, and indicate a fragmentation and polarization of American society and a challenge to the myth of the American melting pot.

The period also includes the creation of the National Endowments for the Arts and the Humanities (NEA and NEH) in 1965, accompanied by regional, state, and local arts councils in almost all states. These agencies have provided a profound public validation of the role of the arts as a necessary and integral component of our culture and well-being, as well as immediate technical and financial support both to artists and arts institutions. Discipline-specific funding categories of the NEA that apply to the crafts include Design Arts, Expansion Arts, Folk Arts, Inter-Arts, Media Arts, Museums, Visual Arts, and the Arts-in-Education program. In addition, in 1978 the NEA launched a study to gather information on size, media, and activities of crafts organizations as a base for future data collection.

Artists, including craft artists, have reacted to the turmoil of the last thirty years by expressing their ideas and feelings through their work. In a simplistic overview, the philosophical content has become more important than function in a significant portion of work, thus accentuating the gap between the world of craft artists and the craftspeople working in production. Imagery for craft artists is wide-ranging; it includes both abstract and representational forms, explorations of past time periods and cultures, non-Western European ethnic cultures and traditions, landscapes, figurative work, satire, and the symbolism of myth and ritual. There is a simultaneous and parallel exploration of "high tech" and traditional materials by white artists and artists of color, although artists of color constitute a very small percentage of the total number of craft artists. Production craftspeople have broadened the scope of the imagery used in the decorative aspects of their work, but functionality remains the primary purpose of the work. The following brief overview of the development of each medium clarifies the distinctions.

The Craft Media

The fibers world continued to bloom, especially in one-of-a-kind art pieces. Although interest in weaving fabric for household furnishings and clothing continued through the 1980s, the dominant thrust of the 1960s moved away from the traditional techniques and limitations of the loom. Monumental sculptural pieces composed of materials such as hemp and sisal were hung on walls, suspended from ceilings, arranged on floors, and put on pedestals. Although the movement was international, much of the most important work was initially done in the United States, primarily by women artists. These artists presented a very strong showing at the "Biennale Internationale de la Tapisserie," when it was established in 1962 in Lausanne, Switzerland, the first major international exhibition showing

such work. The 1970s saw the continued creation of very large pieces, many of them two or more stories high, often commissioned by corporations. A few were environmental pieces, the largest being "Running Fence" by Christo, a sculpture of nylon canvas panels running twenty-four and one half miles across privately-owned land on the California coast.

Other techniques explored and used in the creation of these large sculptural pieces included felting, plaiting, knitting, tapestry, quilting, and appliqué, as well as weaving. Each area of fiber concern developed its own interest group, academic area, association, and following. One area of concentration was the structure and use of the fibers themselves, how they were made, how they took dyes that formed patterns later in the weaving process, and how they could be used in sculptural forms. A second area was the use of the surface of the fabric, both as a statement in itself, and as a surface for further printing, appliqué, embroidery, quilting, and collage. Used as a surface, much of the work became pictorial, presenting strong political statements, such as the work in the 1970s by the Feminist Art Program at the California Institute of Arts, and Judy Chicago's *The Dinner Party*. In 1985 the Peace Banner stretched from the Pentagon to the steps of Congress, and today the AIDS Memorial Quilt, a national project that started with 10,500 patchwork panels, celebrates the lives of those who have died as a result of being infected with the virus.

In metals, while traditional work has continued both in jewelry and in household furnishings, much of the work has become highly expressive as aesthetic and philosophical statements. The use of materials for both jewelry and household wares has broadened to include non-precious metals such as titanium, niobium, and tantalum, common stones, plastics and acrylics, paper, and a wide variety of found objects, the detritus of current culture. Jewelry took on an additional role as small sculpture, and during the 1970s became costume/performance art as well; pieces were enlarged in size to cover the entire body or to move through an area of space much larger than the person wearing the piece. While much of the jewelry of the 1980s is less dramatic, jewelry design continues to run the gamut from highly sophisticated abstract work with precious metals to "throw-away" jewelry of recycled materials. Production and one-of-a-kind work has also continued in tableware, utensils, and dishes.

Architectural metalwork has also grown, due largely to the blacksmithing work of Albert Paley, whose major work is in large scale architectural commissions for gates and doorways, including a bridge railing finished in 1989 for an urban renewal project in Rochester, New York.

Glass has moved to the forefront of the craft art world since the 1960s and is now one of the most popular crafts. There is a strong body of work

made by production craftspeople in the areas of tableware, paperweights, and stained glass, and a new movement in pictorial and sculptural glass. Following the early work of Harvey Littleton, the first glassblowing workshop for artists (most of whom had past experience in ceramics), was held at the Toledo (Ohio) Museum of Art in 1962 to introduce molten glass as a material and to examine materials and techniques. Focus in the late 1980s moved from glassblowing as the primary forming technique to include casting, fusing, slumping, and cold-surface decorative techniques. Glass programs have proliferated within universities, art schools, and at craft centers such as the Haystack Mountain School of the Crafts (Maine) and Penland (North Carolina). Local and national glass associations and journals have followed. By the 1980s, glass centers such as Pilchuck, the Creative Glass Center of America (Millville, New Jersey), and the New York Experimental Glass Workshop (New York City) had opened; their purpose has been to move away from an academic focus and to concentrate on exploration of the materials and aesthetic concepts particular to glass.

Only since the early 1980s has wood witnessed the dramatic surge of recognition that came earlier for the other crafts. Nevertheless there has been a steady increase in the numbers of woodworkers in both furniture and household furnishings and in accompanying conferences, associations, and journals. Contemporary furniture trends follow two traditions coming out of the 1960s. The first is the preservation of the simplicity of form and purity of the wood surface without further decorative elements. The second uses both wood and other materials (formica, color core, metals, and other plastics and acrylics), in non-traditional shapes, often with painted surfaces. As one might expect, most of the production work is more traditional, while the one-of-a-kind pieces are experimental and often strictly sculptural. An interesting crossover, however, indicative of the trend blurring distinctions between "fine art" and crafts, is work by visual artists Donald Judd, Sol Lewitt, Richard Artschwager, and Scott Burton, who have expanded their sculptural interests to include the construction of functional tables and seating.

Ceramics remains one of the most active fields. The years since the early sixties have witnessed both the continuance of traditional functional household ware and the development of sculptural work that explores aesthetic and philosophical issues. Sculptural work is represented both by the Funk movement with its satiric images, originating in California in the sixties, and the technical virtuosity of ceramic artists making functional ware with highly glazed surface treatments along with many elements of the Memphis and Pattern and Decoration design trends of the 1970s. Ceramics, perhaps because of its dominance in the crafts world, has been

particularly strong in its presence in the gallery world, encouraging the professional achievement desired by many craft artists.

Education and Training

In looking at career development in the crafts, a first step is education and training, whether through formal or informal channels. Formal educational opportunities increased again with the expanded curricula of community colleges as well as with the increased number of professional BFA and MFA programs in crafts media in traditional art schools, colleges, and universities. In addition, formalized programs devoted solely to crafts developed within universities, such as the School for American Craftsmen at Rochester Institute of Technology, and the Program in Artisanry, which began in 1975 at Boston University, moved to Swain School of Art and Design in 1985, and finally to Southeastern Massachusetts University in 1987. Other programs, such as the Oregon School of Arts and Crafts offer accredited craft curricula using the liberal arts components of other schools for completion of the BFA degree. Some schools are media-specific, such as the Wendell Castle School, founded in 1980, which teaches furniture making. A recent *Directory of the National Association of Schools of Art and Design* listed 164 such programs.

While formal academic programs in crafts have entry requirements, community colleges usually do not, making training more accessible both to students fresh from high school and for the "later learner." Informal educational training is also given at community art centers, many of which are abandoned elementary schools converted to community use. There are also apprentice programs in which younger students on the professional track work with a master craftsperson or become part of a professional training program, such as the Baulines Crafts Guild woodworking program or the Mendocino Art Center Textile Apprenticeship program, both in California. Such programs are relatively few in number, however, because they are difficult to design and maintain.[23]

Exhibition: Museums and Galleries

After initial training, the craftsperson is concerned with the exhibition and sale of work for income, critical exposure, review, and feedback. The relative importance of exhibition for its own sake versus actual sales depends on the craftsperson's purpose and choice of arena. For the craft artist working on the cutting edge of the medium and concerned with personal exploration of aesthetic and philosophical issues, exhibition and

critical review may be crucial. Before 1960, opportunities to exhibit and sell were usually limited to small galleries within art centers and occasional exhibitions in university galleries and museums; between 1945 and 1959, there were 57 major craft exhibitions, an average of 3.8 per year, 29 of them in museums, 10 in university galleries, and the other 18 divided among art centers, commercial galleries, and municipal art centers. Many of the exhibitions travelled abroad under the aegis of the U.S. Information Agency and through private arrangements with museums in Europe and Japan. In the subsequent three decades the average number of exhibitions per year went from 3.1 in the 1960s to 7.9 in the 1970s to 10 per year by 1986.[24] The exhibitions have shifted in focus from combined media shows to in-depth exhibitions of one medium at a time, providing a framework for more in-depth historical comparison and criticism.

There has also been an increase in the number of major museums actively collecting contemporary crafts, led by the Smithsonian, which provides three major arenas: the National Museum of American History and the Renwick Gallery in Washington, DC, and the Cooper Hewitt Museum in New York.[25] Other museums with active crafts collections are the John Michael Kohler Arts Center (Sheboygan, Wisconsin), the Nelson-Atkins Museum (Kansas City, Missouri), the Detroit Institute of Art, the Oakland Museum (California), and the Brooklyn Museum (New York). The number of museums devoted exclusively to craft has also increased. The American Craft Museum, in existence in New York since the 1950s, moved in 1987 into a new and expanded space on 53rd Street. The Corning Glass Museum, founded in the 1950s, actively expanded both its collections and its activitites beginning in the 1970s. In July 1989, the Museum of Folk Art celebrated the opening of its new building in New York, and the Craft and Folk Art Museum in Los Angeles announced a $12 million endowment and capital campaign to construct a new museum space within a mixed use facility on Wilshire Boulevard. The Society of Arts and Crafts in Boston has announced its plan to establish a craft museum in Boston in the near future.

There has also been increased interest in contemporary work in the crafts media from "fine art" collectors and dealers, indicating recognition of such work in a venue previously unavailable and providing a professional legitimacy for the craft artist. The number of professional commercial galleries that devote themselves exclusively to the crafts, carrying a range of work from one-of-a-kind pieces to high quality production work, has also increased throughout the country. New York alone has twenty-nine galleries that show crafts as their primary focus, while Chicago has thirty galleries carrying craft work with fifteen more

in nearby environs, San Francisco fourteen, Los Angeles eleven, and Washington, DC twelve.[26]

Other Marketing Venues: Craft Fairs and Architectural Collaborations

For the production artist who works with multiples, sales may be more important than critical review although public acclaim is always significant. A major venue for sales is the craft fair. Once sleepy local festivals, craft fairs have increased tremendously in numbers and have joined the ranks of national major trade shows. They range from popular, commercial, locally oriented fairs to the national professionally oriented American Craft Enterprise, Inc. (ACE, a subsidiary of the American Craft Council) fairs, which jury participants for aesthetic excellence and serve both the trade (gift retailers, craft shop owners, department store buyers, and interior designers) and the general public by holding wholesale and retail days. Annual gross sales for the five ACE Fairs now total over $33,000,000 with annual attendance of 19,000 wholesale buyers and 95,000 public visitors; sales for the individual craftsperson at these fairs averaged roughly $16,000 in 1989.

In addition to the ACE Fairs, the Buyers Market of American Crafts sponsors four national juried shows and the Harvest Festival, based in California, runs twenty-one craft fairs in eleven states with over 12,000 participants. Classes and seminars addressing professional business practices for craftspeople have been held throughout the formal educational system through local and regional art councils and by the sponsoring agencies.

Beginning in the 1980s professionalism has increased, not only of the craftsperson in the production, promotion, and sale of his or her work but also of those who work as intermediaries in the commercial world. There is more formalized interaction between craft artists and retailers through more explicit contracts detailing delivery, exhibition, promotion, payment, and artists' rights and through formal classes offered to craft artists in presentation and marketing in both standard educational arenas and through the craft fair sponsors. In addition, the American Crafts Retailers Association was established in 1987 to develop programs and services as well as a bank card discount program and various health and business insurance programs.

Two trade magazines, *Niche*, produced by the Rosen Agency, and *Matter*, produced by American Craft Enterprise, Inc. and George Little Management, Inc. were introduced in 1989 to serve both the artists and

the retailers. In addition, other services have been added to the basic format of the fairs, such as travel arrangements, a suite of hotel rooms for jewelers (insuring security), business presentations, discussions, and most recently, focus groups to discover how to serve both the craftsperson and the retailer.

A professional collaboration between craft artists and architects and interior designers has also developed. While such collaboration has occurred since the early 1920s, the 1980s saw a conscious effort to formalize and promote channels of interaction. The crafts have been featured in recent annual meetings of the American Institute of Architects and the American Society of Interior Designers. Major magazines in the field, such as *Metropolitan Home* and *Better Homes and Gardens*, frequently show craftwork as integral components of both interior and exterior design. *The Guild*, a directory of craft artists experienced in working with interior and exterior design and *Architectural Crafts: A Handbook and Catalog* are examples of marketing efforts that supplement participation in annual national commercial gift, interior, and furniture shows, and regional and local home shows.

Craft artists have also played a strong role in the installation of major indoor and outdoor work in public places, a contemporary version of earlier collaboration with the Works Progress Administration. Projects include the tiled walls in subway stations in both Boston and New York, the steel fence by Donna Dennis depicting ships at P.S. 234 in Manhattan, and the whirligigs installed next to an electrical station in Seattle, Washington. These artists work closely with public planners, architects, and the public at large. The American Craft Museum's 1988 travelling exhibition entitled "Architectural Art: Affirming the Design Relationship," showed architectural work by Ed Carpenter (glass), Joyce Kozloff (ceramic tiles), and Sheila Hicks (fibers) as well as other artists.

SUMMARY

The worlds of the craft artist and the craftsperson have changed and broadened dramatically within the last hundred years and particularly in the last thirty years. The nature of the work, its materials, and its processes have changed, both responding to and shaping the technological discoveries in each of the media. The content of the work has also changed, moving from simple production of functional housewares and tools to complex aesthetic and philosophical statements full of social comment, formerly associated only with the "fine arts." The work has been validated in academia, in the marketplace, through professional associations, and in the art world of galleries and museums. There are many new avenues,

formal and informal, of preparation for a career in the crafts, and there are just as many new venues for exhibition and distribution of work.

These changes indicate yet another shift, that of the role of the craft artist and craftsperson in relation to society at large. While many craftspeople still view their work primarily as avocational and recreational, a much larger number of craft artists and craftspeople now define themselves as professionals, educated for and in pursuit of careers that have pathways similar to other careers, with entry points, career development, and professional associations and responsibilities. This shift in self-definition has in turn instituted changing perceptions of the craft artist and craftsperson by a wider circle of associates. While always viewed as an active and necessary contributor to individual society, there is now greater recognition, respect, and prestige accorded to the producer of goods that have value beyond their utilitarian function, a value that is seen as enhancing the quality of life. Craft artists and craftspeople are also becoming members of professionally recognized groups of workers that perform given functions, can act as a body, and have specific educational, economic, social, and professional needs. The next explorations will be to further define those needs in order to understand how best to serve them.

Mary Greeley

NOTES

1. Lucie-Smith, Edward. *The Story of Craft: The Craftsman's Role in Society.* Ithaca: Cornell University Press, 1981. Chapter 7, p. 163 ff.

2. Lavine, Sigmund A. *Handmade in America: The Heritage of Colonial Craftsmen.* New York: Dodd, Mead & Co., 1966. The earliest ceramic and brick production works were in the mid-1600s, and cabinet making and metalworking (silversmithing) as distinct professions were established about the same time although their products were available only to the wealthy; the earliest glassworks was established in 1739, and metal working in pewter and other metals followed by the mid-1700s.

3. Harris, Neil. *The Artist in American Society, The Formative Years.* Chicago: University of Chicago Press, 1982. Chapter 1.

4. Edwards, Robert. "The Art of Work." In Kaplan, Wendy, ed. *The Art That is Life: the Arts and Crafts Movement in America, 1875–1920.* Boston: Museum of Fine Arts, 1987. p. 223 ff.

5. Boris, Eileen. *Art and Labor.* Philadelphia: Temple University Press, 1986. p. 13.

6. Boris, p. 30.

7. Boris, p. 28.

8. Perry, Louis. *Intellectual Life in America.* Chicago: University of Chicago Press, 1984. p. 220.

9. Edwards, p. 223.

10. DiMaggio, Paul. *Nonprofit Enterprise in the Arts: Studies in Mission and Constraint.* New York: Oxford University Press, 1986. Chapter 2.

11. Boris, p. 84.
12. Boris, p. 83.
13. Boris, p. 90.
14. Boris, p. 32.
15. Boris, p. 37.
16. Boris, p. 48.

17. Constantine, Mildred and Jack Lenor Larsen. *Beyond Craft: The Art Fabric*. New York: Van Nostrand Reinhold, 1983. p. 17.

18. The community was weak in its administrative structure, however, with little agreement on who was in charge of major administrative issues such as financing. The College closed in 1956. Lack of concern for the business end of creating art was not seriously addressed as a necessary component of the process until the late 1970s and early 1980s, when many of the older arts and crafts institutions faced serious financial problems.

19. Semantic arguments and strong individual preferences continue concerning the use of the words "artist," "craftsperson," and "craft artist." For the sake of simplicity, I will use "artist" to define an artist working in the "fine" arts, "craft artist" to describe an artist working primarily in the craft media, and "craftsperson" to describe a person working primarily in production work in the craft media.

20. "Abstract expressionism" is usually used in reference to painting but carries over to the crafts in so far as craft artists deal with their materials primarily from the point of view of form and surface treatment rather than function.

21. Clark, Garth. *American Ceramics: 1976 to Present*. New York: Abbeville Press, 1987. p. 103–106.

22. Constantine and Larsen, p. 7.

23. See Williams, Gerry, ed. *Apprenticeship in Craft*, Goffstown, NH: Daniel Clark Books, 1981.

24. Smith, Paul J. *Craft Today: Poetry of the Physical*. American Craft Council. New York: Weidenfeld and Nicolson, 1986. pp. 287–289.

25. Fairbanks, Jonathan. "Crafts and American Art Museums." In Manhart, Marcia and Tom Manhart, eds. *The Eloquent Object: The Evolution of American Art in Craft Since 1945*. Tulsa, Oklahoma: Philbrook Museum of Art, 1987. p. 165.

26. *American Craft 1988–89 Guide to Craft Galleries and Shops, USA*. New York: American Craft Council. 1988.

The Craftsperson Speaks

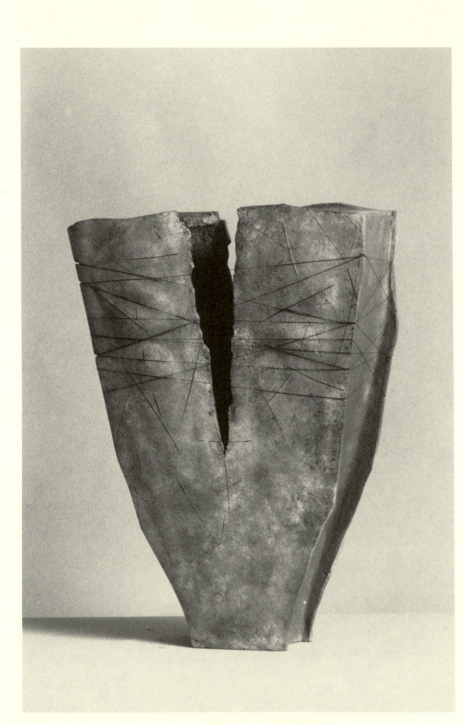

"Bound Torso" by Carole Aoki, 1991 (23″ x 16½″ x 5¼″)

CAROLE AOKI

B. Salt Lake City, Utah, 1950. University of Utah, 2 years, major in chemistry, then art (concentration ceramics) BFA, 1977, California College of Arts and Crafts (CCAC). Manager, retail plant store in Sacramento. 1981, member, Santa Rosa cooperative. Artist in Residence, Lakeside Studio, Michigan. 1990, moved to New York City.

Q: Can you describe your family?

AOKI: My family—I have four older brothers and one older sister.

Q: And where did you grow up?

AOKI: Salt Lake City, Utah. Born and raised for twenty years. My mother was a mother and a housewife, taking care of the six kids. That was quite a job. And my father was a bit of an entrepreneur. He eventually ended up in real estate in Salt Lake City. But we always had family run businesses. He first had a trucking company for produce and then a fruit stand. But it always involved the family, and we did things like selling flowers and Christmas trees, together as a family. So it was . . . pretty close knit that way. But also a lot of fighting between us, because we were so close. That was the immediate family. My father came from a very large family of farmers in Utah. There were eleven children in his family. So there were quite a few aunts and uncles and cousins in Salt Lake City where I grew up.

Q: How about your initial experiences with art? Do you have artistic people in your family?

AOKI: Not directly. My mother had us constantly doing things, making things out of Quaker Oat boxes and shoe boxes. We were a lower middle class family, so we really had to be creative with our toys. And she was always making things for us. I think that was the most influential as far as my art background. My brother is very good at rendering. But he really never pursued it as a career. My grandparents were involved in the performing arts, but no one in the visual arts. They lived most of their adult lives in California, other than being in the relocation camps; and my grandfather stayed in Colorado on a work furlough for a bit and then traveled through Utah. That's how we ended up in Utah. My mother's family ended up in Utah after the war.

Q: What were your initial experiences with art?

AOKI: Well, it seems as though I was always drawing. I was a bit of a loner, as a child, and I entertained myself at times by drawing. And when I was in school, I was pointed out as someone who could draw well. So I was always doing murals for the classroom, or special projects like that. So, all during my education, through grammar school and junior high and high school, it seemed I always did a special art project for the school or for the teacher. But I really never saw myself as an artist, growing up. As a matter of fact, when I graduated from high school, I thought I was going into chemistry. And then, I'm not quite sure why, but I all of a sudden changed from having this bizarre idea of being a chemical engineer to changing my major to art. I knew I could draw well. And maybe there was a little bit of doubt as to whether I could be a good chemical engineer. But I knew that I was good at drawing and good visually.

Q: Did you have art classes in elementary school and high school?

AOKI: Yes, all throughout. But they were very limited. I mean, it was a public school, and there were no special programs. Just the regular art classes that were taken by people as an easy course. So, there weren't a lot of teachers that I had that were very influential in my art education. It wasn't until I went to college that I really started seeing myself as an artist. In high school, I had worked on several special projects and worked on the yearbook and things like that. So I knew I was pointed out as being more artistic than any of the other kids and that was about the extent of encouragement.

Q: When you were taking art classes in high school, were there any particular art forms that interested you?

AOKI: Not really. Because it was a very generic art class. I mean, we just dabbled in everything from drawing to watercolor to making plaster casts of things. And come to think of it, it wasn't very stimulating at all.

And it didn't introduce me to very many art forms at all. And there was no art history taught at my high school.

Q: So, it was mostly drawing classes.

AOKI: Drawing classes and graphic design from working on the yearbook. I remember in my senior year or junior year, there was a potter's wheel in the classroom, but it was always used as a table. It was not used for ceramics. So I really didn't work with clay until I was in college.

Q: And what college did you go to?

AOKI: I spent two yeas at the University of Utah. And then I transferred to the California College of Arts and Crafts, in Oakland, where I received my BFA.

Q: So you actually applied to the University of Utah with the intention of going as a chemical engineer? And, as fate would have it, they had an art department as well?

AOKI: Right. Actually, it was a very good art department. My first year as a freshman, we were still stuck in the old Army barracks. By my sophomore year, they had completed the art complex. It was a very nice facility. And they were starting to get some instructors with real diversity. What had happened in changing my major to art, they made me take basic art courses. And through one of the basic art courses, one of the instructors had us make wooden bowls out of planks of wood. It was very raw material, and then we had to form this object. And I think that's really what got me hooked on making objects, that one experience. I took a lot of rendering classes and color design classes and not really sculpture classes, but just basic, line, texture, form, and color classes. Then there was just that bowl. There was something very wonderful about making this utilitarian object from raw materials. And making something round out of something that was once flat. [*Laughter*]. That really intrigued me. So after that experience, I declared myself a ceramic major. Well, not really, but I signed up for ceramic classes. I didn't declare myself a ceramic major until I was in California. But I loved making that bowl, so I wanted to make more. Then in my sophomore year after all the basic courses were out of the way, I started concentrating on ceramic classes. My parents had moved during my freshman year. They moved to Sacramento, California, to take over my grandparents' restaurant. I always joked with them that they had run away from home. So it was about a year-and-a-half or two years, that I followed. I also met a boyfriend, and he was moving out to California. So it was like this exodus to California. Everyone was going. And I also had a friend who had gone to the University of Utah who was going to CCAC at

the time. So, I think during spring break she invited me to California to see the school. And, that's why I chose California College of Arts and Crafts. It was a wonderful setting. And it was far enough away from my parents, but not too far. I could call them for help if I needed it. Actually, what had happened is that I moved to California, in the summer of 1970, and then I took a semester off and traveled. My grandparents took my sister and me to Japan. When I came back, I started in January of the following year as a junior at CCAC.

Q: Did you stick with ceramics, from that point?

AOKI: Well, CCAC had a policy that before you could declare a major, you had to take certain basic courses again. I was a little upset with that because I was ready to just dive into ceramics. But it turned out to be very good for me. I took printmaking, and I took metal design and welding, glass blowing, wood design, and photography. I finished all the requirements within two semesters. I was also taking some ceramic courses; during this time I really started concentrating on ceramic classes all day and all week.

Q: When would you say that you became an artist? And how did you know?

AOKI: Well, you know, this has been a very hot debate nowadays. Because I think that I considered myself a craftsperson, all the way up until maybe two years ago. Then I started questioning and wondering what do I call myself? I'm doing things that aren't utilitarian. And they have more meaning, the content is starting to be more important than the material I'm using. But I've had a very strong background in crafts, meaning emphasis on craftsmanship and technique. So, I would say that I started really feeling like an artist, this past year and a half.

Q: Let's just change tracks and talk about the people you considered your peers while you were in school. Were they important to you? Did you have a peer group?

AOKI: Well, I think it was something very new. We had Peter Volkous and we had Arneson and all that West coast influence in ceramics. But they were teachers, and a lot of us knew that we weren't teachers. So we didn't know quite what we were going to do with this skill that we had learned and loved so much. A lot of my peers were making very functional work. It looked as though they were going to go on to become production potters. That was the goal for most of us. That we would become studio potters. But Viola Frey, even though my work has no resemblance to hers, was a great influence. She was one of my instructors. She just taught me that there's a little bit more than making a very well-made cup or a very well-made bowl. You can poke fingers through

it and you can do all sorts of things with the clay after you've thrown it. Or you don't even need to throw. And that was important. I think my approach changed a little bit after being influenced by her—by seeing her work. I knew that I didn't need to be a cup maker. I didn't need to be over the wheel all day long throwing fifty cups.

Q:Is that what you were doing when you were in college then?

AOKI: Well, I was trying to use the facilities and the materials that were available. I was still making functional vessel forms, but I was trying to do something a little bit different with them. I really didn't develop much of a style at that point. It was pretty much just getting to know the materials.

Q: When did you start to develop a style?

AOKI: Well, I've always worked with ceramics. But it really wasn't until about four years after I graduated that I decided that this is what I wanted to do for a living. And so I really concentrated on developing something that had my signature on it. And it went through various stages of working with earthenware and stoneware and then finally evolving into porcelain. And that's when I started using colored porcelain, staining the clay. And I think that has been my signature. When people think of my work, that's probably what they identify me most closely with, the colored porcelain work. I try always to do something a little bit different and put a little twist here and there, trying not to just make it functional. Although I really appreciate well-thrown cups, I think I knew that wasn't really where my talent lies, being a technician, and that my talent was more in having a decorative eye, at that time. The decorative work evolved into this work that I've been developing for maybe the past three years as being more of a personal expression.

Q: You mentioned Viola Frey. Would you consider her a mentor?

AOKI: I don't think a mentor. She influenced my work. She was not very close to her students. There were a few exceptions, but I wasn't one of them. I really didn't have a mentor who I really felt that I wanted to follow in his or her footsteps.

Q: What qualities do you think you needed most during your early training period?

AOKI: Well, I've always had trouble with discipline [*Laughter*]. I mean, if I didn't have a deadline or if I didn't have to be in the studio, it was sometimes very difficult for me to be in there.

Q: What would you say your relationship to your materials was during and right after college?

AOKI: Well, I definitely had an affinity for working with clay. I think it was because it's so responsive and plastic and that it can take any form.

You can really make clay look like wood, or metal or any other material. So, I think I liked that flexibility and range of the material.

Q: Do you think that your training period adequately prepared you for a career as an artist?

AOKI: When I graduated from CCAC, it was their policy at the time, not to have any of the students load or fire the kiln. They had a special studio assistant that did that. So, unfortunately, I did not know how to fire a kiln when I graduated. It wasn't until I moved to Santa Rosa, and this was about four years after I had graduated, and joined a cooperative that I first fired a gas kiln by myself. I left CCAC in 1974. So, this is a while back; I'm sure they've changed their policy. But, it didn't prepare me for a career as an artist. A lot of my education was just this empirical knowledge derived from trial and error, by just doing it. And seeing other people's work and seeing their mistakes as well as mine and developing a career out of this.

Q: What did you do in that four-year period?

AOKI: Well, I had a retail shop. This was in the heyday of living indoor plants. So, my husband at the time and I had an indoor plant store and I, of course, made the planters. I threw the planters as well as the cups and other functional work for the shop. That was in Sacramento. And then we wanted to join this back-to-the-land movement, as everyone did at that time. So we moved to Santa Rosa. I eventually converted a chicken coop into my studio. But the first year that I was there, I joined a cooperative in Santa Rosa. There were about ten of us sharing equipment and kiln.

Q: Did you feel prepared for the business side of your career?

AOKI: No, because at the time, I don't believe any of the art colleges or art schools had any sort of business courses relating to art. For me, it was a lot of trial and error starting out with street fairs and by being out in the public and seeing what the public was attracted to and seeing what was the price range of other people's work. So it was just by a lot of hit and miss, and comparison, that I developed some sort of business. What really developed my business sense was doing the American Craft Enterprise Shows. I think by doing them, I learned quite a bit about marketing and I think that's their forte; I think they grew as the craft people that did their fairs grew, at the same time. They started out as a very small fair, upstate New York, I believe, just an outdoor fair. And they've developed into these very sophisticated marketing fairs. They are juried. And most of the events that I took part in were juried. Even for the street fairs you had to send in applications and slides.

Q: Did you give yourself any benchmarks for achievement when you graduated from college? Do you have any now?

AOKI: No. I feel that this is what I love to do, and this is what I'm going to do for the rest of my life, in some capacity, somehow related to it, even when I'm unable physically to do it. I'm going to continue with my art work one way or the other. So I really don't feel like I have to reach the top of my career at forty. I [*Laughter*] have to start saying forty-five now. It used to be thirty-five, when you were supposed to have established your career. But now that I'm thirty-nine, I suppose I should say forty-five. It's a lifetime commitment. So I really don't see that if I don't reach a certain goal at a certain age that I'm a failure. I guess the goal is just to be able to continue with the art work.

Q: Do you belong to any organizations?

AOKI: Well, not at the moment, since I've moved here to New York. I am, of course, a member of the American Craft Council, that's through affiliation with the American Craft Enterprise Shows. When I was living in California, in Sonoma County, I was quite involved with non-profit organizations. I belonged to a cooperative where we ran our own shop and presented gallery shows. Also, I worked with the Cultural Arts Council of Sonoma County, a local level, non-profit organization. That was nice. Although at one point I was a member of three different boards; I decided it was taking up too much of my time and I wanted to concentrate more on my work. Because at that time, my work was taking on a new direction. It was becoming less and less functional. I lived in a very isolated area in Santa Rosa, and it was good for my development at the time. I just stayed in the studio and worked very hard at developing a line of saleable work. But I've always enjoyed having outside stimulation and camaraderie from being involved in organizations like that. Having been in New York for only four months, I feel that everyone is very much into survival and everyone does have to stay in their studio for long hours. But I eventually would like to—if there isn't an organization already, maybe start something. You know, even if it's only a few artists getting together once in a while to talk about our art work. I think that's very important.

Q: And the organizations that you belonged to in California, what were their thrusts?

AOKI: Well, to have support services and to expose local talent. We'd put on shows at the community gallery. I was involved in creating what we called Craft Trails. It was a very rural area and there were quite a few craftspeople in the county; we took the idea from Farm Trails. Anyone who had a little vegetable garden in the backyard could sell their

vegetables. Well, it was the same idea. There were a lot of craftspeople who were selling out of their homes. So we developed a map and a way for people to get in touch—for the public to have direct contact with the craftspeople. I think they're still doing it, except they've expanded it to all the art forms rather than just craft.

Q: Are there groups or institutions whose services you've used that have helped or hindered your progress as an artist?

AOKI: Well, being involved in the non-profits in Sonoma County really aided in my personal growth, as well as creating contact with other artists. And also, seeing how non-profits are organized and how they operate was insightful. I discovered that the organization's by-laws are very important. If the structure is very clear, then it doesn't matter who the members are, because members come and go for various reasons. No matter who had left or who had stayed, the organization still existed.

Q: Have any of these groups offered benefits, like health insurance or credit?

AOKI: No, we had tried to get something going with the Cultural Arts Council. But, nothing really developed from that because of lack of funds for legal counsel. In New York I was contacted by John Venekamp of the Empire State Crafts Alliance. I'm a member of that organization now. And I applied for health benefits through them. It seems to be a very good plan.

Q: How would you describe your current peer group?

AOKI: Well, it's very easy for me to think of them now, because of just having finished the show at the Armory. I have been with my peers for the past four days. And I think there's a little bit of confusion and unsettled feeling, amongst my peers, right now. I think a lot of us are in the same situation, of doing a little bit more than well-crafted work. We're starting to show personal expression in the pieces. It's not only decorative. Or, it's not staying as decorative as it used to be. People are making personal statements with their work. So, really the line between art and craft is getting very fuzzy. I think we as well as our audience as well as the field have yet to be defined. And I really feel that, hopefully, in the nineties, there will be some clarification of what we are doing. And maybe a new vocabulary will be created. Because "craftsperson" and "artisan" in their customary meaning just doesn't seem to fit a lot of us anymore. I felt comfortable, as I said, in the past year and a half calling myself an artist. And I'm feeling a little bit less comfortable calling myself a craftsperson. Because I feel, a craftsperson has this background in the material and an affinity for the material. It's become secondary now in my work. I could really use other materials and be

able to express the same things. I think that clay has not become as precious of a material to me as it used to be. I mean, I really had this attitude that it had to look like clay, it had to be all made out of clay. It can't be painted. But, I think my attitude has changed, and a lot of people's attitude has changed towards the use of clay.

Q: And who are your peers, right now?

AOKI: Some are ceramic people. I know some people that work with metal. The material is becoming less and less important and not the main thrust of the work now. So my peers work in all different media.

Q: How would you say they've influenced your career?

AOKI: I don't know if they've had a direct influence. But I think, seeing my peers going through the same struggle, it doesn't quite make me seem out there alone—that I'm going through these things by myself. There's quite a few of us, I think, that are going through the same problems of trying to figure out where we fit in, in the art world or in the craft world.

Q: Do you have any particular feeling about unionization for artists?

AOKI: I don't know. I look at other unions and see how they took a wonderful idea and somehow, through all the bureaucracy and everything, kind of destroyed what they set out to do. I think that we definitely need some sort of coalition around certain issues. I'm not quite sure about unions though, because it's kind of contrary to what an artist is: this highly individual person that's not a real joiner. So I'm not quite sure how a union would work other than a coalition formed just for specific issues. I think that we would be a strong group. That we could tear down our egos for a little bit to work cooperatively with one another. But I think that's always a problem, the artist's strong personality.

Q: How would you describe your occupation? And is it different from your career?

AOKI: No. Well, I really don't see it as a career, in a way. I mean, it's my life. And that's how I see it. It's my joy and my sorrow. It's everything that I do. It's something I love and something I hate. I don't go into the studio from eight to five and then not think about my art work. It seems like I'm always thinking about it in some way or working on it in some way. That's why I think it's very difficult to think of it as a career. Because it's so enmeshed in everything else that I do.

Q: Do you see a pattern or a progression in your general job history or career?

AOKI: I guess the pattern would be going from production/wholesaling to becoming more personally involved with the images. It seems to me

like a long process to have gotten to where I am right now. And it's still continuing; I guess it will always continue. But, I like change, and I like seeing change in people, personally, as well as within their work. I think my process has gone through a lot of changes. That may not be typical of my peers; I don't know.

Q: How about gatekeepers—those who let you in or barred the way?

AOKI: Well, I really have to give credit to ACE. They opened quite a few gates for the marketing of my work and allowed me to survive or make a living from what I do. They were major gate-openers. And, I think right now, the biggest gatekeeper is myself. Having gone through a show where I didn't do very well, I have to not make that into a barrier, an impasse. It's very difficult to go through the ups and downs that craftspeople or artists have in their career or their life. And I think you just have to keep on doing the work. That keeps the avenues open. It's very difficult, just the short encounters that I've had here in New York. What we think of as "fine art" galleries, you'll find some that carry clay, but they're hesitant to carry more than one artist that works with clay. It's ridiculous because you don't go into a gallery and hear them limit themselves by saying, "Well, we only have one artist that works in oils, and that's it." But they do with crafts. I spoke with one gallery owner, and he said that he didn't want to be associated with the crafts field. He felt that if he represented more than one clay artist, that people would think of him as a "craft" gallery. And that was like—the lowest thing that it could be called. [*Laughter*]. And unfortunately, that's the attitude that galleries have towards crafts. I mean, I think Arneson, even as well known as he is, is still thought of as a lesser sculptor because he works with clay. That's why I feel that things will have to change. I don't want to be forced to do anything that's against my artistic sensitivity or the vision of my art work in order to just sell it. But, I do have to think of making a living. It's very difficult knowing what to compromise and what not to compromise and how far should you go in order to stick to your principles. If you stick with your principles, are you going to find yourself with no place to show your work? That's not what I'm working for. I do the work for myself. But basically, I want to reach other people. Otherwise, I'd not show the work at all, just pin it up on the inside of my loft and keep everyone out.

Q: What would you say are the discrepancies between your career aspirations and your actual career opportunities?

AOKI: Well, right now, I would like to be represented by a gallery in New York. And I think there are quite a few barriers that are in the way right now. I know that I can overcome them but it's going to be a struggle,

finding a gallery to represent my work, and to convince them that my work is a valid art form.

Q: Do you still do any functional work?

AOKI: Just for therapy, in a sense, and also for gifts once in a while. But I enjoy it. It relaxes me and it's meditative, and sometimes when I'm away from the studio for a long period of time, I'll throw on the wheel. It does give you a sense of the material and gets you in that work mode, you know.

Q: What would you describe as a major turning point in your career?

AOKI: Again, I sound like a promoter for ACE, but I think that participating in their shows was a turning point; developing wholesale accounts and becoming a business person. Learning how to fill out order forms and fill out freight forms, filing freight insurance and packaging and crating and wearing many more hats that just making crafts. I had a few pieces break the first time I shipped things out; I learned how to package better. It was a lot of trial and error. Having received the accounts and the exposure from doing their shows, you had to learn how to fulfill your end of the transaction.

Q: And what about moving to New York?

AOKI: Personal events in my life really have affected this work that I'm doing now. I became more . . . aware of my own emotional needs. And I think that's why I started making more personal statements with my work. I was doing this work in California. And then a long relationship ended, a fifteen-year relationship ended for me. I traveled a little bit during the separation. I realized how insular my life was. It wasn't necessarily because of the relationship; it's just how I made it. My life was up on this hilltop, very bucolic and it seemed like the last place on earth I would move away from. I thought this life would last forever. And I actually thought the relationship would be forever. And when those kind of forever things start breaking down, you realize that there are other things in the world that affect you and that can be very good. So when I did a little bit of traveling, I admit I got a little wanderlust. When I got back to California, I decided I didn't have any ties, really. I don't have children, and the relationship was at an end. And I really had the opportunity to travel and experiment a little bit. So, I thought I would move to a major art city. I thought that would be a good challenge for me. So I was thinking of either going to Chicago or Los Angeles or New York. Los Angeles actually was never in contention, because I don't care for Los Angeles' lifestyle. I was thinking strongly of Chicago. I was an artist in residence near Chicago. So I had an opportunity, last summer, to visit Chicago and meet people. It's a nice place. But I ended

up deciding on New York because I have more friends here. I thought, well at least that's a base, to have people and contacts here. So I decided, okay, I'm going to move to New York. And so after I did a show in Philadelphia, this past November, I set aside two weeks to come up here and look for an apartment and studio or a place to live and work. And it's just kind of this, jump in head first in the deep end of the pool, that is a pattern in my life, that I did this. And it was just happenstance. Realizing that just coincidence, really, has a lot to do with one's life. Just by happenstance, I found this nice loft and studio space. It really does feel that it was meant to be but it's still a struggle. Things are still up and down, as usual. But I really am excited by the newness of this and all of the stimulation; I couldn't ask for more stimulation. But, I really like that extreme change. It really got me excited about my own work.

Q: What's been your relationship to money throughout your career?

AOKI: Well, it's been up and down. When I was wholesaling, I was making a very good living out of it. But, the repetition was getting to me. It seemed too much like a factory job for me; it wasn't stimulating and growing for me. So that's why I changed, and then when I changed to one-of-a-kind pieces the roller coaster really started. I think if I would have stayed with wholesaling, I could have had a nice income, a steady income. Because, you know, each month you have x amount of orders to fulfill. And x amount of money's going to be coming in that month. But, once you start doing one-of-a-kind, it's a real hit and miss and roller coaster ride. It's worked out so far. When the bank account is very low, all of a sudden, a commission will come in. It's not all chance. It has been a period of me working towards that. I've sent out a lot of slides over the years. Following through on things. So it's not all of a sudden something appears. It's been a period of working on it for things to come my way. For instance, when I moved to New York, a woman who had seen my work—through slides I had sent two years ago—finally found a client where the art and the client matched. And so she wanted work from me, so I've gotten a commission from her. She thought I was still in California and was quite surprised that I had moved out here to New York because she's based here in New York.

Q: So, do you do any functional work anymore, just to make ends meet?

AOKI: Not the functional work. But I do what I call the more decorative work for commissions. And that's my bread and butter.

Q: How have the costs of supporting your art changed over time?

AOKI: Well, clay is a relatively cheap material. It doesn't really cost very much. And the cost of the actual production really doesn't cost that

much. What has become expensive is shipping and crating. As the work gets larger or a little bit more fragile, shipping and crating becomes very expensive. So it's changed that way. And now that I'm living in New York, everything has taken a quantum leap.

Q: How have grants, awards, competitions, or emergency funds affected your career?

AOKI: Well, they haven't had much effect because I haven't received many significant ones. I've applied for them. I've entered competitions, and that's the healthy thing to do. One competition I was involved in that was really stimulating was a collaboration. I worked with a sculptor, landscape architect, and an architect. We were involved in a competition to design a town square for one of the cities in the East Bay, Concord, California. It was sponsored partly by the city, partly by California Arts Council, and partly by NEA. It was very exciting to work with highly professional people. The dynamics of working with them was stimulating. I really got excited about that and hope to do more collaborating. I'm not sure in what respect. But working with people from different areas of the arts was really exciting.

Q: You mentioned that you had an artist residency in Chicago.

AOKI: Yes. That was with the Lakeside Group. And, it was my first one, and it was fun. It was like a big studio vacation. Because there were no telephones to answer. There were no slides that I needed to send out, or bills, or correspondence that I had to worry about. It was for two weeks. And it was in a beautiful little resort area along Lake Michigan. I would wake up in the morning, have a small breakfast, go out to the studio, and work. And then when I felt hungry, I'd go in and use the cooperative kitchen and fix myself lunch and go walk down on the beach and have lunch on the beach. Then I would come back and I would work. I mean, we really were pampered. There was someone there to cook the evening meal. And then after you ate, you could do whatever you wanted. Usually, I went back out in the studio. It was wonderful freedom to just do what I wanted, without all those outside pressures, those everyday things that you're confronted with when you're in your home or in your own studio. It was really nice and liberating in that way. It was a very creative time too, and I realized then that it's not only the long hours that you put in the studio which are important, but being out there and treating your eyes, and yourself to a little—you know, a little treat away from the studio.

Q: And how did you get that residency?

AOKI: I had sent in slides. A friend of mine had recommended the residency to me, so I had sent in an application and slides. And they

accepted my application. It was interesting because there was a Lithuanian and a Georgian Russian there as well. And there was a woman from China. I think I was the only American. The three of us were the only ones working in the studio; the woman from China was a printmaker. So, it was very good in that respect—a little international cross-pollination, I guess, in our ideas and culture.

Q: And how do you find out about these kinds of things?

AOKI: Well, this one, as I mentioned, was told to me through a friend. But most of them are advertised in trade magazines like *American Craft* or *Ceramics Monthly.*

Q: Was there a particular time in your career that such money would be most helpful?

AOKI: Well, I don't know, I seem to have always made ends meet. I've been fortunate in that I've always been able to have enough money to do what I want. You know, if I had more money, I think that process would be a little faster, but I would basically be doing what I'm doing now. So it would be wonderful to have that time away from all the pressures, like the residency. And if I could have the money to kind of create my own residency somewhere else or to travel or even not having to worry about one month's rent or where I could dedicate a whole month of doing things that . . . well, see, I'm getting back to the idea of things that aren't easily saleable, and I think that's a real—dilemma. I think for the Armory Show, I didn't have marketing in mind. I wanted to make work that I would want to show in a gallery setting. I wasn't thinking so much about selling the work, maybe that's why I didn't sell very much. But I can't make things only with the thought of selling them. I learned that through years of experience as a functional potter and by participating in wholesale shows. You can do things to make your work more marketable, more saleable. But, I've proven to myself that I can do that, and that's not my priority now. I want it to sell. I want to be able to make a living by doing this. But it's not the main objective. All the work that I've done in the past has been very salable, and I know why. I've learned through wholesaling, through doing shows, and by being in contact with consultants what has a more general appeal to most people. The work that I'm doing now, I've got a very narrow audience. So it's a little bit more difficult. I know that if I do anything in blue, or if you put animals on it, you expand your audience quite a bit. So there are those marketing things that I've learned. But I don't want to emphasize the marketing so much anymore.

Q: How about the importance of physical location and work space at different stages of your career?

AOKI: Well, I think work space is very important. I notice visible changes in my work as I move from larger studios. In California after ten years, I had developed a very nice workable studio. It was large enough, having built an addition with tall ceilings. As soon as I moved into that section where I had taller ceilings, my work got taller. It sounds a little strange, but, you know, when you're limited in space, it's very difficult to do large work. When you get a bigger space, you start thinking a little bit bigger. So, I really think it has an effect. Now that I've moved into a smaller space than I've been used to in the past few years, I just find that I spend a lot of time cleaning up after myself. Because I can't leave things lying around. There's not enough space. So it does affect the work. Location. Well, you know, I think that I could have continued doing my work in California. But I have to admit that since I've moved here, I don't know if it's had an effect on my work, it's too soon to say. But I'm more accessible. You know, for instance, this interview would have never happened if I was still in California. Also other things have happened where just hearing that I've moved from California to New York has created some interest in me and my work. So I think location creates just a different type of exposure. I mean, your work has to be good, no matter where you are, in order for you to be successful. But I think I realized this before I moved here, that when you move to New York there's this whole political and social mechanism that goes along with your work. You have to start learning the politics and going out to openings and meeting people. Probably one reason why I moved here is to participate in that. I hate to take it too seriously, yet I want to give it a lot of effort and my all. I think of it maybe a little bit as a game. As a game player, I need to know the rules. But I think I have to continue having fun with the work and don't let it become too overwhelming. And, you know, people take themselves very seriously here. [*Laughter*] You have to do that here a little bit, in order to be noticed. You have to have that confidence, and you have to feel that self-importance. But I hope that it doesn't overcome my basic Salt Lake City upbringing, my life in California. Because I think my life is fine in that respect.

Q: What kind of control do you think you have over your own destiny?

AOKI: I think I have a lot of control. I feel that by coming here and knowing that I can change environments and be very adaptable—I think I have good control over what I do. But it becomes frustrating when you have to start dealing with the exterior forces out there. You know, I feel very much in control of my life. But when I start venturing out into the art world, it feels a little bit out of control—maybe not out of control, but intimidating. But I know if it doesn't work here, it doesn't work

here. It's an experiment. So I feel fine about going someplace else or trying some other place. I don't feel that if I "fail" here in New York or if I don't find representation and my work doesn't sell well here, it's the end of what I'm doing. I'll just go on, move on.

Q: What kind of interaction have you had with the public over the span of your career?

AOKI: Because you do the shows, there's quite a bit of exposure because you're there, and your work's there, and your ego's there [*Laughter*]. Everything is out in the open. So, I've had quite a bit of exposure to the general public. And, you know, in the craft world, I think I've had some recognition. But it's a small, little sphere. And I really do feel that now that I call myself an artist and I'm not identifying so much with the craft world, I'm moving into a much larger sphere. My exposure to the public really hasn't been that great with that larger sphere of public. I'm hoping that'll change.

Q: Do you have any gallery representation right now?

AOKI: I have a gallery in San Francisco, the Andrea Schwartz Gallery, and a gallery in Royal Oaks, Michigan, the Sybaris Gallery. I've had quite a few craft galleries represent my work in the past. But, since I'm not doing vessel forms anymore, I'm showing in galleries representing fine art as well as art that's done in the craft medium.

Q: Do you have a gallery in New York?

AOKI: No, but one of the goals is to find a gallery that I'm happy working with. It's very important for me to find a gallery that likes my work and one which I can work with. I want a long-term relationship with a gallery. I think that's going to take quite some effort here.

Q: What are your criteria for success, as an artist?

AOKI: Well, I think just being able to perpetuate the work and also to be able to enjoy a little bit of the end product. The end product being a little bit of kudos and cash. I thought at one point that not being so fame-oriented, not pushing to become the famous ceramic artist of New York City or the world, that it limits myself. But I'm really not after that so much as being able to do the work that I love to do, of course get little pats on the back once in a while to encourage me to go on. Also, to make money to keep on buying the materials to maintain the work.

Q: Would you say your criteria are the same or different as those for other people?

AOKI: I think it varies. Everyone has their different wants and needs. I think most of the people, most of my friends, not only peers, but friends—they want the same thing. They love what they're doing, and they can't see doing anything else. And so, they just want to keep on

doing that. You know, it does help to get those kudos, to push you. So maybe we are looking for a little bit of that fame. Not fame, but recognition that you're doing a job well and that some of that recognition comes in financial support.

Q: Do you have a number of central ideas that you keep working on?

AOKI: I think so. Especially in the past three years, I think I've been dealing with themes of interior space, literal and figurative. Layering has always been a thread that has run through my work, even through the decorative pieces, a kind of a peeling back or uncovering, trying to expose what's underneath.

Q: Are there any particular periods of your work that you feel more satisfied with than others?

AOKI: Work that I'm doing now, I feel very good about. And it's personally really satisfying for me.

Q: Do you have any particular feelings about critical review?

AOKI: Well, any kind of review is great. I would like to have a critical review of my work. I haven't as yet, but I think it's very important. I'm sure it hurts to read the criticism. But we're getting back to that political and social mechanism that has to work as well as the art work itself. And I think critical reviews are very important in one's promotion of the work: to have it in print. I found that in my dealing with the general public, that people are very unsure of what they like. And they need that reinforcement of seeing it in print. Or the reinforcement of being represented by a particular gallery. I have sold directly to the public, and I've realized that sometimes, especially if your work is not easily recognized as a cup or a vessel or something that someone can relate to very easily, that they're very unsure of themselves as to whether they like it or not. I mean, they like it, but they need someone; they need the reinforcement of a good resume and some critical reviews and something in print. That's another thing. I wish that this whole idea of art as investment wasn't around. I know it's been great for a lot of artists. As a matter of fact, I read somewhere that a potter that has been around for a while, said he's amazed that he's getting "dead man prices." You know, because people are getting prices for their work that they normally wouldn't get unless they were dead. So, I hate to see people buy for investment. I like to see them buy because they love the work and they want to live with it.

Q: How satisfied are you with your career as an artist?

AOKI: Oh, I'm pretty satisfied. I mean, you know, things can always be better financially, and studio-wise, I always could use more room. I don't think there's a studio big enough for me.

Q: What have been your major frustrations or resistances to professional development?

AOKI: I guess the major frustration now is just knowing that the work is good and that I haven't shown it. I haven't been able to expose it as much as I've wanted to and haven't gotten the response. I haven't been able to show it to people that I think would appreciate the work.

Q: Is there any specific event that was terribly satisfying or terribly disappointing in your career?

AOKI: Well, as I mentioned, the collaboration. Working on that was very satisfying. It's been very satisfying that I've been able to do this for over ten years, as a full time occupation. It's occupied all my time and energy. And that I've been able to make a living, that's very satisfying to me. You know, I've been very disappointed in the past Armory Show, as I had mentioned, because of not selling anything. I know as everyone's told me, I shouldn't use that as an indication of the quality of the work. You can't do that. But you can't help but do that. You know, something's wrong; someone didn't see the same thing that I saw in the work. But, the gate was down, that's my rationalization. There weren't very many people going through the show. And maybe that right person or the right people didn't come to the show to see it.

Q: What has been the effect of the marketplace on your work?

AOKI: Well, I've seen my prices increase. The market has been able to bear that. It's pretty amazing when you think that there are people who are getting ten to twelve thousand dollars for a vessel. That's pretty amazing. My work isn't that expensive. But it has gone from when I first started, two-dollar-and-fifty-cent mugs to pieces that are four thousand or in the four-digit range. I think people are able to buy that, I mean to spend that much money on art work. And also, the work has changed. I've put more into the work that would warrant raising my prices.

Q: How would you say that your absolute, basic requirements for being able to do your work have changed since your early career?

AOKI: The basic requirements of just having a studio, a place to work, is always there. I don't think that's changed. And I don't think it really has changed that much, my requirements to do my work. I just need a place large enough to set up the kiln and the work table. Maybe, in the future, the kiln isn't going to be as important. Just a nice work space.

Q: How about the health hazards involved in your work?

AOKI: Well, I'm very aware of them so that's why I keep the studio very clean. I worry about it. I've developed asthma over the past couple of years. I think it's because of working with the clay dust. I don't work

with very toxic glazes at all, so I'm not too concerned about that. But, you know, the clay dust is a health hazard. I use a mask when I'm mixing glazes or clays or spraying. So I'm very much aware of it.

Q: And were you prepared for that when you were in school?

AOKI: No. Come to think of it, I remember them cleaning up the studio and these pillars of dust would be all over in the studio. And there would be people in there working. It really wasn't an issue when I was going to school. But it certainly is one now. I know everyone's aware of it. I have friends who have worked with leather and with metal who have become ill.

Q: What is the one major point that you would make to a young artist about a career in crafts?

AOKI: I think just to do the best that they are capable of doing. Because I think there's a market for anything out there. I guess the best advice is just to do the very best and the most satisfying work you can.

Q: What do you wish someone had said to you when you were first starting out?

AOKI: I don't know. Actually someone did say the same thing to me. The only thing you can do which you have complete control over is the quality of the things you make. And I think that has stuck in my mind. Do the best you can.

Representative collections include: Public: Anchorage Performing Arts Center, Alaska; Corporate: Kaiser Medical Center (CA), IBM (Raleigh, NC), Upjohn (Kalamazoo, MI), Phillips Petroleum (Tulsa, OK), Federal Loan Bank of San Francisco; nineteen private collections.

Honors: "In the Spirit of Collaboration," 2nd place, Todos Santos Plaza; 1989 Ceramic Art Award, California Museum of Art.

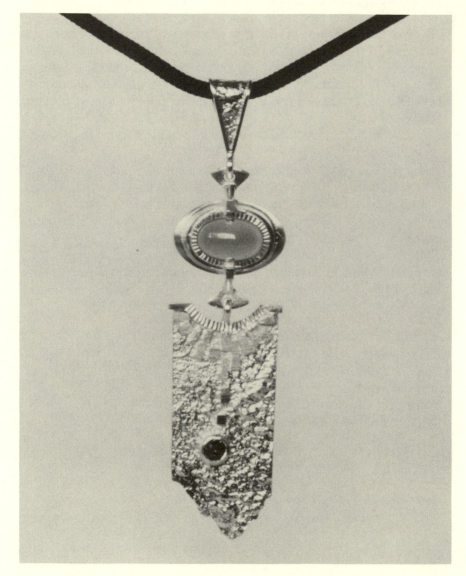

"Pendant" (untitled) by John Cogswell (3½" x 1"; sterling silver, 14 k. gold, and blue sapphire).

JOHN COGSWELL

B. Cortland, New York, 1948. State University of New York, Cortland, 1966–1968. BFA, Gold and Silversmithing, State University of New York, New Paltz, 1979. MFA, Gold and Silversmithing, State University of New York, New Paltz, 1984. Worked for watchmaker/jeweler for eleven years and as illustrator/graphic artist part-time for two years. Director of the Jewelry Department at the 92nd Street YMCA, New York City, 1985– present. Lives and works in Clintondale, New York City, and works in New Paltz.

Q: Let's start by talking about your initial influences. Can you describe your family?

COGSWELL: Yes, I come from an extended Irish family. I grew up in upstate New York in basically dairy country. I went to a rural high school and in the course of my childhood, realized that I felt very artistically inclined. At that time I had no leanings toward jewelry, just art in general. All through my early life I was often told—oh, I was very talented. But in that geographic area, it's probably a *sine qua non* that one should be versed in the arts, but one should also be well aware that you can't earn a living that way. You can't really be an artist. So I really had no intent in making it my career at that time. My father—my mother has no artistic talent that I'm aware of—but my father was always very talented 'though he had no formal training. He taught me how to draw when I was very young. In high school my art teachers always en-

couraged me to continue to further my studies. When I went to college I had originally intended to become an interpreter; I was going to major in foreign languages. I just happened to take one jewelry class that was offered for a six-week period. It was taught by a woman who was by profession a weaver, who really didn't know anything about jewelry. But the college said to her, "You have to teach this class," and so she did. She did the very best that she could but really didn't know a lot. And I was bitten by the bug, I guess. Six weeks in that class convinced me it was something I was very interested in. I went home and I set up a modest, meager little studio in my attic and I started to explore. I tried working with what little I knew; I just started experimenting. This same woman and I became friends. The college was the State University of New York at Cortland. The woman, Barbara Kuhlman—even though she wasn't a jeweler and really wasn't interested in learning jewelry at the time—tried to further my career, searched around and found a number of workshops around the area and encouraged me to attend. And I did. The rest is history, I guess. After about two years I went to a local jeweler, and I wanted to buy some boxes to put pieces in for gifts. He looked at my work and said, "Would you like to come and work for me?" At the time, I didn't feel that I had the skills, but I thought if I could just get my foot in the door I could learn a lot. So I worked for this man for a number of years. He was a watchmaker; he wasn't a jeweler. And I'm sure he knew at the time that I didn't know any of those things. But he was very patient and he allowed me leeway. He allowed me to make mistakes. I had the opportunity to take apart old pieces of jewlery because he bought old gold and old silver jewelry. He encouraged me in my spare time to go back to my bench and take them apart to see how they were put together. It helped to train me, I guess. That was my earliest formal training. After I'd worked for this man for maybe six or seven years I started teaching workshops in the area, and I enjoyed teaching. So I decided that ultimately I'd like to become both a professional jeweler and an educator teaching jewelry to other people. I finally returned to school. I went to one of the major programs—State University of New York at New Paltz. I took my master's degree in gold and silversmithing there and have since taught at the college level. I do a large number of workshops every year.

I have three brothers and a sister. I'm the first person in my family who ever went beyond high school. My sister is the only other one in my family who has a high school diploma. My parents had two sets of children. There were three of us in the first group and then when we were growing up my parents decided—oh, they'd be lonely if they were

home alone, so they had more children. They'd planned to have more, but my mother had problems and she wasn't able to. But education just never seemed to be one of their priorities. I'm the eldest child.

Q: What did your parents do?

COGSWELL: My father was a factory worker and my mother was a housewife. My father's the only one that I ever recognized or saw a talent in, really. We were very poor when I was small, and I remember that on holidays my father would always draw cards for people. I loved to sit and watch my father draw. At one point I also planned to become a graphic artist, so I paint and I draw a lot. And I worked for a couple of years as an illustrator and graphic artist. But I used to love to sit and watch my father draw. He would bring me home pads, pencils, and things that encouraged me to draw. But he was a very pragmatic person; he grew up in a world where art was a nicety, but it was certainly not a mainstay of one's livelihood. And to this day, even though they look up to me as a success, they really don't know what I do. They don't understand what I do.

Q: Did you have any other experiences with art?

COGSWELL: Well, not at that time. Barbara Kuhlman, my first instructor, became my friend also. She was always encouraging me to continue my education and to consider making a career of my artistic talent. Maybe I should back up. In this country, as opposed to the European system, crafts education is purveyed mainly through a university system. In Europe, traditionally, it was done through a master-apprentice system where master craftsmen and I say "master craftsmen," including the fine arts—the painters and everything—would take in apprentices and would pass on knowledge during a period of maybe five years—pass it on to apprentices in their shop who would then go out and become journeymen and eventually master craftsmen themselves and continue the tradition. It started out that way in this country, but about the time of the First World War our country switched from a rural agricultural society to an urban industrial society. And a lot of the manpower from those small villages and hamlets moved into the cities and became the work force. So the people were no longer there. There was no longer the physical demand. The market for the goods produced by these people in the rural areas and the labor source had moved away, had gone to where they could earn better wages. They weren't interested in sitting in someone's studio earning a pittance for five years in order to learn a craft when they could earn much more in a factory. So that system literally just died out, and then the manpower drain from both world wars was the killing blow. About 1950, after the war, infant programs

sprang up in several major universities in this country. From that time on it has grown until now—well, in my field there are probably a dozen major programs in the country. But when I first started out, it was still basically in its infancy. I started working in jewelry when I was about 18 years old and that was in the mid to late sixties. And at that time, there still weren't a lot of programs, and there was not a lot of printed material. Now I have a very extensive library of jewelry books, for example, jewelry and silversmithing. But at that time I was hard-pressed to find one single paperback text that dealt with basic jewelry making. And as I look back on it now, it would be considered very, very basic, almost a primer type of thing. But at the time, I was so happy to find any resource material because I was working on a trial/error exploratory system. At that time there just wasn't a lot of information available. The few workshops that I took with the individuals that were around were very valuable to me, but there wasn't an educational system. That's why now I teach because I feel it's sort of my social contract. There were people out there who shared information with me that I might learn, so I'm trying to repay that debt.

Q: In high school did you have any art classes?

COGSWELL: Yes, I took art classes all through high school, but never any jewelry. I always had a leaning toward art. My earliest art-related experience that I really remember was in kindergarten when we drew colored turkeys to take home at Thanksgiving time. And I remember being so absolutely thrilled with what I had done—that I'd created something. And I never lost that thrill. I always had that sense of excitement about art. So I've always loved art. It's just that at the time even though it sounded wonderful, the prospect of growing up to be an artist, I didn't ever really believe it was a possibility. I just sort of imagined, like the rest of my family, I'd grow up and work in a factory. I failed them.

Q: Aside from Barbara Kuhlman, what educational experiences provided you with validation?

COGSWELL: There were at that time, a few traveling jewelry people who taught workshops—isolated workshops—at sites around the northeast within a commutable distance for me. She [Barbara Kuhlman] found out about those. She was teaching in a university and had little feelers out all the time for things of related interest. She always watched over me; she was sort of my guardian angel as an early jeweler. And she and I are still very good friends; we still maintain contact and keep in touch after all these years. She's long since retired. But anyway, she set me up.

I had the good fortune to study for two twelve-week terms with a man named Barry Merritt, who is a very well-known jeweler in the northeast. Barry is also one who helped instill the philosophy that I should share everything that I know. In my field, especially in the contemporary world, information is hard to come by and people are very tight with their information. They feel that if they share what they know with someone else, other people are going to use that competitively. But that's really foolish, because we all use the same tools, we all use the same techniques. It's what we do with our minds, our creative sense that makes us different—better than or equal to or more competitive than other practitioners. And in the course of that workshop, one of the other participants asked Barry that very question: "Aren't you afraid—aren't you worried that we'll compete against you if you share all this knowledge?" And he laughed and said, "By the time you get to where I am, I'm going to be somewhere else anyway." And I thought, "What a wonderful philosophy." So I've always tried to live up to that. That's why I've always pursued the workshops and have gone back to school and do what I do now.

Q: Did you have any resistances?

COGSWELL: Yes, like money. First of all, when I first started out I wasn't doing this as my source of income. It started out purely as a hobby and developed from there. It was a number of years before I could really say it was a professional venture. So even then the validation was negative. I couldn't earn enough money to support myself. I was hard-pressed to earn enough money to buy more tools and more equipment to keep going. And I thought, "Well, I don't know if I could ever really do this or not." And so I still pursued the idea of becoming an interpreter or going into some other more saleable occupation. When I started working for the commercial jeweler, then I suppose you could say I was earning my living doing what I'm doing. So then in addition to my activities there professionally with him in the store, I also had my studio going, and I started to exhibit in galleries, participate in shows, sell commission work, and started to earn income from it. And since that time I've always earned my livelihood doing what I do.

Q: When would you say you knew you'd become an artist? And how did you know?

COGSGWELL: That's a hard one because it's the difference between knowing that I was artistically inclined and knowing that I was going to be an artist. They're two different things. I would say probably when I was about twenty-five. It's hard to remember that far back. It reached a point one time when I was offered another job while I was working

for this jeweler and had my little studio. Someone came and offered me a non-art, non-jewelry-related job that would have paid me much, much better. And I realized that the money wasn't important enough to me. That I enjoyed what I was doing far more and decided not to, that I was going to stay where I was. And I thought about it long and hard, and I was sorely tempted because the money would have been very good. It was a factory shop and for Cortland—the place where I grew up—it offered a wonderful benefits package and the salary was much higher than anything else locally. But I wasn't interested. It really wasn't much of a decision. When I went back to school, in order to help support myself, I fell back into graphic art. I did freelance work for newspapers and magazines, and I designed cards and things for people. I did graphic art a lot. And I still draw extensively, but I consider myself a jeweler.

Q: So how long a period was there between graduating from college and you said you went back to school?

COGSWELL: Yes. I graduated initially from my undergraduate school, where I went directly out of high school. I entered in 1966 and left four years later. I went back to school in 1977. So I had a hiatus of about eight or nine years. I can honestly say that my first college venture was a complete waste of time. I barely remember the experience. I went to college because it was expected of me. I did very well through school, and I was just told, "Well, you know, you have to go to college." There was familial pressure and school pressure because I did so well in high school that they just felt that I had to; it was my duty, my responsibility. I'm an eldest child; I'm very responsible. But I had no idea what I wanted to do. It was a floating experience. Well, all of the kids that I grew up with came from similar circumstances. They were either farmers or their parents worked in factories or whatever. I guess none of us ever aspired to much because we didn't know anything else. I went to college with a number of my classmates. We all floated. That period of the 1960s and the 1970s became the dropout era. It was the age of hippies and drugs and everything else, you know, and we all floated through that period. I've since moved away from that geographically. I don't keep in touch, I'm ashamed to say. I really don't even have much contact with my own family anymore. They pushed me to go to school and to learn as much as possible and be a success, and now that I am, we have a problem trying to communicate. They feel that I live in a different world and exist on a different sphere. And I know they don't feel comfortable with me. So they never call. And I'm very busy. I often don't take the time to keep in contact with them, or with any of the people that I grew up with—any of the friends. Once I did focus, once

I knew what I wanted to do, then I knew exactly where I wanted to go. I mean, the direction that I wanted to head in; a lot of my friends were still in the dropout stage, still floating. So I lost contact with them.

I started researching college programs and figuring out how I was going to pay for my education once I got there. Graduate school's a very expensive proposition. I didn't know what I wanted when I went to undergraduate school. I was perfectly clear on what I wanted when I went to graduate school, but I was in the midst of a group of people who were a lot younger than I, both in terms of maturity and focus. It always awed me that these people would pay so much money to go to a school to resist learning as much as possible. They did everything they could to defy the teachers and not do their work. And I came back expressly for a purpose into a major metal program at New Paltz. Many of the people that I met there at the graduate level were and are my very good friends. We still are very close. Many of us live in the same area. The New Paltz area is home to many major artists and craftspeople. There are probably several hundred of them within a fifty-mile radius. And some of them even teach for me here now, I've imposed on them as friends and they've buckled under. But many of them have also gone on to become very well-known contemporary craftspeople. And it was in their midst that I feel personally that I really came into my own; that I really blossomed. There was so much energy there at that time that it was extremely inspirational. A wonderful growth period.

Q: What about mentors? Clearly there's Barbara Kuhlman.

COGSWELL: If I had to pick others I would pick two other people. They were my instructors in graduate school at State University of New York at New Paltz. Kurt Matzdorf and Robert Ebendorf. And both of them are major forces in contemporary metalsmithing, extremely talented, very energetic, excellent teachers. They both maintain their own studios and teach as well. The old saw about, you know, you're either an artist or you teach isn't true, for them. They're major forces in contemporary jewelry—metalsmithing—in this country. Still very active, both of them. But the three of them—Barbara Kuhlman, Robert Ebendorf, and Kurt Matzdorf are certainly my mentors. We've also maintained very close contact and bonds, and they've been instrumental in helping me achieve what I've achieved and getting where I'm going. If I were to add to the mentors—my wife has always been extremely supportive and no matter how poor we were, she always was there to help me and to support me. We put each other through school. She's a speech pathologist and works with special education programs. But she always was there. She always has been, always is.

Q: What qualities do you think you needed to get you through that period?

COGSWELL: Pigheadedness, which I have more than an abundant share of. Perseverance and faith, I think. Blind faith. There were lots of difficult periods there. But just knowing what I wanted and persevering, just keeping after it, I think, have seen me through most of my hard periods.

Q: What materials were you working with?

COGSWELL: A lot of materials. First of all, in traditional, historic jewelry, gold and silver are usually the precious metals of choice. Platinum sometimes, but by comparison it's used in such small amounts that it's really not a major jewelry metal. But we were also encouraged to explore other materials, and each had different working properties. Also, in contemporary jewelry, anything is fair game: from a bottle cap on the street to a rusted fender buried in your flower bed to handmade paper. Regardless of what the material, the material's there for you; you just simply have to see it. We were always encouraged to use anything, as long as it didn't rot and smell. Anything was fair game. So I've always liked to work with mixed materials. Even more so, since I've left school because I'd spent years working with a commercial jeweler—almost all of my work there was gold and precious stones, mainly diamonds. When I came back we were poor students who were buying supplies out of our own pockets and working part-time to pay for that. We didn't have the money to buy precious metals and diamonds all the time, so we started working with other materials. And because of my background, my formal training within that commercial industry, I was very resistant, at first, to trying those other materials. I just thought, "Why would I want to work with copper? Plumbers work with copper." Or aluminum or any of those things. But the older I get and the further I get from that experience, the more experimental I become, I guess. I like working with all materials. And I encourage my students to do the same. I truly believe that the beauty—the value of a material is what you do with it, the artistic things that you do with it, not the market value of the materials. I like designing, also. So concurrent with playing with the materials, I'm always thinking in terms of my design sense. And now I design first. I usually work with a pad and pencil and work my designs out first, a more formal approach.

Q: Do you think that your training period adequately prepared you for a career as an artist?

COGSWELL: Yes. At the time that I went back to graduate school the team of Matzdorf and Ebendorf were an ideal solution to an age-old problem. How do you take art and make a viable career? Robert

Ebendorf is a very spirited, inspiring personality, and what he did was get us excited about what we were doing. Kurt was the more pragmatic half of the team: He was very clear that you should be well-trained; that you should have good financial production sense; that you should know how to design; that you should know how to build the pieces and know how to market them. So the two of them were a perfect pair. Bob was the one who brought us in and awed us with all of the technical information and what we could do with it and told us we were artists and made us believe that we were artists. And Kurt came in and said, "Okay, now for the functional training, listen to me." The two of them were just an ideal pair. So when I walked out of there I knew how to market my goods, I knew how to make them; I knew how to design them; I knew how to control my materials. I was very well-trained. It was probably one of the best training periods of all. Many schools suffer from the "You are an artist; do what you want" syndrome. And these kids pay a lot of money and come out and all of a sudden reality goes slap, and they realize that they really don't have any preparation for life, which is sad. I see people come out of other programs who simply disappear. You never hear from them; you never see them again because I don't think the schools prepare their students adequately. I also think that one of your responsibilities as an educator, particularly at that level, since so many kids go to graduate school so young they really don't have a clear idea of what they're going to do with their lives, is that you have to exercise more foresight than they do. You have to be older and wiser than they are and know that they're going to need this down the line. And even though they're resisting it at the time, you've got to force it down their throats. You've got to make them listen although they won't appreciate it until ten years later.

Q: Did you give yourself any benchmarks for achievement?

COGSWELL: Just graduating from college. [*Laughs*] When I graduated from undergraduate school I never thought that I would go on to graduate school. At the time I started considering graduate school I had no money and was terrified of the prospect. I had to quit my job, move, and embark on a totally different lifestyle that was absolutely frightening to me. But I simply set the goal that I was going to do it and I did. That was my biggest goal. Since that time I have smaller guideposts—mileposts, I guess. I don't have major goals. I don't want to be the best in the world; I'm happy to be who I am. It's very easy to get caught in the trap of doing the same thing again and again and again. Especially if it becomes successful at first, it can be a trap. If you sell pieces and they become popular, you can sell a lot of them and that's very gratifying

egotistically and financially also. But it's a trap because it keeps you from moving on into new areas. Part of the reason that I like to teach also is that it augments my income so that I don't have to sit at my bench every day and do the production work day after day after day. I'd find that stifling, deadening. So one of my short-term goals, which changes all the time, is pushing myself in new directions, trying new things. What I'm doing here now is something that I've never done. I don't know if you know anything about the Y's programming here, but we have major programs in a number of areas. The jewelry program here is a continuing ed program, and of its kind it's probably the biggest and finest in the metropolitan area. I have about twenty-three people who teach for me here. All of them are studio artists who earn their living working out of their studios, and they take a day out to teach for me. We have about 350 students per term who come here, and they come at all levels. We have people who simply get out of the house because hubby says, "I need the house on Tuesday." Some of them are studio artists who want to learn new techniques and come to study with the people here, or they want to go into business and want to learn enough to be able to go out on their own. So we have people at all levels here. And I try to accommodate that. When the offer came, how would I like to direct this program, I thought, "I have no directing skill; I don't know anything about doing this." But I said, "It's a challenge, it's a new direction, so it was a goal." And I think I've done passably well.

Q: What were the first organizations that you joined, and do you belong to any now?

COGSWELL: Well, there aren't a lot. I belong to the American Craft Council; I belong to the Empire State Crafts Alliance. I belong to the New York Artists Craftsmen's Group; I belong to the Society of North American Goldsmiths. The first one I belonged to was Empire State Craftsmen, simply because it was the first one I'd ever heard of. Empire State Crafts holds shows around New York State, and one of them was held in Ithaca, which was fifteen miles from where I grew up. I was so starved for information and so happy to come across anybody who was doing anything like I was doing, that I sought out information. And at the first fair I ever attended, someone said to me, "Oh, you should join Empire State Crafts Alliance." And I did sit on the Board of Directors of Brookfield Crafts Center in Connecticut. I'm the Treasurer. And I've participated in helping fundraising events and things. I have not held offices in the Society of North American Goldsmiths or American Craft Council or anything, just a member.

Q: Can you describe the period during which you first achieved professional recognition as an artist?

COGSWELL: I would say at the time that I was working for the gentleman in upstate New York in his jewelry store in the mid-seventies. Because I was sitting at a bench doing the same things day after day after day, my hands became very well-trained. My eyes became very well-trained. I hadn't developed a lot of individualistic design sense yet, because I hadn't seen a lot at that time, but my work became very professional. And then when I did start seeing things at the craft fairs, when I applied myself, I could do them very well and got writeups in little central New York State papers. I think my work was professional-quality there. I started selling in galleries and people started approaching me and asking me to teach workshops and things.

Q: Have groups or institutions whose services you have used helped or hindered your progress as an artist?

COGSWELL: I don't think any of them have hindered my progress as an artist. And it's hard to answer the "help" part of that. I have to look at it from the sense that where I grew up I was starved for information, my first copy of *American Craft* had sources and other materials and related things in it that opened my eyes. I knew I could go to New York and look in their museums and see things. I knew I could send away for some of the titles listed in there. There were tool suppliers. The world opened up for me. So in that sense, they were very helpful. But in a grander sense, an overall sense, I think that all of them often fall short of their mission. I think that they aim at the upper echelon within each of the disciplines and they lose sight of their constituency down in the trenches. There are many people who need help down there, who need lots of different things. Those needs are not addressed by these organizations. For the individual craftspeople, whether potters or jewelers or tapestry people, they're sitting at home and may have no marketing skills. They don't know how to get those things because the forums and the conferences that cost two thousand dollars and take place in the big glitzy cities are just beyond their reaches. Those needs aren't met. They may be subsisting at a survival level where they're selling enough work to pay for their income and buy new supplies to keep things going, but they can't afford life insurance. If legal problems come up with their work, they have no recourse. They don't know what to do or how to find out. The tax laws are against them, basically, and there's no one out there to say to them, "Well look, this is what you should do or how you could do it." I think that's what all of those organizations were for. That's certainly in the charter for almost every one of those organizations. But

I think that they've lost sight of it. I think that for the most part *American Craft* likes very much that it has a glossy format and that it's a real coffee table book magazine. And it certainly is gorgeous, but the work and the focus and the readership that they're really after are the collectors and the upper echelon, big-name craftspeople. I think that's at the expense of the little people down below. I think that's a mistake; I think it's shortsightedness. And I think it's endemic through all of those organizations. I know a few organizations around the country that are very active at grass-roots support and trying to reach those people and help them. There are a number of crafts schools around the country. For example, Arrowmount, Penland, Haystack, all of those were founded fifty, sixty years ago by people who wanted to help people in those rural areas to market their crafts, raise their standard of living, and that was what all of these things started from. American Craft Council started the same way, but it doesn't address those needs anymore. The schools still do to an extent, but now in order to survive, they have to bring in enough income to support themselves and they have to aim at a group who can afford it. The people who need it the most—the poor people in the rural areas—certainly couldn't afford to go to these schools to get the information. But there are some craft organizations that are still very focused in their charter purpose. There's an organization in the southeast—it's called Southern Highlands Handicraft Guild. And you have to be one of those poor, backwoods craftsmen, basically, in order to be part of their organization and to benefit from their activities. I think that's really what they're all about.

Q: Have they offered you benefits such as health insurance, credit?

COGSWELL: Just within the last two years I see that American Craft Council has introduced a modest insurance program. I have other insurance from teaching. Now through Dover Publications or any book club, you can buy a book that tells you how to do your taxes. Or you can read the pamphlet by the I.R.S. None of the academic programs of all these universities deal with these things. The art departments are concerned with the niceties of everyday life. They want to teach your mind, your intellect, your artistic talent. And they actually tell you don't worry about those little detail things; other people will take care of those. That means that when you graduate, you walk out there, you don't know anything. And usually when you're starting out you don't have any money; you can't go to seminars; you can't find out from other people or hire professionals to do this for you; you're left to your own devices. I would say the attrition rate is the very highest within the first five years after coming out of a program. I think most people—probably 75

percent of them—just die. I don't mean literally, but figuratively die, just fall by the wayside.

Q: How did you learn about things like inventory?

COGSWELL: School of hard knocks. Working in the jewelry store, because it was small and I was expected to do a number of things—I kept books, I billed, I went out front, worked as a salesman, I dressed windows. At that time it became very clear to me that you had to know how to make a living as well as have talent. That you couldn't get by just knowing how to paint or how to make jewelry. You also had to know how to bill, how to keep inventory, how to do book work, how to sell. As good as my education, my technical training at New Paltz was, one of the things that's never addressed is the financial end of it, the business end of it. I don't know of any school that does that. Even though those schools may have technical classes—you can take accounting or book-keeping, those are considered technical credits.

Q: Do you have any feelings about unionization for artists?

COGSWELL: Well, I think that's very difficult because we're such a dispersed, disparate group of people. We all have individual needs, and we're spread out all over the country. A good union has to have a lot of communication among its members. There are a lot of people out there who work eighty hours a week trying to support themselves. They haven't the time to go and sit in the union meeting or read a lot of literature. They often don't have the time to get up and find out if there are other activities related to them going on in their own geographic areas.

Q: Who would you describe as the group that you rely on as your peers today?

COGSWELL: Well, I have close friends. Those of us who went to school at the same time that I've remained in touch with—some of them teach for me here. I would say those are professional peers. We're still friends; we still communicate. We talk art; we talk ideas and design. I also have people that I've met—since I do a large number of workshops every year, and I teach at a number of craft institutions around the country. I've come to know the directors, some of the staff, and some of the other people who teach there. But those are the people that I feel are my professional counterparts, the people that I maintain professional rela-tionships with, and that help me in my work and my growth.

Q: Would you say that you rely on them for opinions about your work?

COGSWELL: Yes. When you first start making work you're happy for any good reviews regardless of where they come. They usually come from your family and close friends. And at first you're just delighted

when they smile on your work and you feel like you've just done wonderfully. And then after a little while you realize that no matter what you did, whether it stinks or not, they're going to say, "Oh, how lovely" or "How wonderful, we love it anyway." And so you start aiming at a more discerning public. After a while you learn that money is a wonderfully high form of flattery—because if people like your work enough to part with the green stuff, they're saying, "We really admire your work; we appreciate what you're doing." But ultimately, you find that you aim your work at a jury of your peers. People you consider at the same level of technical accomplishment and design accomplishment and everything. People who really can look at the piece and can really tear it apart. And then if they like it, if they appreciate it, that's very nice.

Q: How about critical review?

COGSWELL: Virtually none. There's a history of sound critical approach in fine art. I'm talking painting, sculpture, architecture, and music. Within the fine crafts—to differentiate between home craft, you know, little stuffed cushions and things—there's almost none. And the problem is that the crafts have always suffered from this quality distinguishment from fine arts; we're always sort of second-class citizens. What's happened is that all of the craft magazines have tried to approach a critical discussion of crafts in terms of artistic terminology and end up sounding a little out of place because it's a little false. It's a little phony. It's trying to borrow something by way of substantiation. Trying to say, "Well, we're as good as you are." Well, we are, it's just that we don't seem to have been able to pull together and develop a terminology that befits us. So you'll often find glowing descriptions of things but rarely critical reviews.

Q: Has there been a critical dialogue about your work?

COGSWELL: Of my work? Written? Minimal. I don't do production work. I do one-of-a-kind pieces, and I also do a lot of commission work. So a lot of my work is commissioned and delivered one on one to my clients. The work that I do show in galleries is in exhibitions. I get reviews from those things, but for the most part galleries hire people to come in and do reviews. Since these galleries want to sell the work, the reviewers tend not really to be critical. I mean, if you're a gallery owner and you're carrying the work of a diverse group of craftspeople and you want to sell that work, you want people to become aware of what's going on in your studio, in your gallery. The first thing you have to do is get publicity. So you might hold a show. You come up with a theme, invite or jury a number of entries to get them into the show, and then you beat the bushes for publicity. You want people to notice that you're there.

It's nice to have a review of the thing in a major magazine, in *The Metalsmith*, for Society of American Goldsmiths, for example. You approach someone that you think will give you a favorable review, and you say, "Would you write a review, a critical review of the show?" But most of the people who do this are craftspeople themselves. First of all, if they write something negative the same thing could happen to them. And since they're not versed in craft criticism, because there is no craft criticism out there, most of them end up being descriptions of how pretty the show was. I get much better criticism from my peers, my friends, when we sit down and talk about our work. They can be honest because they understand that criticism is not meant as a negative attack on someone's work. It's simply how you perceive the work.

Q: And do you have gallery shows?

COGSWELL: Yes. Right now I'm represented by a gallery in Green Bay, Wisconsin. Because most of my work is commission work (I do one on one with my clients), I don't have gallery outlets. Most of them depend on production work, and I don't do production work. I bore easily. That's why I like to teach and travel and teach workshops, and I work in two different studios. I have a jewelry studio of my own in my home, and I share a silversmithing studio with one of my former teachers, Kurt Matzdorf. We have a silversmithing business, and that aspect of my work is totally different. Kurt designs almost exclusively for it because we do a lot of Judaica and stuff for temples and synagogues and things. I'm not Jewish, and it gives me an opportunity to work on a scale and in a certain area that I otherwise would never have an opportunity to do. I love doing that. I spend a couple of days a week working with him when he's got big projects. Other times I work in my own studio and do my jewelry. I paint and draw on the side. I travel and teach workshops. I direct the program here, and I teach here. I do lots of different things. But I stopped doing production work a long time ago. I found it deadening. It was a trap. I kept making more of the same pieces to support making more of the same pieces.

Q: Could you just briefly talk about your job history?

COGSWELL: Well, part of the reason that I went back to New Paltz was that one of the things I wanted to do when I came out professionally was to teach. So I started looking for teaching jobs. I've taught at several colleges, short-term, and I've also done lots of workshops. And little by little my lifestyle has evolved to the point where now I do lots of different things. I like that. I actually enjoy doing this kind of teaching more because the people who come here or come to my workshops come because they believe that I have something to say to

them. They're good students. When I teach at a university I find this attitude that, you know, "I don't want to come to class, I don't want to do what you're telling me to do, why do I have to learn this? I don't want to learn how to set stones 'cause I'm never going to use stones." They fight and resist everything that I'm trying to tell them. I'd consider teaching at a university program again, but I'd have to think about it carefully.

Q: Would you say that you saw a pattern or a progression over time in your job history?

COGSWELL: Yes. When I first started out I was just going to be a jeweler. I was going to do limited production work where I only made a certain number of each piece. I was going to be a smashing success and do shows. I thought that sounded very romantic and gypsy-like, and I liked the idea. And it turned out, as I said before, there was no artistic diversity in there, no chance to keep introducing new designs all the time. Diversity has always appealed to me, so it has evolved to the point now where I travel a lot. I usually do about a dozen workshops. They'll range in length from eight weeks to one day. The older I get the shorter they get.

Q: You mentioned gatekeepers who helped you enter the field. Have you had experiences where people have barred your way?

COGSWELL: Well, actually not. My family probably simply because I think they felt threatened. At first they encouraged me to explore my own artistic ability and then they felt threatened when I did. But beyond that, no, I've always felt encouraged by everyone and touched because I carry with me a lot of things from a lot of people. That's why I teach and why I do the things that I do. I share as much as I know with other people because I enjoy that and because I think everyone else did open those doors for me.

Q: Some people describe gallery owners as gatekeepers.

COGSWELL: Yes, because being a gallery owner is a very competitive thing. First of all, it costs a lot of money and is a very risky venture, even when you're successful. They tend to have very limited straight line interests, they want to make a profit. So they try to encourage and to promote their little stable of artists, but they'll promote them in such a way that it helps them. They'd rather see you make fewer bigger sales (even though that may not be what you're interested in), rather than experimenting at your bench and, you know, coming up with lots of little exciting ideas and things. So in that way, they're going to try to steer you in a course that's most conducive to what *they're* doing. That's part of the reason why I don't do a lot with galleries. The other thing is

that when you exhibit in a gallery the markup is a major obstacle. If I price my work on the basis of the time I put into it, that's the single most expensive feature of my own work. If I then have to market that through a gallery they're going to mark it anywhere from 40–60 percent higher than what I'm charging at a wholesale level, which puts it in a very high bracket many times. It's harder to sell there. Now that may be hard for them, so they're either trying to push you into very high-priced (if they've got the clientele to support that) or into sort of a fast-moving, medium-low range. You know, lots of earrings, lots of things that'll turn over fast.

Q: Have there been any discrepancies between your aspirations and your actual opportunities?

COGSWELL: This is the self-actualization part. I'm going through that period. I'm in my early forties now and I don't know if you know this, but men go through this change of life, when all of a sudden you wake up in the middle of the night and you start wondering about things like, did I accomplish the things that I started out with? What about life insurance? Health insurance? Is it enough? You know, things that you never thought about before. So this is one of the things that I thought about. Have I realized the things I set out to do? But they've changed. My goals changed all the time; they still change. So yes and no. I'm happy with what I do. I feel that I'm successful in what I've done. I've become very good at what I do. I'm not famous in the sense of being one of the top twelve in *American Craft Magazine*, but I'm well-known in my community. My workshops are sought after. I always have a steady supply of students and clients. And I have the freedom to do what I want to do. I can vary my schedule. I can design the kind of pieces that I like. The people who come to me say, "I want you to make me something, and I want you to make whatever you want to make." They don't come and say, "This is what I want you to make." You know, they've already preconceived the item. I like that. I think in that sense that's what I started out to do. I want to be my own boss. I wanted to be my own artist. And I am.

Q: What would you describe as a major turning point in your career?

COGSWELL: Realizing that I could become an artist and actually make my own living. It was probably the single most exciting and frightening thing in my life. I would say probably back in 1969, 1970. I had no money and I didn't have the means to do it right then, but I knew it was possible. Because by then I'd already met several people who were out there doing it and I knew if they could do it, I could do it.

Q: What has been your relationship to money throughout your career?

COGSWELL: I've wasted a lot of it. I've never been a rich man monetarily; I probably never will be. Nor have I been plagued by poverty. Money really hasn't been a major obstacle, even though I grew up poor. Maybe because I don't need a lot of money to be happy. But I've always had enough money. I've always been able to sell enough work and to teach enough classes, and my wife works. I wish I knew more about how money worked. One of the disadvantages of growing up in a poor rural society is that those people really don't know how to make money work. If you have a little money and you know how to use it properly you can make more money. Maybe if I took the time to take some classes and study that, I could probably learn better, and maybe I will someday. I'm learning to play with a computer and things like that. There's lots of things to do out there, not enough time though. But money's never been a major problem, not a major focus of my life.

Q: How about the costs of supporting your art? Have they changed over time?

COGSWELL: Well, the cost of my education was probably the single most staggering bill I've ever encountered. I'm still paying off student loans. I had a scholarship through undergraduate school, and I worked a part-time job so I had no problem there really. When I went back to graduate school, first of all everything had increased in price. I had absolutely no money and was totally reliant on a few grants and lots of loans. Graduate school is very expensive and jewelry graduate school is even more expensive. So I borrowed lots of money in order to do that. I've never regretted it. I'm still paying. I think this year is the last.

Q: Also you work in probably some of the most expensive materials.

COGSWELL: Yes. But when I started working in a commercial store, because I didn't have to pay for the materials that I was working with, I broke diamonds, I shattered opals, I burnt gold, all those things happen when you're learning. But my boss never batted an eyelash. I also learned that the retailer makes a big markup on them because consumers go out and pay enormous prices for things that wholesalers charge very little for. My boss used to say to me, "It's just gold." When I went back to school, I saw the kids around me who were very tight with their work, simply because they were always afraid they'd ruin something and waste the gold or waste the silver. To me, my materials are just materials. They're just metals or just stones. Of the stones that I work with, some of them that I find the most beautiful cost me 50 cents apiece or something. The cost of my materials is a very small factor in my work.

Q: You mentioned grants earlier. How have things like grants, awards, competitions, emergency funds affected your career?

COGSWELL: Well, when I first went to school, for my first year I was very lucky to receive several grants which helped me get through. In the years that have passed since—and especially under the Reagan Administration—most of the grant programs are just not there anymore. And in professional circles—National Endowment for the Arts and on more local levels—the grants are fewer and farther between and much smaller. I've never gone after any of those Endowment grants or anything.

Q: How about awards or competitions? Have you received those or won any?

COGSWELL: Yes, I've won first prize awards but not a lot. Those are ancillary benefits. If you exhibit in a show and you happen to win an award or get a note of achievement it's nice. It's very egotistically gratifying to know that you were an award winner. But first of all, awards in that kind of a situation are on the whim and whimsy of whoever happens to be jurying the show. It may be a newspaper editor from Oshkosh, Wisconsin, or it may be the curator of the Renwick Museum. So you have to be a little honest and a little discerning in where the praise is coming from and what it really means. That's not important to me.

Q: Was there a particular time that award or grant money would have been most helpful?

COGSWELL: No. Because if I hadn't gotten grant money I would have gotten loan money, which is what I did. When grants weren't forthcoming or when I didn't receive them, I simply went to the bank and took out a loan.

Q: What's the importance of physical location and workspace?

COGSWELL: Well, I have my jewelry studio in my home. And the silversmithing studio that I share with Kurt is five miles from my home. And then I have access to the studio here, and when I teach workshops and stuff I'm used to working out of a box; I'm very portable. Because I grew up the hard way and I had to make do with what I had, I've learned to get a lot of mileage out of my tools. I can do many things with very few tools. My field is probably the most technologically involved of all of the crafts. And it's a real trap to some people because there're lots of tools and equipment out there, they feel they have to have one of everything. And they never really learn how to exploit a single tool to do many different things, as I do. So I can really sit down and, with a little space and not much by way of tools and supplies, do a lot. Anywhere I go. And I do it all the time. That's part of my workshop thing.

Q: What kind of control do you think you exert over your destiny as an artist?

COGSWELL: Lots. Because I know that if I don't do it well and I don't do it right I'm going to fall by the wayside. I will perish. They forget you very fast in these circles. And if they forget you, they don't buy from you anymore. That's part of why I go out and push very hard. I work very hard at what I do.

Q: What are your criteria for success as an artist?

COGSWELL: I don't look for success mirrored in terms of winning prizes in craft shows or getting writeups in major magazines. Those are not my goals. Those are not the things that I aspire to. I know when I do well. I always like to challenge myself. I always try to build into every piece that I make a technical challenge. Something that I've never done before. Something that's going to make me stretch. And I may be the only one who knows that I did it, but if I did, it makes me feel very good. I don't know if anyone else has ever told you this, but I know it happens to me. Sometimes I'll be so proud of having done something like that I'll take it to bed with me. I lay it on my nightstand and in the middle of the night I'll turn my light on and marvel at it for a few minutes, put it back down, and go back to sleep. I know that sounds foolish, but those are little personal milestones. When I hand a piece to someone and they turn it around in their hands and I see them study it and I can see in their faces that they're really marveling at what I've done—to me, that's an achievement. That's a milestone. Those are the things that I go after. Most of them are purely personal. When I do aim it for someone else, I aim for a jury of my peers. People that I know are knowledgeable and really appreciate what I've done.

Q: Do you have a number of central ideas that you keep working on?

COGSWELL: Well, the answer to that is really only just evolving to me. People used to say to me, "Well, what style do you work in?" and I could never verbalize to them. If I had to look at my own work, I was always kind of confused. But the longer I work and the greater the body of my work, I find that there are certain trends, certain directions. I love textures on metals and I really love the colors of metals and materials. And I like folded materials. I love the voluptuous quality of metal folds that look almost like folds on Renaissance or Baroque sculpture. I mean, that's why Michelangelo and Da Vinci spent so much time working on beautiful folds because they really just loved the play of light over those folds. There's a voluptuous quality to them. Well, I love that same kind of quality, but I do it on a smaller scale with jewelry. I like to exploit the plasticity and working properties in my materials. And those things

thrill me. Learning new things about them. The more I know the happier I am. And the more I've learned, the less I know because there's always something else to learn. It always keeps me excited. I like that.

Q: Are there particular periods—of your work—that you've been happier with, more satisfied than with others?

COGSWELL: Tomorrow.

Q: You'll always find more satisfaction?

COGSWELL: Yes. You know, a lot of beginners never want to sell their first pieces. They're so close to them—they've worked so hard and spent so much time, put so much of themselves into them, they're really too close. They can't be critical and they can't stand back and look at it and say, "Well it works," or "It doesn't," or "I'm happy with it," or "I'm not." By the time I've finished most of my pieces in my mind I know exactly what it's going to look like, I know—it's finished already in my head and I've moved on to the next one. Because it's always what I'm going to do tomorrow that I'm waiting for.

Q: How satisfied are you with your career?

COGSWELL: I love what I do. I'm very happy with it.

Q: How about frustrations? Have there been any major frustrations for you?

COGSWELL: Sure. Anytime that I try to do something and can't. Or things that I think will work and don't. Or when I need the money to do something and haven't gotten it. Or when I need the time to do something, time has become my biggest enemy. Finding the time to do things is probably the most frustrating thing in my entire life.

Q: Now what are the things that you want to do, and what are the things that are eating up the time that keep you from doing them?

COGSWELL: Well, it's always what I'm doing now that keeps me from doing the things that I want to do tomorrow. I think we all really want to be Renaissance people where you do everything, but there's not time. Teaching things is just as much a part of who I am as making things. It's integral to what I do, not just obligation. It's a social obligation to me. All the loan money, all the grants, everything, to me in my mind were my society's investment in me saying, you know, now it's your turn. You know, we believe in you, we're going to help you through this, but you in turn owe that debt back to society. You have to carry on that tradition. And I feel that very strongly. That's very much a part of who I am. But I also enjoy teaching. I really like that very much. It's very much a part of me and I would feel only partially successful if I couldn't do it anymore.

Q: What would you describe as your biggest satisfaction in your career?

COGSWELL: Being able to do the things that I never thought I'd be able to do. The simple little thing—having grown up thinking that it's nice to be talented, but you can't possibly survive as an artist, and then finding out and living a life that proves it's not true.

Q: What has been the effect of the marketplace on your work?

COGSWELL: Well see, because I have a very selective marketplace, I've sort of designed the way that I work. The shows, the craft fairs really have no bearing on what I do, so I don't have to worry about those things. I've had to cultivate. I've had to build up a clientele who are appreciative of my work and who will buy it, but that was part of my teaching venture because you educate your public just like you educate your students. So it's been a very rewarding experience actually. You know, a lot of these people who collect my work have become very good friends of mine—people that I know around the country. I like that very much. But as far as the good years and the bad years of the market in general have really not had much effect on my work or on what I do.

Q: How about the relationship to your materials? Has that changed from your early training?

COGSWELL: That's a love affair that goes way back and probably will last until I die. I work with the most malleable metals in the world; their plasticity, their working properties, and their colors and stuff offer absolutely infinite, endless challenges and opportunities. And I just love working with them.

Q: Have your absolute basic requirements for being able to do your work changed since your early career?

COGSWELL: No. I think I'm happy if you give me a place to work and a few tools to work with and stuff. And I usually fit what I'm doing into what I have at hand.

Q: What about health hazards?

COGSWELL: All of the arts and crafts are fraught with them. Because I have to teach, and I'm responsible for my students, I've become very aware of the dangers and I try to minimize those in the workplace. I try to teach them safety with the torches, the acids, the chemicals. We use lots of things. All of the machinery we work with runs in little machines that throw things right at your face. You only get one set of eyes, one set of hands. All of the crafts that we work with are very toxic, very dangerous. And I personally try to make sure that my students are apprised of those dangers.

Q: What one major point would you make to young artists about a career in the crafts, or what do you wish that someone had said to you when you were first starting out?

COGSWELL: Well, I wish that earlier on, while there was still more time, that someone would have said, "Yes, it is possible," and "Yes, you can support yourself," and "Yes, your dreams can come true." It would have been nice to believe right from the start that it would have been possible. I wouldn't have spun my wheels for so long and not gotten anywhere, not done anything simply because I believed what I'd been told. I wasted probably a good fifteen years of my early adult life not doing things that I could have done because I didn't think I could. I wish information was more readily available. I wish also that someone would have helped me formulate in my head my own goals. You know, part of it is when you're young you can't see down the road ahead of you. You don't know where you're going to be or what you're going to want in ten years. And it would have been nice if there'd been someone with a little more foresight who could have said, "Well, at least prepare yourself for eventualities, and these are the things you should know." And I think in a more parochial sense, it would have been nice in my formal education along the way if someone had said, "Also, you're going to need business acumen. You're going to need a little accounting experience and stuff like that." Information about taxes, things about insurance that you've got to find out for yourself little by little, and there's no one to share that information with, or to get it from really.

Q: Do you do that now with your students?

COGSWELL: Absolutely. That's why I teach workshops all over. And I teach everything. My wife always says, "When you teach, you teach everything." And she's right. You know, if they use the wrong word, you correct their words. As I'm talking (and I talk a lot), I demonstrate and build things and show them how to do it and tell them why I do it, and I talk about design and about practical experience. I show them how to make a pie—I'm a great cook. I do everything. You know, it's all part of it. Sometimes we'll take an afternoon—if it's a beautiful day, go out, sit under a tree and talk about how you put a resumé together or something. Anything. Anything that will help them.

Representative collections include: Private: Numerous.

Professional affiliations: Society of North American Goldsmiths, American Craft Council, Empire State Crafts Alliance, New York Artist-Craftsmen, Brookfield Craft Center (Treasurer of the Board).

Honors: Student Delegate to World Crafts Council Conference, Vienna, 1980; Ruth Bennett Memorial Art Scholarship, 1978, Who's Who Among Students in American Universities and Colleges, 1978–79; Scholarship Award, Haystack Mountain School of Crafts (Deer Isle, ME), 1979.

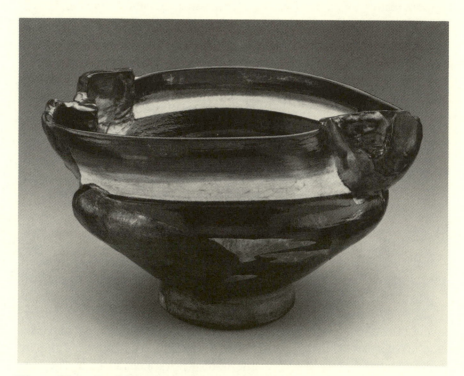

"Storm Water Bay" by Wayne Higby, 1990 (12½″ x 19¾ ″ x 14″; earthenware, raku tech.). Photo by John White.

Three

WAYNE HIGBY

B. Colorado Springs, Colorado, 1943. Studied at the Colorado Springs Fine Arts Center and the Boulder Recreation Department. BFA, Ceramics/Painting/Art Education, University of Colorado, 1966. MFA, Ceramics, University of Michigan, 1968. Chair of the Division of Ceramic Art, New York State College of Ceramics at Alfred University, 1984-present. Lives and works in Alfred Station, New York. Exhibits internationally.

Q: I'd like you to describe your family in early childhood.
HIGBY: Okay. This is like going into a time warp, right? [_Laughter_] My family consists of three members, so I'm an only child; I don't have any brothers or sisters. I did have a mother, and I did have a father. My father died in 1965, but the family was located in Colorado Springs, Colorado. Originally my parents were from Kansas City. My father was in the military during World War II, at Fort Carson, which I think now is Camp Carson. But Colorado Springs has a lot of military. They built the Air Force Academy there, and the North American Air Defense Command is in Colorado Springs. Anyway, my parents were there during the war, briefly, and that's where they decided to move. And I was born in Colorado Springs during the time my father was there in the war. I was born in 1943. So when the war was over, they moved back there, and he started his law practice. He graduated from Washburn University, in Topeka, Kansas, and then went to Colorado Springs. Most of the time that I lived in Colorado Springs, we lived in a house about a half-hour

from right downtown, on the eastern side of the city. It was in an area called Austin's Bluff, which is a kind of a park. And we had a house that was situated up against the back of a bluff and looked out towards the city.

Q: How did they feel about the talent that caused you to develop your art?

HIGBY: My father wasn't particularly interested. I don't know whether "interested" is the right word. But, you know, as a young professional, he was trying to develop his law practice and was just working in the sort of environs of Colorado Springs, making things happen. My mother, on the other hand, had this notion of being a good wife and mother in the sense, how do you help your husband's career, and what do you do for your child? She made sure that I was exposed to a lot of things as a kid. I took dancing lessons; I took figure skating lessons. I went to the Colorado Springs Fine Arts Center—they had a program for children. And being a child, didn't know much about it one way or the other, except I must not have complained. I don't remember disliking dancing lessons or disliking going to the Arts Center. Then, when I was in elementary school, somewhere in the middle, the fifth or sixth grade, I had a scholarship to go back to the Arts Center to work. So I had shown some signs of something in school. I remember it wasn't that I was uncomfortable in school, but I felt kind of at odds with it a bit. I think at the time I didn't know whether that was because, being an only child, I was very introverted. So the kinds of things everybody was doing, I was always sort of sitting and observing, not knowing that that's what I was doing, or feeling kind of uncomfortable about relationships, and wondering, "Now, how come I don't feel like I'm quite fitting in here?" Probably the art was a way of getting recognized in some sense. I could do something that someone else couldn't do, so that was neat. And I had had that experience as a much younger kid doing a lot of different things. So I had gotten this scholarship and that probably encouraged me. I wasn't very good at math or English.

Q: Did you develop basic peer relationships at that age? Or was your mother important at that age, as far as influencing you?

HIGBY: I think she probably was very important in some way. I don't think that I felt like I was missing anything. I wasn't at home ruminating about the fact that I wasn't out with the kids. But also my father had an interest early on in horses. And actually, when they first moved to Colorado Springs, they lived up in the mountains, in a place called Green Mountain Falls. There was a stable there. I remember pictures of me leading the Bronco Day Parade on a black pony. Horses, from that

point on, were kind of a part of the family existence. But I think as a kid as long as I can remember, I had horses right out the back door. So I would come home from school and ride my horse. I rode my horse all summer long, and my horse was sort of my closest friend. Probably when you think of peer group, I thought my peer group was all four-legged! But I didn't really miss those other relationships, I guess.

Q: When you were a child, what art forms were interesting to you?

HIGBY: I did a lot of painting, I remember. And I did ceramics. About four years ago, my mother sent a UPS box full of all these ceramic things that she had kept that I had made when I was in second grade or something. And there was one green vase-like form about eight inches tall, and it had "Wayne" written on it in big letters all the way around it! [*Laughing*] I don't know what that means, the ego was strong at second grade, or whatever.

Q: When did you become an artist, and how did you know?

HIGBY: I guess that probably happened my freshman year in college. I didn't take art in high school, I didn't do any art. My wife was taking art classes. We met when we were fifteen. She lived down the road from me. We had this passionate affair ever since chemistry class, that's where I met her. She had moved to town, her father was with the Air Force, and I met her in my high school chemistry class. Isn't that romantic? Anyway, she took all this art, and my other friends in high school were involved in art, but I wasn't. I played the trumpet, so I was in the band. I was also very involved in drama, did a lot of drama stuff in high school. So I guess in a way, I just sort of thought everybody had talent, whatever that mysterious thing is. I just figured everybody drew and made things. My friends sure did. The rest of the time I was riding around on a horse, so I don't know what the world was doing! [*Laughing*] But, I went off to the University of Colorado. Actually, I wasn't planning to go to school at all because by that time I had started breeding horses. I was going to lots of horse shows and county fairs, and I used to put my horse in my trailer and take off. I don't know why my parents let me do this. I really wanted to be someone who raised horses and worked with horses and was sort of a wrangler or a trainer for someone who would show horses and animals. And I figured you didn't need to go to school to do that, I just had to keep doing what I was doing. And at the same time I guess I was doing drawing and things on my own, and just trying to get through high school.

Well, that was not what my parents had in mind. So you were going to college, you know. And you had to have some more education because your future was important, and just raising horses was not going

to do it. So I went to college as a pre-law major. My father was a lawyer. I think my mother wanted me to go to William and Mary, or someplace like that on the East coast. And I didn't have really good grades. I had terrible SAT's, just awful. Actually, I think we had about five hundred kids in our senior class, and I think I might have been forty-sixth or forty-eighth. I wasn't bad in school particularly, but all the SAT's and things were just zero. I was a terrible test taker. And there was incredible anxiety doing that. God, I hated doing that. Ugh. Anyway, the University of Colorado is a state school. So they took everybody who wanted to come as a freshman and then tried to flunk them all out. That was okay, I was going to be a pre-law major, and it was going to be Higby & Son, or Higby & Higby. And it was funny, because I even went for rush week, fraternity things. Now, if you can picture what I've said so far about being this sort of introverted person who hardly ever spoke to another human being! It wasn't that bad, I had a few friends, but I wasn't fraternity material. But that didn't work out at all. I remember, I went home after about two days, going, "Geez, that was weird." So I was registered as a pre-law major and taking basic curriculum, and—this was a turning point probably—I went to the law library on the campus at the University of Colorado. I think it might have been in my first semester for a kind of orientation. All the pre-law students who had declared were invited to see a kind of mock trial as a kind of orientation thing. So I went into the law library, just hanging out waiting for everybody else to show up, and it had never dawned on me before that that there were no pictures in law books. I mean, law books are just these big, thick, heavy things! You opened them up, there were no images, right? And it had never occurred to me that I was going to have to spend the rest of my life with these books! And for a person who did very poor on their, you know, logic, verbal, reading, in the SAT's, you know, I was not a reader! I was outside working with horses, or I was drawing, or doing something that was obviously either very physical and coordinated kind of thing or very visual. And the books scared me to death. I can't do this, this is frightening! There is no way I can go to school and do this! There happened to be some paintings in the law building, you know, portraits of famous lawyers or something. And I remember walking out into the hallway after having had this confrontation with these books, and walking down the hall, and just looking at these paintings and going, "Oh. Well, this is interesting." Because there was this thing where I sort of understood the paintings. They weren't great paintings, but I could tell I understood something about that. I got another feeling, in another flash, like I didn't understand the books, but

when I walked out and looked at the paintings, there was something else that happened. So, I just decided, the next day I went to the big library, and I went to find the books with the most pictures in them! [*Laugh*] It's really scientific reasoning, right? And the books with the most pictures were the art books. And I thought, this is it. Enough of my friends in high school had been involved in art, and I had obviously had these other experiences with it, my scholarship when I was in elementary school and all that.

So it was all there. But I think it was something that was being subverted for a career, for something important, something logical. I called home some time after mulling this whole thing over and just said, "I can't do this, and I'm going to transfer into the art program." You had to take freshman and sophomore year art courses and then submit a portfolio your junior year. If you passed the portfolio review, then you could come into the art program as a major. And I said, I have to start now, because I have to take these freshman foundation classes. I'll take the requirements, like the English that I needed to take, but I have to take this art history and this art theory class. I called my father, and it was not very easy at first. You know, you can't just go to school and have fun. You have to do something. For my parents, art was something that you got after you were a success doing something. If you were a big successful lawyer, then you got to buy art. Art was the icing, it wasn't the thing that you did. Art was too much like labor. The arts are dirty or laborious, or artists are flaky. They didn't want me to be a flake. So probably my greatest identity in the family was my grandfather, and that was something that upset my mother a little bit. Not that she didn't like her father. But her father was what I would call an artisan. He worked in Kansas City; he only went to the eighth grade. But he did a lot of the mural work and the gold leaf work in the Nelson Art Gallery, and he did carpentry and cabinet making. And he was on retainer by a number of major buildings in downtown Kansas City as a painter. They called him a painter. But what he really did was mix color, before Sherwin Williams had those color swatches. You know, now you can go to the hardware store and look at all the color swatches and pick them. In those days, you had to have my grandfather on retainer, because if you needed to repaint the foyer of the building, the only person who knew how to make that color was this guy who somewhere in his basement was doing this with pouring the paint together. And I realized after thinking about this whole thing that it was my grandfather that was sort of an inspiration, and I kept thinking about that. But since he didn't make any money in my family (when my mother grew up her family was very, very poor)

it was like, "Son, wait a minute! I've been trying to get out of this situation for years, and now you want to do that?" In that sense, there's probably some classic evolutionary mechanism where the first generation is shop, blue collar, and then there's the effort to become the professional. And then that security perhaps at some point triggers another kind of freedom. Because I don't think I was worried about money.

Q: How about ceramics? Why did you choose ceramics as your medium?

HIGBY: That happened a lot later. I just started taking all of the basic courses. I was really painting primarily. I thought I would go into painting. And in my junior year I was accepted into the art school based on my portfolio, and I started taking painting classes. But also that year, a very close friend of mine and her family decided to take a trip around the world, and they invited me to go with them. I talked it over with my parents, and because I was interested in art and all of this, I think my parents decided this would be a good idea. So I took a trip around the world, I don't know whether it was six or seven months, starting with Japan and working that direction. I was trying to see all the things that you're supposed to see, whatever it was, and check out all those things that I was learning about in art history. So I came to the Mediterranean. I was on the island of Crete in the Heraklion Museum. And in the Heraklion Museum, there are the most incredible pots you ever want to see. All the Minoan culture. I think I walked in there thinking I was going to see a nice anthropological museum. Probably to make a giant leap, I became a potter the day I walked into that museum. There was something about those pots that just really blew me away. I was keeping a diary on this entire trip, and I still have that entry in my diary. "What about pottery, what about clay?" And I wrote a lot about the decoration on these pots, about the floral themes and the sea-life that had been transposed into painting on the surfaces of these forms and about the magnificent sense of shape, volume. Donna, my wife, was back at school, and I wrote her this letter about how I'd seen this stuff in this museum, and that when I came back I was going to try and find out if anybody made pots. She, at that time, was taking a pottery course; I didn't know it. She wrote me back; and someplace I got a letter from her, "I'm taking a pottery course!" I got back to school and just decided I wanted to know about ceramics. Ceramics was part of the art education program; there wasn't really a major ceramic commitment at the school.

Q: Did you set benchmarks for yourself?

HIGBY: I don't think at that time I did. I know I had this incredible experience with the pots. The other major key to what I've done, is that

I had a kind of revelation on this trip when I was in Calcutta. It sounds so corny to talk about it, but when you're twenty-one things are corny. I came from Colorado Springs, which was like the Newport of the West. It's still a very upwardly mobile community, and it was founded by people from the wealthy class of Pennsylvania. So I never had seen the world at all; I didn't have a clue. I was very naive. I wound up in downtown Calcutta, an incredible place, where people are lying around in the street. And I was in this English hotel that's very nice, traveling with these people—we didn't necessarily do it on the cheap. And I really just couldn't understand it. I couldn't figure out how I wound up in Calcutta with this fat airplane ticket and there were these people in the street, this poverty and this sea of humanity, as they say. And for four days I stayed in my hotel room. While the friends I was with, they went out to the museums and went out to the things you were supposed to see. I simply couldn't go outside. I just said, I thought I'd just stay inside and read a book. I was really confused, and I was worried about it. For some reason, I thought if I gave these people all my money and my clothes, it still wouldn't help, would it? I mean, I didn't understand this at all. That experience coupled with the pots.

So I really had decided when I went back to school that it was pots I was interested in, and that I probably would try and do something with art education.

Q: How did the training that you received affect your career?

HIGBY: The training I got was practically nil, as an undergraduate.

Q: You were primarily self-taught then?

HIGBY: Yes. Because I was continually trying to put myself in the situation where I could get something. And I think that when students leave here I think I almost would like to feel that they thought they were self-taught. I mean, as a teacher, I don't want to have any ownership over the students. But I know that in my own experience, seeing what goes on here and what I do as a teacher, and what my experience was, that I pretty much just was on my own. It was there, but you really had to dig it out for yourself.

Q: Is mentoring an important part of your growth as an artist?

HIGBY: Well, I had mentors, but not until much later in my career. And probably that's a concept I didn't realize until much later, what it meant. But I decided I would try to do something with art education because I thought you have to make the most out of this opportunity that you possibly can. You really have to make this pay off because there's someone in Calcutta who doesn't have it. And there's no trade-off. So what you have to do is really shut up and do it. And teaching, for me,

I thought now that's a way where I can give something back somehow. I can sort of help somebody else do something. And I was going to be a high school teacher and then work in clay, make pots. And conveniently enough, the clay program was in art education. So, when I went back to school, my closest art teacher person was just a person that I kind of admired who had been my art theory teacher as a freshman. He said all these things I didn't understand, and that impressed me a lot. He also taught a drawing class that I got an A in. When I went back to school after this trip I went to see him. I started talking to him about the things that happened and things I was thinking, and it turned out that his wife was a famous potter, just by coincidence. (His name is George Woodman, and her name is Betty Woodman.) So he said, "Well, I know a potter, if you're really interested in pots." I started taking a course at night, after school. She taught at the Boulder Recreation Department, a clay course. I just went up there everyday when she was there, and I started working up there plus doing my university work plus doing the clay program that was connected to art education. And the two of them became a first sort of inspiration in the sense I began to get a feel of an artist's lifestyle. She was a great cook; she fixed all these incredibly different kind of foods and lived in this house that was full of paintings and sculptures. She had a studio right off the kitchen. And he was a painter as well as a scholar-philosopher. I think he got a degree in philosophy from Harvard. You'd go to their house, and they'd play great music that you hadn't really heard before. That's what really developed the clay. They convinced me that I really didn't want to be a high school art teacher. I don't know that they twisted my arm at all, but Betty really felt that I should go to graduate school in ceramics. She introduced me to some well-known ceramic people, Paul Soldner being one of them. To make a long story short, I got a scholarship to go to Claremont, where he taught. And then he decided not to be there, so I wound up going to the University of Michigan.

Q: Do you belong to any organizations at this point where you have contact with other artists?

HIGBY: Well I belong to an organization called NCECA, which is the National Council on Education for the Ceramic Arts. It's like the College Art Association, only it's material-specific; all these people work in clay. I work here at the College of Ceramics, with five other ceramic artists, all of whom are, to me, very interesting people. And they're very influential on triggering thoughts. But to take that another step, the students that you work with are as influential in drawing you out and making you think. Also my career in clay has gotten to the stage

where I meet a lot of artists. So I'm out of my studio meeting artists who are painters and sculptors. That professional level of effort, sharing ideas about things, being on juries, that's influential because it really makes you think and ask yourself questions.

Q: When do you think you first achieved professional recognition as an artist?

HIGBY: Has it happened yet? I think it's happened—I'm still working on it! [*Laughter*] You always go to these plateaus, and then you say, gee, there's another ladder! In some funny way, probably when I was about thirty years old. I graduated from the University of Colorado, 1966, and I went to Paris to get married. My military father-in-law was working with NATO, so my wife and I went there and were married in a little village outside of Paris. Then I went to the University of Michigan and worked for two years. At Michigan, (we were about twenty-two years old then, my wife and I), we had two babies. So at twenty-two, twenty-three years old, I had two kids and a wife. And that will really make you hustle. I remember sitting on the porch—it was August. I didn't have a job, and I had graduated. I still was interested in teaching, but now it had gone into the college level thing. I had my first museum exhibition when I was twenty-five at the Joslyn Art Museum in Omaha. I went there for my first teaching job. I marched right into the museum first thing and said I need a show because I have to get out of here and get a better job! Then I got a job at the Rhode Island School of Design, and each one of those things gives you a sense that you're becoming more of a professional. I had been in a major exhibition called "Objects USA," which was a huge craft collection. I think I may have been the youngest person in it, or one of the youngest people, just right out of graduate school. The piece that was chosen for the show was a piece I had done in graduate school. Then in 1973 when I was thirty years old, I was invited to have a one-person show at the Museum of American Craft in New York. So that was a big deal in terms of my field.

Q: Were critical review and acceptance by the academic world very important as far as your understanding of when you became professional?

HIGBY: I think you go through those stages. At first you think everybody's an artist, and then you think no, and then you think, I wonder if I could be any good, and then you meet a professor, and they invite you to dinner, and you think, well, maybe I could be. I always wanted to be the best at what I did. My parents probably instilled that in me. I remember my father finally getting over it about art and telling me, "Well, I guess it's okay." As long as you're the best, you can do whatever

you want." So there was a kind of pressure when I realized that I was doing this to prove myself to them as much as anything else. And the rest of it's, what is it, timing? Luck? You know, I liked my work. So three months later I had a one-person show at the museum. Well, they published a little thing on it, and that must have gotten someone else interested.

Q: Do you have any feelings about unions? Do they exist at all in your field?

HIGBY: They exist in the field of higher education and elementary and secondary education. We don't have a union here at the University. I have never been a part of one. I don't know how I feel about it. I'm not a joiner. I think a lot of these things that artists and other people can do collectively are very important, and I get involved. I don't know how I am with the collective. I'm of very independent mind, I know that. And that works when you're working with groups of people, up to a point. But I don't know whether I'd feel comfortable with someone telling me you had to do this, unless I had really come to that conclusion myself. So, I don't know. My parents were very heavily involved politically, and my mother wound up being the Superintendent of the United States Mint, which was a political appointment from President Nixon. My father ran for the Senate in Colorado and was the district attorney in the area, so there was a lot of politics in my family. So I'm quite aware of the political dynamic and the use of unions and those kinds of things. At the same time, I've never been an official member of a political party! [*Laughs*] But I'm very opinionated, and I like working with people. I'm currently president of the board of the Haystack Mountain School of Crafts, in Maine. And I love working with the board and the other artists and trying to make things happen up there, raise money and create an environment. But there's a lot of volunteer effort. I didn't have to sign up. I don't know how I would feel about that.

Q: Do you feel that in your career there were gatekeepers who either let you in or barred your way?

HIGBY: I didn't really feel barred from anything necessarily except by my own limitations. You know, I was barred by the SAT's, because I just couldn't take the tests. So whoever those gatekeepers are, they can just move over! When I first came to Alfred, we had the graduate record examinations for all of the students. I was hired to help do something with the ceramic program, we have a large graduate program in clay. The first semester I was here I just talked everybody into eliminating the exam as a requirement. I didn't think passing those tests was essential to being an artist, and it had nothing to do with intelligence. I

think art is predicated on a very fine kind of intelligence, but it's a different kind of intelligence. It's not linear. Those [tests] are certain kinds of hoops you have to jump through, some of which I think in terms of the career of an artist are superficial. There are things in everyone's life like that, so you do your best.

But I never felt the system made it tougher. I felt more like it was just my own limitation. Gosh, if I could read and write and spell it would be. . . . What's curious about that, I suppose, is that in the last ten years I've really made a concerted effort to read, write, and spell. In my early career as an artist, I really was very much a non-reader. I flunked freshman English in Boulder, I had to take it three times. Finally they told me if I could pass a punctuation test, I could go on in school. Partly I wasn't interested in it, and partly I just didn't read books! So, now it's funny, because I have become known (to a degree) as this sort of intellectual ceramic artist. I saw Paul Soldner several years ago, and he said, "Oh, you're the intellectual one in our field," and I thought this was pretty funny. But it was because I was writing and have been teaching a graduate seminar, and I have been invited to a lot of conferences as a speaker.

Q: Do you think of your career as different from your occupation?

HIGBY: I was at this conference two years ago in New York, "A Case for Clay in Secondary Education," and I guess because of my interest in education I was invited. So that was part of it. You know which are you, an artist or a teacher? And I said, "Well, in those two words there's this little hyphen." Sometimes I think of myself as the hyphen. Or, as I described it in my talk, I think of myself as a bridge, which puts it into a positive context. I'm really not one or the other. I'm either this strange fusion, or I'm that space between. I work on one side of that bridge, and I work on the other side of the bridge very intently, and I invite people to walk back and forth across.

Q: Do you think there are discrepancies between your career aspirations and what you've actually achieved? Or opportunities that you've actually had?

HIGBY: I could answer that in the affirmative in one way. It's such a complex thing because I never see things one way. But I remember, at one point a young student asking me, "Well, now, how do you do this? How do you balance career and family and teaching and being in your studio, and all of that?" And part of it is the combination, you know. To a large extent it's the relationship I have with my wife. The two of us have been deeply in love and committed to each other for a long time. So we give up things for each other, and she's given up a lot of things

about her career for me. But she also wanted to raise kids and have a family, and I've been out trying to make it happen. But I said to this young person, I said, "Well, from my point of view, life is more important than art." And so my life and the life I have with my family in general is really the most important thing. And also I think art comes from life, the living of it appears in your work. It has for me. My experiences. And I think I realized that at a certain point. It's only been within the last ten or twelve years that people are beginning to say, wait a minute, ceramics could be art. The Metropolitan Museum has bought pieces of mine and others; it was very slow to come. There was a point where I realized that if I wanted to make some other kind of commitment, some other kind of trade-off, then I could do more work in my studio, have my work in *Living Color* and more magazines, and be selling at higher prices. Because, at a certain level, the rest of it is connections and hustle. I could be going to New York more often. I know what that's all about, and I know I can do it. There's enough interest in my work to know that it's just a matter of putting your energy in that spot. But that's not it. The teaching, being here, being with these people, these young people, and trying to help them do things and find their way and—I don't care if they go into art. Just helping them understand what their potential is and giving some sense of encouragement is really important to me. I decided that years ago. I haven't changed my mind since downtown Calcutta about that. So you make choices to have a life rather than a career, and I wanted to have a life.

Q: Do you think your relationship to money has changed throughout your career?

HIGBY: I need more now! I have two kids in college! [*Laughs*]

Q: How have the costs of supporting your career as an artist changed over time?

HIGBY: Well, it's still funny, because I remember when I was on the New York Foundation for the Arts, actually, when I was working with an individual artist group before the New York Foundation was even in existence. We invented the New York Foundation out of this group. And how often the issues that we would discuss and argue about were, "Well, is it more important for a young person to have money?" But when you're in mid-career, everything is more expensive! I mean, now it's not, "I've got a studio, and I can make some things, and I can continue to enter shows," but at this stage in my career it's about having a monograph printed on your work if you're going to show someplace; it's about six color photographs instead of one. How you get off one plateau to the next one has something to do with recognition and

people's awareness of what you're doing. I've gotten some grants that have been really helpful.

Q: How about awards, or competitions?

HIGBY: I won some competitions when I was starting out, best of show. The juries at the various NEA's have been very good to me; I've had three of those. And I was given a grant—I mean, how do you know you're a professional? There is a group out of Brown University called the Gardner Howard Foundation, and they give grants to mid-career artists in all fields. I think I may have been the first person in ceramics to get one. But it's one of those things where you can't apply. One day I was sitting here at this desk, and the phone rang from the Gardner Howard Foundation. I had been nominated and did I want to have this money? What I was requested to do was to take a year off from teaching and go to my studio, and they would support me for what I needed. So I went to the Dean, and I said, "Look, this is happening, and I could take my sabbatical now, and with the sabbatical plus that money I could take a year off from work." That was a tremendous leg up because it almost got a little bit of a backlog of work to build in the studio. And I got to reintroduce myself to myself as an artist, which is super important. Teaching is a very projecting kind of thing, and making art's very introverted. The introverted part was natural to me, but I've been teaching for so long I'd forgot. Right now, I'm involved in a project that I'm a little nervous about, but it's very exciting considering my earlier goals. I'm being given a master teacher award for 1990 from the University of Hartford. It's a cross-university committee; I was nominated by someone there out of a group of ten or twelve possibilities, physics and English and all of that. So I go in October. My only requirement in receiving the award is that I give an address to the university, which would entail all of the various departments, music school and physics and all those things, and obviously to the students. I went to meet with the committee; and what they really wanted to know was what an artist has to say, how I could create a reasonable communication across all disciplines. They've never given this award to an artist, but they were still worried about how could I give a lecture that would be interesting to everyone, which I thought was curious.

Q: How has your workspace been important?

HIGBY: It's very important. I live five minutes from school, but I live in the country. I have thirty acres; I have a big barn; I have a studio. So I can be in and out of here. I also have a studio here, just downstairs. I teach three days a week, supposedly, but I'm also chairman of the department. I have this ritual. I go to my studio every morning, even if

it's only for five minutes, and I sort of stand in the middle of it, going, "Yes, this is the gravity" and I carry these thoughts about my work. Usually at the end of the day I wind up in my studio. Sometimes, obviously, I'm not doing anything there. But on the other hand, I'm keeping that going. I make deadlines for myself: I had a show in Detroit; I'm having a show in New York in December; and I'm having a show in Kansas City in April. That forces me to keep being in my studio. So it is a feeling that I'm carrying my studio around with me, and I'm there. Of course what I'm doing here is an extension of that, although I don't talk to the students here a lot about my own work. I have a sort of principle about that, as much as I can I try not to teach through my own work. I try to find out what the students are about.

Q: What kind of control do you feel you exert over your destiny as an artist?

HIGBY: I guess I've felt in control. But I don't worry about it much. The only part I feel is not in control is related to a much bigger picture, which has to do with the culture and the cultural acceptance of certain media: you know, the notion of clay as craft material, the ideas people have culturally, and critics have about craft, low art, high art. That's a thing that is pervasive to a degree. It's changed, and I've watched it change. I probably have, without overstating it too much, had something to do with helping it change. My work is predicated on the concepts and ideas behind the vessel, the sort of non-functional pot, that I, along with some other people who are my elders in a way, have developed as pioneers of that aesthetic. And when the Metropolitan Museum of Art in New York begins to collect it, even if they don't show a lot of it, they've decided it's going to be important. They don't know exactly when, but in the last few years, the work in that vein has begun to be collected by the establishment. So I think I've had an effect through my work. And I think I've had an effect through my teaching. People have gone out of here and also helped change things, helped people become more aware. And through writing, all those things.

Q: What would you say are your criteria for success as an artist or a craftsperson?

HIGBY: I don't know. I think as an artist I make it for myself. It's the old "I am" sort of thing. You know, I ask this question in my graduate seminar, and I say, "Okay a simple question, you're the last person on earth. Would you make art?" And we kick that one around. You know, it's a good one for a conversation with a bunch of artists. And I always answer it and say, well, of course I would. Because that's my identity. I mean, I'd have to scrounge around and be able to eat, but I'd make

things, I know I'd make things. There'd be a lot of time on my hands to make things. You know, tie branches together or whatever it happens to be. So I know I'm doing it for myself. My own reification making thoughts and feelings real, trying to understand something, give myself gravity, prove I exist.

Q: Do you have a number of ideas that you keep working on?

HIGBY: Yes, I've had two or three threads. One is a very personal thing about ceramics and about landscape as environment, as some kind of visual poetics, some kind of mystery. That probably has a lot to do with my childhood and being in the landscape. But landscape is a mechanism for getting at something else. Perhaps it's not that different in a funny way from nineteenth-century American landscape painters, from the luminous painters who I'm really interested in, even more theatrical ones like Church and Bierstadt, or Chinese landscape painters and issues of landscape. So these things are very private things that I am working on. I've been working on this for years, in one form or another.

The other has to do with how is art related to life. What are the philosophical components? And I'm really interested in that in terms of how it relates to human evolution and human nature and intelligence, and why cultures are the way they are, why people act the way they do. Psychology, sociology, philosophy, I'm really interested in that. And how it crosses into the field of art. And education, all levels of education, which is close in some way. I'm very interested in problems of art education. I work with high school students, still. Every year I do the choreography for the local high school musical, just to keep my finger in about what's going on in education in the arts in high schools, and working with kids that age.

Q: In your work are there specific periods that you feel more satisfied with work?

HIGBY: Yeah. But for an artist it's hard to objectify. I'm most satisfied by it right now. But probably if you'd asked me that ten years ago I'd have said, "Oh, right now." I don't know. But I'm really interested in what I'm doing right at the moment. I've made some changes, and I think I've made some other kind of funny breakthroughs. I haven't ever made any real leaps. Things evolve out of other things. But recently I have felt more confident because as an artist a lot of things grow out of insecurity and anxiety. I'm always trying to make something I don't really know about, and it's pretty insecure territory. Now I think, perhaps because I've achieved a few things, I've reached another level of self-confidence. Something's happening in the work that's really inter-

esting to me. It's not a major change, but I think the most recent work that I've been doing is perhaps the strongest.

Q: What is your relationship to critical review and critical acceptance?

HIGBY: I think critical acceptance is important. I would like to make work that would have levels. In other words, that I could make work that would mean something to someone who knows nothing about art, and at the same time it would resonate for people who know a lot about art. So I sort of toy with the phenomenon of accessibility. I think pottery in itself and my work is predicated on pots, like those Minoan pots—I think pottery is an art form of accessibility. Its thematic nature is accessibility. Whether it's functional or not, there is a kind of quality of invitation into the work because of its common threads through history and because of its recognizable form. Its configuration is predicated on pots and probably predicated on function originally. It's first and foremost important that it meets my standard, whatever it happens to be, that's all it is. And if nobody else agrees with me, that's too bad. There was a time in contemporary art, when I was first involved in the late sixties and all through the seventies, where using imagery was not cool. We're talking conceptual minimal art, those were the heavy threads, with the exception of pop art, which is really also kind of conceptual. In a sense the rationale for it is conceptual, but landscape painting? I mean, that went out with the nineteenth century. So not only was I interested in doing landscape painting, but I was making pots, which clay, okay, now we're really talking low art, because pots are also tied to functional things. If clay isn't a fine art material, making pots is certainly the worst—at least if you're going to use clay you ought to make sculpture. So I lived through a determination to do something in my work that had to do with pots and landscapes. Critics, of course, need to make a living, too. They need to be recognized. So critics often are not interested even if they kind of like the work, they're not interested in building their career around work that is not hip. They're not interested in going out on a limb for work that doesn't look potentially more "avant garde," or tougher, whatever that is. They want to be recognized as having great vision or being hip to what's going on. So the critical evaluation of my work has been a little bit along those lines.

Q: Overall how satisfied would you say you are with your career as an artist?

HIGBY: Fine. I think it's fine. The one thing that's important in one sense is simply longevity. And my career is more solid now than it was ten years ago. I still have invitations; I'm still working, and people want me

to show. I would like to be able to string it out. Maybe there's some advantage in being interested in life enough so that I haven't flooded the marketplace! [*Laughs*] There's still a demand!

Q: What would you say the major frustrations and resistances were in your development?

HIGBY: I think the major frustrations are simply the common ones perhaps that all craftspeople have. It is the genuine recognition of the intensity and quality of the work, the real validity and beauty of it as art, and the recognition of a broader range of artistic endeavor as really being important. It ought to be accessible to more than eight people in New York.

Q: How has your relationship with your material changed from your early career?

HIGBY: Well, it's funny for a ceramic artist, the one thing that happens is that you do get this passion for a material. I always equated that a little bit with my experience with painting. I loved paint; I loved mushing around and just spreading the stuff on, brushing it and getting all these effects way before I ever had any clue about another kind of an idea. I think I access making art simply through the materials as much as anything. Although I think the concept of the pot—when I saw them on Crete, the objectness, the iconography of the pot, the thing that resonated about the human being on earth—somehow was a concept that was really fixed at that point in my mind. That something like that could be so close an analogy to the figure and to human existence, and at the same time conceptually be such an interesting, fundamental notion of what it means to be a human, that you take nothing and you make something. And you make something potentially that you could put something in, that helps you do something else. The way humans create order out of the chaos of nature, so to speak, that the pot is a kind of construct that's fundamental in what it says about the intellect of the human, the making capacity of the human. And then the pot, interestingly enough, has this incredible figurative presence. So at the same time it's kind of a mapping of the intellect of what it means to be human. And then there's a direct analogy. It's almost portraiture of what it is in the abstract to be a human being—vertical axis, all of that. That combination, which I didn't understand in the beginning but I felt it, and the material phenomenon that was like making three-dimensional paintings, I think the clay and the three dimensions appeal to that sensibility of thinking and moving. So those are all very naive and very intuitive things that gradually have become very recognized phenomena for me. And I've gotten better at it. Practice makes you get better.

Q: What advice would you give to young artists entering your field?

HIGBY: I think trusting yourself is fundamental. You must trust yourself in a field that breeds insecurity from step one. You're reaching into the unknown; you're coming back with information; you're trying to make thoughts and feelings real. They're yours. No one else has them. And there isn't a ready-made support system. You have to make it. There is an art world. There is appreciation, but you really have to make it happen for yourself. And you've got to work harder. There has to be passion to do it that's totally irrational. It's obsessive compulsive behavior, that's the only rationale. It's a form of insanity, but it's saneness. The other thing I have been saying is look, when everybody else gives up, you'll still be working. Then you'll have every opportunity there is. You'll have all those spaces to work in and all those materials. So self-confidence, how do you get it? You've got to trust yourself. And don't give up.

Representative collections include: Corporate: US News and World Report (Washington, DC); Public (selected): American Craft Museum (New York, NY), Museum of Fine Arts (Boston, MA), Brooklyn Museum of Art (Brooklyn, NY), Everson Museum of Art (Syracuse, NY), Joslyn Museum of Art (Omaha, NE), Metropolitan Museum of Art (New York, NY), Minneapolis Museum of Art (Minneapolis, MN), Museum of Modern Art (Tokyo, Japan), Philadelphia Museum of Art (Philadelphia, PA), Victoria and Albert Museum (London, England).

Professional affiliations: Haystack Mountain School of Crafts, President of the Board of Trustees; International Academy of Ceramics; National Council on Education for the Ceramic Arts.

Honors: Master Teacher, University of Hartford, 1990; New York Foundation for the Arts Fellowship, 1985–86, 1989–90; NEA Visual Arts Fellowships, 1973–74, 1977–78, 1988–89; George A. and Eliza A. Gardner Howard Foundation Fellowship, 1986–87.

MARGARITA LEON

B. Maracaibo, Venezuela, 1957. Studied art at the College of New Rochelle, New York, 1977–78; School of the Museum of Fine Arts, Boston, Massachusetts, 1978–81; BFA, Sculpture, Pacific Northwest College of Art, Portland, Oregon, 1985. Founder, Creative Kids, an art school for all ages. Works as a sculptor, teaches art in Portland, Oregon, and exhibits nationally.

Q: Margarita, could you describe your family and early childhood?

LEON: My family was a very established family in Maracaibo, Venezuela. They encouraged us to do the things that we needed to do for ourselves when we had ideas of things we wanted to do and explore. They were very supportive. And as kids we were taken to museums and different functions that we needed to attend to be part of the family. My father is a banker, and therefore, we needed to learn something about that. My mother was a housewife, and there were some social things that we needed to know. I am the only girl. I have an older brother and a younger brother. They were allowed to do different things than I was, because of the difference in sex. Since I was very, very little I was always able to draw and was fascinated by being able to do things with my hands. My dad was a ham radio operator and had all these different color cables and wires and exotic materials. I used to like to play with those and draw while he was talking. Other than that, there was photography, which was encouraged by him. I always felt that he encouraged me because that way he could play with it himself more. And he got me a darkroom

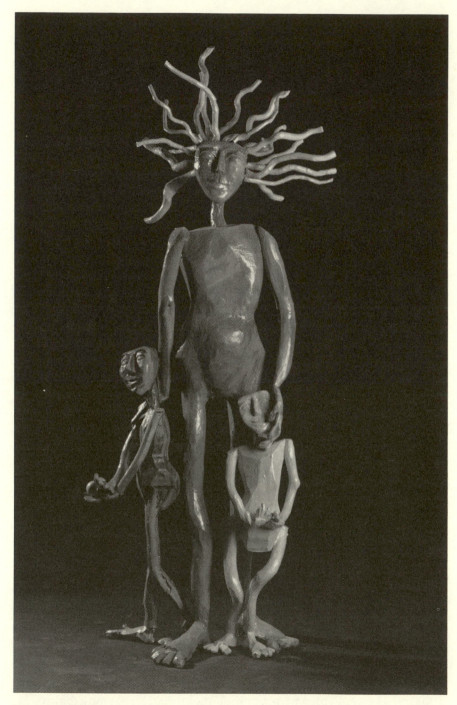

"Tongue Tied" by Margarita Leon, 1991.

when I must have been ten or so. We spent many hours together developing film and just taking amazing pictures.

Q: What were your initial experiences with art?

LEON: My mother especially tried to encourage me to be more outgoing and to fight more because I was female. That's why I went to study in Canada in boarding school when I was twelve years old to learn French and English. She felt that I needed to know more than anybody so that I could accomplish the things that I needed to accomplish for myself. We were a very happy family. My older brother is still in Venezuela, and the younger one is in Washington, DC.

Q: How did the members of your family feel about your artwork?

LEON: Well . . . there was always encouragement, but there was always, to me, the sense of "That's what Margarita did; that's okay. This is Margarita and this is what Margarita does. Margarita sees things a little bit different than the rest of us, but that's fine. She'll get somewhere." It was accepted, encouraged, and they tried to feed it at the same time. But it was what I did. I always think it was seen as being a little odd and a little different and just a touch to the other side, whatever that other side was.

Q: Did your mother do any artwork herself? Or your brothers?

LEON: No. My brothers knew how to draw, and they drew well, especially my older brother. My younger brother was more a person of ideas. So his drawings to me were always more interesting because they were odd.

Q: What educational experiences provided you with early validation or resistance to your artwork?

LEON: In school, in kindergarten and just growing up in Venezuela, you're encouraged to do a lot of painting and drawing, and you learn through arts. It's very strong that when you do your homework, you do a drawing with it. You do a dictation, you take it home and do a drawing for it. There's always some artwork in it. Things work differently down there than they do here. I know that the school that I went to was run by nuns but was for poor people. And I was always winning contests and things like that within the school for doing murals and paintings or collages.

Q: What art forms particularly interested you in your early education and training?

LEON: Photography. Painting and drawing. And although I didn't realize it then, I was always doing something else on the side. And that something else was making figures out of clay or sticks—wood. When you go to school in Venezuela, when you start kindergarten they do

psychological tests. For the first three years my psychological tests showed that I had this incredible fascination with sticks and seeds and things that I'd pick up. I kept them and did things with them. And then nobody ever saw them again. [*Laughter*]

Q: When did you become an artist?

LEON: I think I consciously became an artist when I was four years old. That's when it was apparent to me that I needed to do this for myself, in whichever form it took. I didn't know. I just knew that it was a part of me and that to be able to survive I had to do it. I went to a museum. I went to see the Museum of Simon Bolivar, who is the liberator of Venezuela. And I saw all these things that he had when he was a kid. And I went home and I gave similar things to my mom—toothbrush, clothing, dolls, toys. And I said, "Here, save these. These are the first things for my museum." That's the most conscious moment when I thought that's what I had to do. I had to be an artist, and that's what happened to artists.

Q: When did you begin to specialize in your art forms?

LEON: My art form is sculpture. Oh, I think that they were always in me, growing. But they have begun to materialize as wood forms in the past ten years. Before that they were paintings. And they were the same kind of creatures: people. I haven't done any people that have skin color or look like you and me. They have always had bright colors and whimsical movement. I am concerned with all the technical aspects of them: proportion and movement, negative and positive space, all those things. But I'm mainly concerned with what they express and how they move that expression so that the viewer can see it.

Q: Let's go back to school for a moment. How long did you go to school in Venezuela?

LEON: Until the sixth grade and then I went to Canada for the seventh grade. I didn't speak a word of English or French: I had a great ball. In Montreal, the boarding school closed so I went to its parent school, which was in Albany, New York. I was there until I graduated. Then I went to the College of New Rochelle in New York, then to the school of the Boston Museum of Fine Arts, and then the Pacific Northwest College of Art here in Portland.

Q: Did you have much art in high school?

LEON: No. It was there, but I never took it because I always did it on the side. I did it every day. I never felt that I needed to go to school for it.

Q: And then college. Did you have art there?

LEON: Yes. In fact, my major then was art. Painting mostly. Even though I never took much art in high school, I took one class. The teacher

decided that she would try to get me to the school that she had gone to. And she always encouraged me through the years even though she knew of me by the school contest and my work. So she was always very encouraging and that's how I got to the College of New Rochelle. But the College was very strict, and I didn't feel like I was getting what I wanted. I had this search, this quest for something that was going to teach me whatever it was that I didn't know. That was not the right environment for it. So I went to the Museum School in Boston. I was very close to graduating and felt that I hadn't achieved my quest yet, that I hadn't gotten what I wanted and that they weren't going to give it to me. And I needed to go to maybe a little place somewhere. That maybe because it was little it would have the answers that I wanted. So I came to Portland, Oregon. I was enchanted by the scenery here.

Q: You still did not get what you were looking for at the Museum School in Boston?

LEON: Right. I don't think I have it yet. I think maybe that's why I do art. That that's what my art is all about—to try to fulfill these questions I have inside of me. I guess I thought that people were going to give me those answers instead of me making them happen or finding them.

Q: Describe the importance of peers to you in this time after high school and early college.

LEON: I don't think I had any. I didn't have friends in school in Boston. In the College of New Rochelle, nobody made that much of an impression on me. I was after my art. Then here, I guess, is where more people were around. I'm not sure what you mean by peers other than artists. I mean, there are artists all over the place, and I'm mostly in my studio. That's what happened to me, I'm mostly just working.

Q: Who were your role models during this period of time?

LEON: Well, I think there are three artists that I have very much appreciated. And luckily enough, I had known since a very early age. And those were Picasso, Magritte, and Matisse. I think that forever they'll be there for me.

Q: What qualities do you feel you needed most during this period?

LEON: Just to keep my eyes open. To be able to see. To really see things around me and to be able to do.

Q: What materials were you working with during this period?

LEON: In school I worked with whatever materials we needed to be working with and whatever class materials we were allowed to use. At the same time I was working on my sculpture, which was wood and steel and cheesecloths wrapped around the steel and the wood.

Q: How would you describe your relationship to the materials?

LEON: Oh, it's fascinating. That's why I do it. My hands just need to feel it. And do it over and over, and experiment and explore and push it and beat it and paint it and take it off and manipulate it.

Q: Do you think your training during this post-high school period adequately prepared you for a career as an artist?

LEON: I have a little bit of conflict in answer to that question because I've been training myself since I was so little. School was just something that you had to go through, but I had been doing my own training. Let's say I was in high school and I wanted to do some printing. There wasn't any way for me to get anybody to teach me about the printing; so I would get books, teach myself, and do it. I had been doing that all myself from very early. So I don't think the school itself did it or was enough or was sufficient. It's what I have done for me.

Q: What would you say school did give you?

LEON: It gave me a knowledge of what was out there. It opened my views a little bit more. It introduced me to new materials that I might have not discovered on my own. It gave me ways of working that other people had, introduced me to people and institutions. And the other side of being an artist.

Q: Did you give yourself certain benchmarks for achievement when you started?

LEON: [*Laughs*] Yes, of course. I had to be famous in ten years, or at least famous for myself. To have accomplished something for myself.

Q: And have those changed?

LEON: No. I mean, once you fulfill a quest, three million other quests surface. So you have to fulfill those before you can go on. And you just keep on going. So it doesn't really change; it just grows and grows.

Q: What were the first organizations you joined as an artist?

LEON: I'm not sure I have any organizations. The only thing that I am presently involved with is an ethnic group trying to promote the arts. It's very new. They have only had a few meetings, and I haven't been able to attend any yet. But I do communicate through other people to them.

Q: Describe the period in which you first achieved professional recognition as an artist.

LEON: Oh, boy. I don't know whether I have achieved that yet. I know that there are people out there who know about me and who seem to appreciate what I do, but I don't know if there is . . . that acknowledgement of, "This is Margarita Leon—da-da!"

Q: When were you first accepted into a gallery?

LEON: I never tried for a gallery. When I was in New York or in Boston, I had somebody from Sotheby's invite me to New York to talk to me about my artwork. At that time I was making plans to come here so I said, "I can't do anything; goodbye—I need to go on my quest and find out what this is all about." So I did that and then about three years ago the Pulliam Nugent Gallery opened. They were looking for artists, and they came to the studio. So things have happened. I haven't gone out there.

Q: Have you entered shows or competitions?

LEON: Yes. The Portland Biennial has purchased a piece. The museum has. And then different competitions. I have been in competitions from a long time ago, whether through school or outside. And I'm presently one of the four finalists for a commission for the Lloyd Center.

Q: How would you describe the group you rely on now as your peers?

LEON: People that are trying to do the same things that I am doing. They are trying to fulfill their quest, their ideas and going after what they want. And fighting for it tooth and nail.

Q: How have your peers influenced your career?

LEON: It's nice to have them there. It's nice to know that there are other people there that are fighting themselves. And so that you're not the only odd bird out there trying to do something. So it's just a body next to you that says, "Yeah, we're okay." We tried to form a group, actually, among four artists who were trying to promote themselves and to get out of Portland with their work. The city's very nice to live in and we would like to stay here, but we would like our work to be out, because in Portland it does not work. It was just four of us doing it, in a very serious way. In fact, we got the Oregon Arts Commission and we talked to major people to help us—to direct us and tell us what we needed and what kind of money was available for us. Our goals were to have four-people shows in museums and in galleries, as a group, mainly New York and Los Angeles.

Q: And have any of those shows materialized yet?

LEON: Not yet. This is very new. This is about a year old. And it takes a little bit of time, I think.

Q: How would you describe your occupation? And is this different from your career?

LEON: No, it's not different from my career. In fact, it's not different from what my life is. My life is this which I do from the moment I get up to the moment I go to bed. My husband is in the studio doing the same thing, and my kids are there. So it's a family affair.

Q: What word do you use when you're filling out a census form for your occupation or career?

LEON: Fine artist.

Q: Describe your general job history, from the time you began your career until now.

LEON: Teaching art classes. I have invented my own school so that I didn't have to answer to anybody and have the time to work in the studio. The school is primarily for kids from 3½ up. We teach individuality and creativity. We teach a maximum four kids at a time. And we try to have them all different ages so that they are all doing different things at the same time. We throw things at them. They're in the studio so that they see what we're doing and the process that art takes. I believe that outside people have this thought that when an "artist" does something it flows out of their fingertips. It's there; it materializes. And that is definitely not true. There is a lot of pain, a lot of effort, and a lot of frustration, as well as happiness and fulfillment and all of those other things. But it doesn't flow out of their fingertips. And kids need to see that so that they are able to do it themselves and get what they really want out of what they're doing. It's very easy to get frustrated in art. When your head says, "This line should be this way," and your hand does not do it, one can get very discouraged. And that's what we try to teach the kids. That if you can stick it out, you can see what you can do for yourself. Your imagination is your power. If you have it, you can get anywhere that you want to go. It's up to you. It's not up to the teacher. I'm only there to give you techniques and show you how to do it so that you can do it for yourself only. We have a major show for the kids every year at a gallery, for which their work is framed, put on pedestals and treated like artists' work. The invitations are like artists' invitations. And their show is out for a whole month. If they want to, their work is also for sale. I think our lowest price is $120 for anything. So that they feel that it's not the work that is saying that they are artists, but also that the price speaks for it. They have been in radio talk shows, TV, and newspaper about their art, as artists. We also are invited every year to do different shows at buildings. And they are treated the same way. Once in a while we have group classes and that's when we invite a specific artist who has a different discipline than we have. Or it might be the same kind of discipline. It might be somebody working in sculpture, but differently than I do, so that they can see somebody else's work and manner of working to inspire something else in them. They get hands-on experience at that time. Plus the artist brings special work that they can see and touch. They come once a week for a minimum of two hours. There are some kids that come for three hours a week. There was one that was going for four hours a week [*Laughs*]. She was coming two

different days. We don't have sessions. We don't start in September and end in November, for example. We start and they go until they have had enough. We have found out that there are kids that come because their parents feel they should come. And those we politely say, "Thank you very much." We're very serious about what we do. Extremely serious. And therefore we demand that seriousness out of the kids and the parents. I think that there has to be a relationship with the parents too. So the kids need to want to do this for themselves. Forget the parents. It has to be them and it has to be a voice within them that drives them through and is able to do the things that they want.

Q: Do you see any patterns or progressions over time in the relationship between your teaching and your own artwork?

LEON: Having kids around all the time gives you a very fresh outlook because you're forced to see things the way they do. And to me that's what every artist wants, to be able to see things afresh all the time. So I have that. I have this fresh look that they provide me with. And whenever I get too hard in the way I am looking at my work, they are able to put it upside down for me so I can see it again. They are able to criticize my work and tell me what I'm doing right or what I'm doing wrong. And I value their opinion.

Q: Describe the gatekeepers at various stages in your career—those who let you in or those who barred the way.

LEON: I think that the first gatekeepers I ever had were my parents. And those definitely let me in. If it wasn't for them, I don't think I would have been what I am today. Their encouragement and their go-for-it—it's odd, it's weird, but if that's what you want to do, go for it. They were there to help monetarily, morally, and psychologically. When I was ready to give up and throw in the towel, they were able to say, "What is it that you want?" So I was able to look at it and say "Yes, this is it." Other than that, I think, Mark Bronowski, who is also my husband, for his support and his "Don't give up; keep on fighting" and throwing new ideas at me. I think somebody who donated some money to the school so I could continue to go. I won a scholarship for my last year at Pacific Northwest College of Art (PNCA), without which I wouldn't have been able to finish.

Q: How long ago did you graduate from PNCA?

LEON: 1985.

Q: Were there any people that hindered your progress?

LEON: I don't know. I'm pretty resilient. And I'm very much able to shut out whatever I don't think is being good for me.

Q: What would you describe as the major turning points in your career up to this point?

LEON: Probably being in a gallery, just because that has opened me up to people or has opened up my work to people. People have realized that my work is out there. The museum buying a piece gives you a notch. If I get this commission for the Lloyd Center, I'll get another notch. The quality of people who buy the artwork. Curators. Mary Jane Jacobs came to our studio and had great things to say, that gives you a hundred notches. Those things.

Q: Have there been discrepancies between your career aspirations and your actual career path?

LEON: Well, you always want more than what you get if you're fighting for something. You just want to move faster. And you get a little frustrated because you're not able to make it move faster, whether it's monetarily or distance. Physical distance. I'm thinking of New York.

Q: What has been your relationship to money throughout your career?

LEON: Very little. Non-existent. My money goes to my materials primarily. We do feed ourselves a little bit. But it's getting better as more people buy the work and as the school grows. But money's something out there. One of the things I would like to be able to do is to sell my work so I can have the money to make work. It's a vicious circle. It doesn't stop.

Q: How have the costs of supporting your artwork changed over time?

LEON: It's very hard. Materials are very expensive. Having the studio is very expensive. It just has grown. It's like a monster that eats everything that you give it.

Q: Have the costs of materials affected your choice of materials for the artwork you make?

LEON: I like to say no and yes at the same time. I know that's a contradiction, but I think that sometimes it has and sometimes it hasn't. Sometimes you just stand on your head and you close your eyes and you go ahead and do it, and sometimes you know better and you just know you have to wait a little bit.

Q: What has been the importance of physical location and workspace at different stages of your career?

LEON: It is nice to be able to do it from Portland. Since my husband is a painter and is going out for the same things that I'm going out for, it would have been better career-wise if we could have been closer to New York or Los Angeles. Just because they tend to go for people who live in the proximity rather than people that are far away.

Q: Why is that?

LEON: Work accessibility. Just being able to contact the person right away and being able to see the work right away and things like that. Other than that, I would think it was a pride of having people be from where

they are, or trying to help only those people that live in that city. I think all cities have that. Those are some of the things that would have helped us. At the same time, I don't think we could have had the studio and the space that we have anyplace else. So that's a price for Portland. Now, Portland's art market and art growth is very, very low. It's getting there, but it'll get there in the next hundred years. And I think that's because most people say, "This is Portland, this is what happens in Portland, that's that." I think that we're starting to fight and say, "Well listen, I'm here and I don't like it." And so we're trying to instigate other people to say, "Yeah!" and fight for it too.

Q: What kind of control do you think you exert over your own destiny as an artist?

LEON: I think it's very much divided into luck, who you know, and how well you do your art. And the amount of persistence that you have. Unfortunately, it's not your work by itself. As everything in life, it's who talks about you to whom, what they think and what they do with that information. And the other is this luck about being at the right place at the right time. Those things are not predictable, and those things you can't choose. It's just there or it isn't. I feel I have been tremendously lucky.

Q: How have you interacted with the public over the span of your career?

LEON: One of the most stimulating things for me is to hear what people have to say about my work because my work is about people, their feelings and their emotions. I feed on what they have to say and what they think. I like to be around when people are looking at my work. Sometimes I like to be there as a mouse just listening because it is nervewracking. Other times I feel like I have to go out there and introduce myself and talk to the people. I'm always available. When people have something to say I always encourage them to either come to the studio or to talk to me some more. I like to be very open and accessible.

Q: What are your own criteria for success as an artist?

LEON: That you do excellent work. That you're persistent. And that you don't give up. You go for it. Whatever it takes, you do.

Q: How do you know when your work is successful?

LEON: When it tells you. I know that sounds odd, but a piece of work is finished and it looks right when it is. There is no measurement for that. It's visual and you see it. It's there.

Q: Are your criteria for success the same for others as for yourself?

LEON: I would think so. I would demand of any successful artist to have worked very hard to accomplish what he wants, what he wants his art to do, whether I appreciate his art or not.

Q: Do you have a number of central ideas you keep working on throughout your work?

LEON: Yes. Humanity. People as individuals who have feelings and thoughts. How they express those feelings and thoughts through body language and how they act next to other people, that relationship of two bodies together. What I like the best about my art is when I'm doing it. After it's done, it's done. And it has no other value to me other than what that has motivated for me to do. It pushes me into new work. Therefore it's good while I'm doing it. So it changes from one work to the next.

Q: What are your feelings about critical review of your work?

LEON: People have been very kind to my work. They have had lots of good things to say. Sometimes I wish that they would do a criticism and not just a reaction of their feelings. Artistic review. Artistic thoughts. What it does. What it doesn't do. What they think is wrong with it; what they think is good with it. A criticism is positive and negative at the same time.

Q: How satisfied are you with your career as an artist?

LEON: I think that I have done my best, that I can always do better, and that I'll keep on improving myself and fighting.

Q: What have been the major frustrations in your professional development?

LEON: Not being able to have eighty-hour-long days. All the money that I need for my materials and what it takes for me to do my artwork. And not being close to the major cities that I need to be close to.

Q: What would you describe as the greatest satisfactions in your career?

LEON: When I see a piece that has given me a lot of trouble and then it finally all of a sudden surprises me.

Q: What has been the greatest disappointment?

LEON: When it doesn't work. [*Laughs*] So far I don't think I have had very many disappointments. Everything has been just part of something else that I can eventually turn around and make positive.

Q: What has been the effect of the marketplace on your work?

LEON: People buy my art a lot. I feel that Portland prices are below any other prices in the rest of the art world, and that needs to change. Even though Portland is little and you can have your big studio, you also need to think about what else this artist needs to succeed, and not just say, "It's Portland, therefore we pay little prices in Portland." It doesn't work. If Portland or Oregon wants to keep their artists, they are going to need to acknowledge that artists are people too, that they have families, that they need to clothe themselves, eat, have health insurance, be able to help themselves to become bigger and better.

Q: How has your relationship to materials changed from your early beginnings to now?

LEON: Well, if I find new materials I incorporate them with the old ones. There's always a shuffle. I mean, sometimes two things work better than three and, you know, you choose—it's always visual and tactile.

Q: Have you added a great many new materials? Some you've worked with all the way through.

LEON: Right. Wood, paint, cloth, gold leaf. And then ceramics. Clay. I don't want to call it ceramics; I want to call it clay. As a material, not as a train of thought. At the moment I'm playing with the idea of bronze, bronze casting, cast in resin. Just because it would allow me to do certain things that are not appropriate for me to do with the materials I have. I don't want the materials to stop me from doing what I want, I want them to help me. The idea dictates the material. The idea might say that I need something that moves through, that has certain qualities, and then I would have to go and search for what materials will provide me with those qualities. In fact, when I was a painter and a photographer, one of the things that I liked about what I did was the physicality of it. The photographer having to climb trees, having to do crazy things to get the shots that I wanted. And the painter, by painting huge canvases, that I had to get up physically on ladders and run around. When it stopped being that physical or that interesting for me I think was one of the things that made me focus more into sculpture, that being able to hug it, to beat it up, to change it, with power, with muscles, with sweat.

Q: How have your absolute basic requirements for being able to do your work changed?

LEON: I don't think they have changed. I think they just grow as I grow as an artist and as a person. I have always demanded the best that I could give. Whatever it took, that's what I had to do. Whether I was drawing on a two-by-two-inch piece of paper or making huge sculpture. It was whether it worked, it didn't work, and what I had to do to make it successful for me.

Q: What one major point would you make to young artists about a career in the arts?

LEON: Think about it carefully. Make sure that you have the desire to go through all the parts that you need to go through. That you're strong enough to go through it. That it's a need within your soul, not just in your mind or in your hands. If you're a pianist and you know all the keys, but you don't have that extra sensitivity, you'll never be a great pianist. Same with art. It's not how well you do the things, but how does your soul interact with how well you do things.

Representative collections include: Private: Steve Kline, Michael and Alice Powell, Dave and Marilyn Zyen, William Jamison; Corporate: L. grafix; Public: Oregon Art Institute (Portland, OR), Lloyd Center (Portland, OR).

Professional affiliations: Founding member of ethnic artists group in Portland, Oregon.

Honors: Oregon Biennial Purchase Award, 1989; Sculpture Award, Pacific Northwest College of Art, 1985; Sculpture Grant, Pacific Northwest College of Art, 1984; Tri-City Painting Competition, second prize (Albany, NY), 1974.

STEVEN MASLACH

B. San Francisco, California, 1950. Attended California College of Arts and Crafts (1969–70), studied with Marvin Lipofsky and Sam Herman. Founded Maslach Art Glass, 1971. Lives in Marin County, and works in Greenbrae, California. Exhibits internationally.

Q: Would you describe your family and early childhood?

MASLACH: I was born in San Francisco but grew up in Berkeley, California. My parents were educators. My father was at the University of California in engineering. I would say that I came from an academic background. I've got a brother and a sister, both older. My sister is now a professor of psychology at Cal, so she stayed pretty close. My brother, after graduating from Harvard, worked with me briefly, and now he's making glass but in a very different way.

Q: What were your initial experiences with art?

MASLACH: Well, this was back in the 1960s. It was caught up in a need for personal expression. I started painting early on. That is, in junior high and high school, I'd paint all night long—paint in oil, listening to the radio and . . . I had an influential teacher, Rolph Penn, at Lick-Wilmerding High School in San Francisco. I realized I wanted to be in the arts. As I say, my father was an engineer, and what I'm finding now is that I've applied a lot of that understanding of the physical and how to do things, how to put things together. That's vitally important in my work.

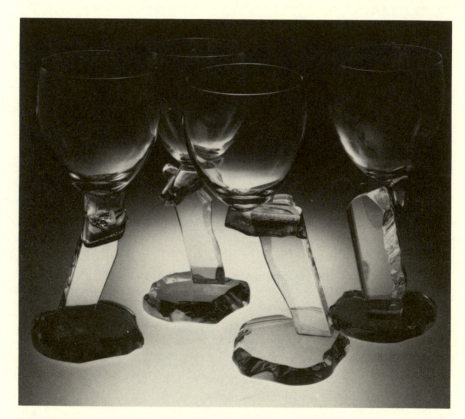

"Two Persons Joined" (dichroic goblets) by Steven Maslach, 1988.

Q: How did the members of your family feel about your talents?

MASLACH: I was the black sheep. I was the youngest, and my sister went to Radcliffe; my brother went to Harvard. It was this very academic family, in an academic community. I was playing rock and roll drums, shooting pool, and painting, and not doing the things I was supposed to do. In fact, I was put into the college track in high school but only wanted to take shop courses. And I won out, I guess. I did well in those things that interested me, but at the time, I had no use for math, for example, and did horribly. But I loved English, drama, and music. Fairly quickly, I started directing. In fact, I had a role in a few of the high school productions, but mainly coming out of school, I knew that I wanted to be in the arts. That was the clearest light, and it turned out to be very accurate. It was really in art school that I gravitated toward three-dimensional work. So it took a lot of fooling around to realize what I wanted to do.

Q: Were there any particular educational experiences up through high school, that gave you particular validation for your art?

MASLACH: I never drew that well; though I liked what I did with color. I don't think I received any particular kind of recognition or encouragement through high school anyway.

Q: Any particular resistances?

MASLACH: Yes. I think, in fact, that may be why I persisted. I was supposed to be a very bright kid. I was supposed to be into math and science instead of rock and roll and metal lathes. I think the relationship I had with my father was not good. I didn't feel he particularly discouraged me, but I don't think he took much notice.

Q: When did you become an artist?

MASLACH: Well, isn't it funny? I ask myself if I'm an artist now. "Are you an artist?" is something that one grapples with all the time. What I knew is that I wanted to become an artist. And I feel very strongly that it's the process of becoming, the exploration, the journey, not the destination. So I think of myself now as a glassblower, or a welder, or even a businessman. And there are those moments when I feel very creative, and I say, "Yes, I am an artist." And I knew I wanted to become an artist in high school. I work sculpturally, in abstract forms. I find myself very much wishing to create a response to color and form, and I know from my emotional response when I've achieved it. But deciding and setting how to set out on the process of achieving it and to specifically put down what will bring about that same response in other people is a very slippery thing. I think it's necessary first to make connection with yourself and your responses—to know how to create

those forms, images, colors, experience—that are motivating and central before you really have anything to offer anyone else. So it's taken some time. What's curious about the creative process—at least for me—is that it's by and large a difficult thing. It's like trying to walk through plastic. There's something holding you back; there's something you can't see through, you can't get through. And then there's a tear; there's a rip, and something is revealed that works, that's right. But it's momentary. It's subtle; it's transient; it doesn't last. And it's elusive. I know that of my work if I do twenty-five pieces, there's no more than, say, two that really, really have the essence.

Q: Let's go back to the education and the training for a moment. What happened after high school?

MASLACH: After high school, I needed to move out from my parents'. And so, at seventeen I moved out and went to work. You know, I'm skipping something really important. When I was fifteen, my father was due for sabbatical, and I guess I was a somewhat difficult teenager. They decided if they were going on sabbatical and traveling in Europe, it was better if I also travel or go somewhere else rather than stay in Berkeley. On the other hand, they knew that I would not travel with them and stay with them. They allowed me to hitchhike throughout Europe for six months. I was fifteen when I left; I turned sixteen. I had certain contact points in Europe that I was to stop and call or go to the American Express. For part of the time, I traveled with a friend of the family, a girl a few years older than me. But I hitchhiked around, I took a house in Ibiza, an island off of the coast of Spain, off Majorca. I hitchhiked up to Sweden, met friends, played the drums. I went all around. I came back to see my brother at Harvard, then hitchhiked across the United States, and returned to high school, and graduated from the public school, Berkeley High. There were times when I was hitchhiking that I didn't know if I'd go back. I guess I could have been one of those people that just sort of takes off. But I did go back to high school, and it was at that point actually I got very interested in drama and art. But I felt that I'd seen a bigger look, I'd had a bigger taste and some things came into focus. I realized that there were some responsibilities. I had to graduate from high school. I had to play my cards right.

Q: Did you see much art?

MASLACH: Not in particular. And yet, there's a small island off Ibiza, called Formentera that was an artist's colony and had been for years. In fact, during the Spanish Civil War, many of the socialists were driven out to the island. And there was a strong international art community there. It somewhat opened my eyes.

Q: Did you have one or two years left when you came back?

MASLACH: I had just six months, that is, I had a year, but I was able to graduate early. I had just enough credit. And after leaving high school, moving out and working, a teacher from the California College of Arts and Crafts (CCAC) in Oakland had come to visit the high school on a career day sort of thing. And I realized that this would be a very good school to go to. In fact, I went there when my Vietnam deferment was such that I had to make a decision to go to Canada, go to war, or go to school. So I went to school.

Q: Do you think you would have made the same decision if Vietnam hadn't been part of the equation?

MASLACH: I think I probably would have since I was moving refrigerators and driving a truck, and it only went so far. It just paid bills, you know.

Q: How did your parents feel about your going to CCAC?

MASLACH: I think they were pleased. I think they felt I was doing something legitimate. My brother had been a conscientious objector and did alternative service while he was at Harvard. And I actually knew I was not going to war. I knew that. I think they were accepting of the fact that I was headstrong and I was going to go my way. I don't think they had any belief that I had any particular talent but I think they knew I had the inclination.

Q: When did you begin to specialize in your current art form, in glass?

MASLACH: I was painting on acrylic. I was trying to experiment with transparent color. I had also started casting resin, and I was interested in three-dimensional form. Everything was very crude. But I was experimenting baking resin in the oven, so it would crack and fracture. And I was very fascinated with color, brilliant color, if it could be achieved. I even started playing around with polaroid light and the generation of pure colors. And now, twenty years later, it's exactly what I'm doing. Though, at the time, baking resin leads to poisonous gasses and terrific headaches, and I stopped dabbling and started working directly in glass when I saw Marvin Lipofsky's work.

Q: Did you study with him?

MASLACH: Glass was reserved for the upperclassmen. In my first semester, I don't think I was aware of glass at all. But there was a day when I saw someone blowing glass, and I knew that's what I was going to do. There was never a doubt. So I just started cutting my classes, and hanging out and waiting. And if someone didn't show up for their time, I would dabble, and I became such a nuisance that finally I was allowed into the class. And not at Lipofsky's say-so, but the teaching instructor,

Ruth Tamura, who, with her oriental patience—she's Hawaiian-Japanese—and her good nature, encouraged me in glass. And that made a great difference.

Q: You've mentioned as people who are important in your formative years at this stage Rolph Penn and Ruth Tamura. How did they serve you as role models or as mentors?

MASLACH: Let's see, Rolph Penn, was a man . . . just very much involved with vision. He had an almost businesslike approach to the creation of work. It seemed so organized. It seemed so matter of fact and acceptable. It was clearly a wonderful thing to do. It was the first time I felt that it was really worthwhile, that it wasn't screwing around. It was a legitimate thing to do. And I think that validation . . . of the arts, I think that's what I got from Rolph Penn. He was a very strong man, and so even though I was still being difficult about things, I think that didn't phase him at all. I think he was a very responsible teacher because he could encourage lots of different people. There were other people that could draw wonderfully right away; I was not one of those.

Now, Ruth, as I say, I think she lent me her patience. Marvin's primary focus was at the University of California, where he was also teaching, and we were the poor cousins at College of Arts and Crafts. At this time, I had taken all these shop courses. In fact, at Lick-Wilmerding, the high school I went to in San Francisco for two years, it was required to take shop courses. So I had learned how to weld; I'd gone through all of that. It's funny that you don't always know what you're going to need later, but it turns out I was doing exactly the right thing all along. I see that now; I had no idea then.

Q: What qualities did you feel you needed most during this period of time?

MASLACH: Well, I had to work very hard on those areas in which I was weak. There is another instructor, a man named Jacques Fabert, a painter, who gave a drawing course that was very difficult for me. But drawing for Jacques Fabert included much more than the ability to see and put down on paper what you see. Much, much more than that. In fact, drawing for Jacques Fabert was the experience and the valuation of life and concept and getting that into the work. It was a very, very big thing; and it was very difficult for me. I had to work very hard at it, but I stuck it out and got a lot from that course as well. And of course, starting to work at glass, I loved it. I loved to blow glass. It was never difficult. If there was space, if the oven was not full of glass, I'd work all night long.

Q: How would you describe your relationship to your materials, to glass?

MASLACH: Well, glass, at the time, was a very new material for crafts-people. Molten glass was not available. To design an object and sit down and work and make it oneself, fashion it oneself, was a very unusual thing. Typically, glass is designed by a designer, and then created by a worker, or an artisan. And there's a great separation and distinction between the two. This is the European tradition. The American glass movement, as it's called, studio glass movement, which dates to 1963, is significant in that the designer and the artisan became the same person. So when I got into glass in 1969 I was the third generation. First was Dominick Labino and Harvey Littleton. Littleton's student was Marvin Lipofsky. I was Marvin Lipofsky's student. Also the glass was terrible to work with, very difficult. We didn't know that then, but the physical glass—the formula, its chemical composition—made blowing glass and forming it very difficult. So it was a great struggle, a great challenge. We would sit in front of furnaces absolutely burning ourselves and working for hours, just to fashion the simplest sculptural form or vase form or bowl. The material that I've designed and work with now is so pliable. It's so encouraging, compared to that stiff, hot, awful stuff that we made.

Q: Do you think your training during this period adequately prepared you for a career as an artist?

MASLACH: Oh, absolutely not. Terribly, tragically, horribly not. In fact, I only stayed in the program for two years. And I did not graduate from Arts and Crafts because after two years I really learned all there was to know—all there was available from Marvin Lipofsky and the glass class. I felt very strongly that school was the place to learn about how to make glasses, how to make furnaces, how to do this and that. I went out in the world, and I knew nothing, had none of that background. The response I got, when I presented this point of view was that this is not a trade school; this is an art school. We deal in ideas; we deal in forms. We don't deal in the mechanics of the thing. I thought that was totally backwards. Well, things have changed a lot, and now there is excellent technical information available to students. But I still believe that in most of the art schools, the emphasis is on one's artistic dialogue, on one's artistic statement. I mean, my God, you get college students that are so concerned about what it is they're trying to do and say before they know the first thing about the materials, before they've experienced much of themselves or life. And frankly, I remember how I was so burning with all sorts of desires in those days, so I'm not saying that you should strap yourself into some technical program and master that first. But I am saying that one's artistic vocabulary, one's dialogue, is

continual, it starts early, and it's neverending. And I don't think there should be the emphasis on that. There's got to be a place where you can get the benefit of practical knowledge without having to pay for it all yourself later, which is exactly what I did.

Q: When you got out, did you give yourself certain benchmarks for achievement?

MASLACH: Well, I had intended that I would work as a sculptor in glass. I had intended that I could make my living doing that. And I was sadly mistaken. In those years, the early 1970s, and for what I had to offer, I tried to establish a studio; I learned very quickly that I had to make a product to support myself, to support my studio. If I had desires to be a sculptor or an artist, it would be later. I was totally unprepared as I came out. But I very quickly realized that I had to start making things. And one of the objects I settled into were functional objects like stemware. I started making ridiculously clunky, thick, unmanageably, painfully cumbersome objects. But they were so new and so unusual to people that I actually found myself selling some things. And as I say, I was able to establish my studio, after much, much pain.

Q: What were the first organizations you joined as an artist?

MASLACH: Well, one of the early organizations was the Glass Art Society, the national glass artists' association. Back in the old days, it was directed toward hot glass blowers, of which I was one. It has evolved into involving many different people in the glass community—collectors, gallery owners, cold glass workers, warm glass workers—that's slump and fuse, as well as the blowers. I got involved in that organization fairly early. I became active in it, getting up to the board of directors. I did involve myself and served on a panel or two, I think the first one in 1978 at Madison. In fact, I may have already joined the American Crafts Council (ACC), that definitely is another organization. And I guess the third is a small, local glass blowers organization called Bay Area Studio Art Glass (BASAG). And it's an association of the eighteen or so studios in the Bay Area. We don't meet all that often or accomplish all that much. But it is a vehicle by which the glass studios in the Bay Area get together. This group appears to have limited itself to the hot glass studios in the Bay Area. In fact, there's another one that has helped. I served on the editorial advisory board of *The Crafts Report*, which is one of the trade newspapers of this community. I started doing the American Craft Enterprise (ACE) shows in, I believe, 1981.

Q: When did you become active in the infrastructure of ACE or ACC or both?

MASLACH: Well, I became active in that about four years ago. About four years ago I came on the board. It's been satisfying in that I feel that I'm giving input, giving support, and giving form to an organization that has a lot to do with my life. I make my living by and large here. My friends are here at the ACE events. It's been satisfying in that regard. However, my experience now is fairly long in the arts and volunteering in the arts. Volunteer organizations in the arts have got to be one of the most maddening, frustrating, draining activities that one can expose oneself to.

Q: Describe the period in which you first achieved professional recognition as an artist.

MASLACH: I established my studio in 1971. I would say that there was approximately five years of real hell getting started. I think the first show that I was accepted to, of stature, was the California Design Show in 1976. Soon after that my work was selected for the Crafts in the White House event, from which my glass was used by the Carters, I believe, or the Mondales. It was a wonderful story how it happened. They contacted a number of craftspeople, without telling them where the work was to be sent. And I was very much against just sending work off to someone not knowing. And so, I wasn't very cooperative, until they called me one day, and said, "Well just send that box we told you to pack up, just send it to 1600 Pennsylvania Ave." [*Laughter*] I hurriedly removed the seconds that I'd packed up and put in the best work. In any event, it took that period of time before I began to feel that I'd gotten past my apprenticeship and into my profession.

Q: What is the group that you would now describe as your peers?

MASLACH: Currently, I feel at this stage of my career, I feel that I am on the threshold of passing out of the ACE community. I no longer show much of my functional work. I'm concentrating on my sculptural pieces, my unique pieces. I'm starting to take some commissions. That sort of takes me out of the realm of the ACE show. There's a number of us that are sort of at that level where our careers are maturing. We are onto something else, and we're not quite sure what. But it's those people at that level that are the veterans of ACE, that have been on the glass scene for some time—different people, different media. I'm on the board of ACE with several of them, and those are the people I feel are my peers. I mean, all of us have a certain stature in our particular media. All of us have been considered to be near the top for some time.

Q: How have your peers, this group, influenced your career?

MASLACH: I've been encouraged to get beyond the making of utilitarian glass, which I did for many years. I should explain that at the time when

I established my studio, I went deeply into debt and had some
disasters, like a flood, for example. I'm right on the shores of San
Francisco Bay and have been flooded a couple of times, but very badly
in 1973. After getting through all of that, I didn't really have a vehicle
to sell my work and make a living. What I decided to do was take a
manufacturer's representative. It was really the only thing to do. That
representative took my work to gift shows. This greatly influenced the
pieces that I was making. I was making articles that had to be within
a price range, within a function, and within a color. I was pretty much
at the mercy of my representative, who would tell me, "Well, this is
the lavender year." I would promptly run out and start making some
little lavender doodad, you know. I was able to survive like this but
not fully. I was surviving, but I wasn't really thriving. It was not giving
any growth to my creative side. So the influence first of ACE, which
allowed me to sell the work myself directly to a group of interested,
supportive, and sympathetic buyers, to a sympathetic community, and
to be exposed to people in my media and others that were grappling
with the same problems that dealt more with their personal motiva-
tions rather than their financial requirements, became a great influence
for me.

Q: How would you describe your occupation? And is this different from
your career?

MASLACH: I've gone through a number of evolutions, or simultaneous
progressions to the point where I am now a small businessman that hires
twelve people. But I am a small businessman that endeavors to also be
a designer and to be a gallery artist. And I see these things as being very
different, and I sort of break them out. I believe that designing, at this
point, and managing the business at this point, is an occupation. And
that artist, those periods of time in which I'm truly creative, is my career.
I know that I could stop managing my small business and continue on
as an artist. I didn't know that until recently. But I know that now.

Q: What particular patterns or progressions do you see over time through-
out your job history?

MASLACH: What I felt was necessary for me to do has changed quite a
bit. I would say, for the first five years, I really felt like I was an
apprentice with no master. I felt that there wasn't someone to teach me
and that I had to do a lot of learning. And I did go the long way around
on some things. Nowadays, some people go to Sweden to a factory
school, or they go to Murano and work in a factory, or study with a
master, or they work for someone like myself. I did not have this
opportunity. But I'd say in that first period of time, I learned all I could,

and I worked very hard on hot glass blowing all the time. After that initial five years, I started having some success, running my studio. By this time, I was hiring several people. And then it became necessary to learn how to manage people and make a living. I think in the period from about 1976–79, I started shifting more to business. A very important event occurred in 1979. It was the New Glass Show, sponsored by Corning. There was a show in 1959, and this was to be the survey twenty years later. It was going to be Glass '79, sort of a survey of things that were going on. Well, it changed. It became New Glass; they wanted to see what was new in glass. I had a production studio at this point and was making these utilitarian designs, some of which were very nice, but it wasn't all I could do. I was rejected; I was rejected from Glass '79. And I really hadn't done anything else for it besides my normal production designs. I was devastated. This was the first time I was left out of the glass community. And I realized that in the last two or three years I'd been working with glass directly less and less, and I was getting more and more miserable. That was a very valuable lesson for me to learn. I had that requirement that I work directly in the glass, and I thought it wasn't there, and I was very mistaken. And so now, central to my happiness is a certain amount of time in the glass. And it's interesting, because I see around me people whose job evolved from on a bench to behind a desk. They're different from me. But I feel like I'm a better business manager at this time and certainly a better personnel manager. I've learned a lot about myself and people, but my job has changed. Now, a lot of my job is the job of being an artist and being creative.

Q: Describe the gatekeepers at various stages in your career—those who let you in or those who barred the way for you.

MASLACH: Ruth Tamura certainly let me in the door by letting me in the glass class. It was really her decision, and she didn't let Marvin overrule her. I'll be eternally grateful for that. Marvin exposed me to a lot of things but at some points closed some doors. Dick Marquis is a guy, Richard Macus, well-known glass blower, who rented my studio to teach a glass blowing course in 1973 for the University of California Extension. And that went well; I was able to sort of attend just by the fact that it was mine. But he did something very nice. He let me take over and teach it the following year. And I was very glad of that. I think I realized I wasn't interested in teaching, or at least not at that time. I think I'm a very different person now. But that was encouraging. And from there, my representative, Jay Gustin (a wonderful man, he died recently). He got me to the point where I could support myself making

glass. After that, I'd have to say Carol Sedestrom Ross, who is the main force behind ACE and has been for years. It was her effort to create a situation in which craftspeople could sell their work and support themselves that made it possible for me to get to the next level. So those are several people that have helped greatly.

Q: What are the discrepancies between your original career aspirations and your actual career opportunities?

MASLACH: Well, I always intended that I would be a glass sculptor. I was so naive. You know, I realize now that there are few sculptors that make their living at their art, very few. It's come all this long way around. But one thing I did, and I am glad I did, I paid my dues as a glass blower. I learned so much about glass, but I learned it by the eight hours a day, every single day approach. Yes, it's a struggle, absolutely. But I find that I can visit people. For example, I visited Lino Tagliapietra, glass master in Murano, and I could walk in and understand everything he was doing and everything his assistants were doing, and he knew I could understand. We had an immediate rapport, because I am a production glass blower. That was formative for me.

Q: What would you describe as the major turning points?

MASLACH: In general, there was that first period of apprenticeship, which really, if I had the opportunity or a broader vision, I could have studied abroad or possibly worked for someone else. But I worked in my own studio to get through that time. Getting enough recognition, and then connecting with Jay Gustin, who sold enough of my work to support my studio, that ws a major turning point. The Glass '79 show, my realizing that my work was good but not creative and not fulfilling my needs, was very important.

Q: What has been your relationship to money throughout your career?

MASLACH: I believe I've learned something about money. I believe that having money is not as marvelous as not having money is terrible. In other words, the crushing weight you feel when you cannot meet your payroll, or your rent, or your gas bill, and that anxiety that you wake up with at three in the morning, you do not feel an equal elation when you have a couple extra thousand in the bank. Frankly, when you have money, you just don't notice it. It's just kind of there. The first time you get it is a little shock. Because generally, it means you have to pay tax on it. I did go through a period of time when there were some real tough points. There was a time when I was so broke I took my MasterCharge and charged a bunch of cash and gave everybody $40, because I didn't have a dime. There was a time when I was flooded. There was 2½ feet of water in my studio. And my area around the Bay was declared a

disaster area. I went to the Small Business Administration (SBA), and they were giving out 3% interest loans, and handing out money right and left. And I applied. Never heard from them. And some months later, I said, "Geez, you know, I really should be hearing sometime." They said, "Oh, well. We looked at your books. You would have gone out of business anyway. So we didn't think that you could apply for anything." Well, I lost everything. I lost everything, and I stuck it out. But I'll never forget that. I'll never forget. I will never forgive them.

Q: How has the cost of supporting your art changed over time?

MASLACH: I remember gas bills that were tiny, when I was first melting glass. Now it's a very expensive thing that I do, working in glass. It's a very expensive proposition, but there's now beginning to be an acceptance of that and an acceptance of my work. So people are willing to pay the price. I still find it shocking sometimes when I have to pay the payroll or maybe the gas bill. It's the single biggest bill I have, and it's thousands of dollars a month. It's a full-scale thing. And really, the best way to learn hot glass is to go to work for someone. There's just no way around it. Having the furnaces on for me is like a gun at my back. You've got to produce. You can't just run them and play around. You've got to make something. It's easiest for me to speak about the most recent things. The year before last, I won a design award for a goblet; and this was sponsored by the Baccarat Crystal Company, and Tattinger Champagne. My winning this award was the first really international recognition. And it coincided with the Craft Today USA show, which opened at the Louvre, or actually at the Musée des Artes and Decoratifs. And I traveled to Paris with my wife, Julia, as a guest of Baccarat and Tattinger, and went to the opening. Then we were taken to Baccarat, given the grand tour, put up in the chateau, and ended up spending three weeks traveling in France. And I really felt, when I was standing, looking at my work in the Louvre, I thought, "My God, better remember this, because this is defifnitely a peak."

The year before that, Julia and I were flown to Japan as guests of the Yamaha Corporation. I've been selling glass in Japan for eleven years through the Yamaha Glass International Glass Show. And I was selected—actually I was the only artist selected for every year of the show. It seemed that every year that I was about to be dropped, I made a major design change or a major turn in my career and was selected yet again. So I lectured in Tokyo and traveled with the show. I would have to say being selected for the Poetry of the Physical Show when the American Craft Museum opened, those are three of the recent highlights that I think were very influential.

Q: Has there been a particular time in your career where money and awards would have been particularly helpful, above and beyond the emergency funds after the flood?

MASLACH: I nearly gave up after that flood. My first wife left me. I was giving everything to my studio trying to grapple with this. I was losing money hand over fist going into debt. I was devastated. And it was sort of the final blow, when the SBA told me I was a loser and not worth a dime. You know, when everyone was getting money. My God, I was honest about everything, and everyone was showing these ridiculous losses and things. I would say that the New Glass Show at Corning, I think not getting into that, it got my attention. It threw me back in the race. I was getting complacent. I was turning into a little business. And that was the thing that slapped me in the face and made me realize that I wasn't working hard enough, and I didn't deserve to be in the show. I mean, mind you, I was a production glass blower, making goblets. And other production glass blowers making goblets got in the show. But I happened to get out. And my getting out, I think, was probably more influential than if I had gotten in. To my career, it was more of a message and more of an influence.

Q: What has been the importance of physical location and workspace at different stages?

MASLACH: When I first opened my studio, as I say, it's right on the shore of the San Francisco Bay, it's right on the wetlands, there was nothing out there but beautiful birds and mud and the bay. It's absolutely gorgeous. Now I'm surrounded by concrete and asphalt, and steel buildings, and things have changed a lot in these nineteen years. But I remember those days just going down that street, and blowing glass all day long, and it was wonderful. The San Francisco Bay Area is a wonderful place to be. Now it's so expensive that the people that work for me often have to commute. I can't possibly pay them enough to live in Marin or to buy a house in Marin. I believe it's the most expensive county in the country. I may at some point move, but at the same time I'm part of the local community. The school children come to my studio. People come by. In fact, I've supplied glass for so many weddings. But people come by and they tell me how my glasses were specified in their divorce, you know. If that's any sort of compliment, I don't know. What I'm talking about in particular now is the functional work, the stemware. My work has made it into the lives of so many people. It's often those pieces that are up on the shelf, in a special place. And they only come down once or twice a year, or when certain people arrive. They've come into the fabric of people's lives. And people have come to me with

broken bits of glass and a handkerchief with tears in their eyes, saying, "What can you do about this?" And I think about all of that, about all of those people that I've made my work for and they're going to treasure it and hand it down. It's going to go to the next generation and that I like very much. For myself, I am primarily interested in doing sculptural work now, and investigating more complicated pieces. At the same time, I do not have a value judgment over the functional work or the other work I've done, even the lumpy green stuff, any of it. And I've become aware that when I finish with it, and it enters someone else's world, my time with it is gone, but I appreciate and feel honored by the works of mine being taken into other people's lives.

Q: What kind of control do you think you exert over your destiny as an artist?

MASLACH: Well, at this point, I feel I have many more choices than before. At the same time, I am, like many other artists or craftspeople, at the whim of other forces. That is, the influence of collectors and galleries, politics, finances. By and large, I know several things that are valuable. I can make a living. I can make a good living. I have the skills to survive. I can survive without compromising my inner yearnings, my inner requirements, this is very valuable to know. It comes after many years. This doesn't come easily.

Q: In what ways have you interacted with the public over this span?

MASLACH: Well, my studio is open. I have a studio store. And people come by. I make myself available at two, or possibly three of the large ACE shows every year. I do speak occasionally, when asked, to an organization. I enjoy the fact that I have invested myself in my work. What is difficult, or a little unsatisfactory is making myself available and just getting, "Oh, you do such beautiful work, and oh, this, and oh, this, you're so wonderful, you're so talented," which is all kind of thin. It's those little moments when somebody comes by and says, "You know I was the one that called and bought 52 marbles from you that were all different. And I sent a different marble every week for a year to my lover." That's the sort of thing that really gets me going.

Q: What are your own criteria for success as an artist?

MASLACH: Success for a creative person can be a real curse. It's taken me some time to realize this. But I will make some pieces, some that are stronger than others. And I generally choose those to photograph, because I feel, well, this is a particularly significant piece. And it's generally recognized as such. And those slides, photos, whatever, are seen by other people who promptly declare that they would like one like that. And thus the immediate pressure is then that you are asked to

reproduce, or somehow work around a particular idea over and over again, that is a slight alteration of a form. There is a tremendous force immediately that comes with success to stop being creative, to become a duplicator.

Q: What criteria do you use for yourself?

MASLACH: Well, that's the point. I feel that I have to parry this force. I have to draw my line somewhere. I have to say, okay, all right, look, I've done this. I've had the idea, I like the idea; I still like it, but I've exhausted it. I've got to move on to more fruitful ground. And that's the point, moving on, to continue to move. I'm sure it's true for most creative people; it's such an enormous universe. There are so many possibilities. There will never be enough time in my lifetime. I have ideas for many, many lifetimes.

Q: How would you describe or summarize the central ideas that you keep working on?

MASLACH: What they are is a presentation and a response to the natural world. I was very strongly influenced by my father's love of the outdoors. My father was a packer and a guide in Yosemite when he was a young man. And from age one I found myself in the High Sierra. The tumbled blocks of granite, the forms of ice and water, the colors, the purity of the high mountains, all of that comes out in my work. Some of the series of my works, I even name around that. The Pressure Ridge series refers to some of the pressure formations that form when ice on water is driven up against a shore. These tumbled blocks of broken glass are really central in the work that I'm doing sculpturally now. Two particular images recently have influenced me quite a bit. One was when I visited Carrara in Italy, Carrara and Pietra Sante. From a distance, I saw this mountain covered with snow. And we were driving towards it. And I said, "God Julia, look at that, there's still snow." She said, "That's not snow, Steve." And I said, "Well, it's not a glacier, but it's shining. That is snow, I will bet you." And as we approached, we realized that that entire mountain is white marble. And as you get even closer yet to where you drive up to the quarries, which we did (we just drove straight up to the quarries because I was so elated), you see the perfectly vertical, horizontal, and geometric cuts of the wire saws that define the quarry. Then the tumbled blocks of inferior grade marble are thrown off the mountain. This image just shines in my mind.

The other is the cliffs of the Wachau. The Wachau is a valley of the Danube in Austria, which I visited with Julia's brother, a cellist in Vienna. And I saw on the cliffs up above the river, a broken castle. It was made out of the natural stone. It was unclear whether a castle was

growing out of the natural rock or dissolving back into it. It's an image that I've played with as I look at our glass, granite, and limestone office buildings and monstrous edifices of our civilization. I can see one day all of this dissolving back or growing up in the same sort of way.

Q: What are your feelings about critical review of your work?

MASLACH: I've not had a great deal of critical review of my work. I think my work is generally found to be very beautiful. And often I believe that there's sort of a sense that if work is beautiful, it is generally not profound. This is something that I've considered and have been mulling over with Julia for some time. And I should mention that my involvement with Julia, with my wife, has been very sustaining. I have an inner dialogue, and I have a dialogue with Julia. But in bouncing these ideas off of her, and of others, there is the opinion that beautiful work can be profound. But I'm not sure if I'm there yet. Maybe that's the next step. Beauty, the colors I work with, and the clarity of the glass, the pleasing forms, I'm after a response, I'm after a response in myself, a joyous response, in myself and in the people that view my work. And somehow, that doesn't leave room for the stuff that good criticism is made of. That is to say, I believe that criticism is a creative act. There's not so much that you can say about beauty, or a piece that is just right. I believe criticism often involves imagery or a particular point of view, a personal expression that is very clear and cohesive in a piece. I do not use imagery in my work, though I've considered it because I feel like I have a lot to say that I'm not currently saying in my work.

Q: How satisfied are you with your career as an artist?

MASLACH: I am satisfied with where it is, with how far I've come. But I think that if there's one thing about creative individuals, they're never satisfied totally. And it isn't that you choose to move on with it, but really that you have to. I feel, therefore, that realistically I'm glad with how far I've come; but I'm very aware that there's a lot more to do. And a lot more that I want to do. I'm compelled; it really isn't a matter of choice.

Q: What have been the major frustrations in your professional development?

MASLACH: I think the years that I spent grappling with running a business were difficult. Being left out of Glass '79 was very important, very frustrating. And now, now it's just that I feel frustrated that things move so slowly.

Q: What would you describe as your greatest satisfaction in your career?

MASLACH: I think the greatest satisfaction, occurs when myself, my assistants, and Julia, everyone is working correctly. And it often occurs

when there's a great deal of pressure and we all have to get on it; we all have to move; we all have our different things to do. It all comes together just before a show, or a deadline or something. There's a brief moment of time when we all get to stand back and say, "This did it. This is right. This got the best out of all of us. We did our best, and there it is." You can see it and feel it.

Q: What has been the effect of the marketplace on your work?

MASLACH: Happily, I live in the United States. There is a reason why the American Glass Movement could only occur here. And the reason is there is the economic opportunity for such a creative movement to occur. I've been very fortunate, I think we all have in recent years, that we have been at peace, we have been prosperous. These are good conditions. In fact, the whole crafts movement, the whole sort of inward turning of our society towards objects that matter could only occur in a society that was peaceful and prosperous.

Q: Has your relationship to your materials changed from early on until now?

MASLACH: Yes. In fact, a lot of people come to me now, and they look at my work, and they say, "How did you come up with it? Did it just happen? Did some accident happen one day? And the fact is, no. Not at all. I know what my material will do. Therefore, my excitement shifts to other realms. But in terms of the actual material, I am a master of it. I really know glass. I melt glass. I can make glass do any number of things, any color, I can make it runny and smooth, and cast well, and blow well, and shiny, and dull; I can do all of that. And that is very satisfying. I don't have to worry about it any more. I don't even think about it. See, I've always wished that I could do that with drawing. I wish I could draw so well that I could forget about drawing. And I don't. I have to work at drawing.

Q: How have your absolute basic requirements for being able to do your work changed since your early career?

MASLACH: Well, back in those days, I just wanted to eat something other than tuna fish. You know, I lived in my studio for some years. I had kind of a plastic sort of tent thing. It wasn't even a room. And it was right on a mezzanine near the furnaces. And I remember waking up in the middle of the night, thinking it was on fire. You know, the furnaces were roaring away. And I spent some really ghastly years, where literally, I ate tuna fish all the time. I'd work until I was ready to drop. I lived with my dog in my studio. Thank God, those times are gone. I guess they were necessary. I lived on $300 a month, and I was paying $95 a month for a truck. I did that for a couple of years. And I always thought, boy, if I could make a thousand dollars a month, I would just be the happiest

man on earth. And of course, you know, you keep changing that. And now, I want time more than anything else. I mean, I want to keep my house, and keep making my payments, and this and that. But I have a two-and-one-half year old son. I want to spend Saturdays and Sundays with him. I don't want to work on the weekends any more. I don't want to work past five. Or if I have to work late, I go back after my son's asleep. So money is just enough to keep going, keep everything going, and provide for my family. But not a hell of a lot beyond that. It's the time that matters.

Q: What one major point would you make to young artists about a career in crafts?

MASLACH: Interestingly enough, there seems to be a drive to define oneself so quickly, to make decisions about one's work and oneself. I always felt that I was very flexible when I was young. Particularly when I was starting off. But when I think back on it now, I was really very opinionated. And I thought I knew it all. I really did. When I was twenty-one, no one could tell me a damn thing. And I know it sounds pretty stupid now. If I was twenty-one, and someone told me this, I might not be too receptive. But my point is this—do everything. Do every possibility. Keep everything open. Keep an open slate. Don't give up to prejudices. Don't turn your back on a thing. Be passionate; always be passionate, absolutely. Don't let your passion get away from you. Whatever it is that you're passionate about, it could be women, it could be men, it could be forms, or politics, or anything. You've got to get in touch with those driving forces, stay with them to propel you through your work, whatever it is. You could be passionate about making money, I suppose. I think some people are. But I'm seeing comfort set into the craft community. Some people are taking the easy way. But I'm convinced that if you get in touch and stay in touch with yourself, not give in to fad, I think that'll always serve you well.

Representative collections include: Private: David Jacob Chodorkoff, Jack Lenor Larsen, Stanley Marcus; Corporate: Hotel Utah, thirteen chandeliers (Salt Lake City, UT), John Portman, Architect, Riverwood Building, two glass sculptures (Atlanta, GA), Northern Trust Bank, glass sculpture (Phoenix, AZ), Philip Morris Corporate Collection (New York, NY), Yamaha Corporate Collection (Tokyo, Japan); Public: American Craft Museum (New York, NY), Chrysler Museum (Norfolk, VA), Corning Museum of Glass (Corning, NY), High Museum of Art (Atlanta, GA), Oakland Museum of Art (Oakland, CA), Smithsonian Institute (Washington, DC), The White House Collection, Smithsonian Institute (Washington, DC).

Professional affiliations: American Craft Council, Board member, Bay Area Studio Art Glass, Glass Art Society.

Honors: The Denji Takeiuchi Prize, "The International Exhibition of Glass Kanazawa '90" (Kanazawa, Japan), 1990; 3rd Prize Winner, "Essence of the '90s," Perfume bottle competition by St. Louis Glass, Indol, Preface, and Bloomingdale's, 1990; Grand Prize Winner, "A Glass for Wine" goblet competition sponsored by Baccarat Crystal and Taittinger Champagne, 1988; Merit Award, "The American Crafts Awards 1987," Dichroic Bowl Fractured Series; Merit Award, "Feet of Glass," The Art Glass Alliance of Maryland, 1985; Purchase Award, "Americans in Glass," Leigh Yawkey Woodson Art Museum (Wausau, WI), 1978.

ALPHONSE MATTIA

B. Philadelphia, Pennsylvania, 1947. BFA, Dimensional Design-Furniture, Philadelphia College of Art, 1969. MFA, Industrial Design-Furniture, Rhode Island School of Design, 1973. Lives and works in Westport, Massachusetts, and teaches at the Rhode Island School of Design.

Q: How did you first get interested in artists and their work?

MATTIA: I guess for me it happened when I was in undergraduate school. Prior to that, I had not really been exposed to much in the way of art, no art programs in high school and some sort of general art programs (music and art) taught by the same nun when I was in grade school; no art exposure. As a kid, growing up in downtown Philadelphia, I was in and out of every major and minor art museum and natural history museum in the city—not to look at the work; they were free playgrounds for us. I knew the Rodin, the Museum of Fine Arts, the Natural History Museum, and the Mutter Museum of College of Physicians of Philadelphia. I knew them all more intimately than I do now because we used to spend many afternoons in them. I think I ended up in art school as an offshoot of my interest in model making. The people I worked for in high school suggested that I think about something like that. I worked at a very good quality hobby shop in Philadelphia. I mostly made car models and things like that, although I had experience with other things as well because I was selling everything from brass locomotives to plastic World War I and World War II airplanes. The people I worked for

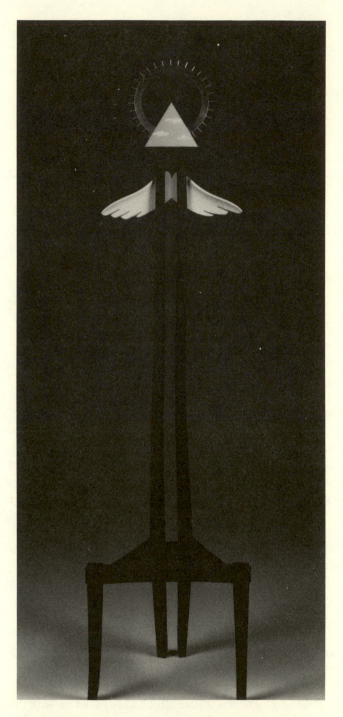

"St. John" by Alphonse Mattia (72″ x 18″ x 18″;
ebonized walnut and gold leaf and painted, curly
Maple). Photo by Powell Photography.

were pretty interesting. In fact, the owner of the store was in the process of taking over a plastic model airplane company, a British company, that specialized in manufacturing World War I and II model airplanes. They also had a part-time person who worked for them who built display booths and things like that for the trade shows they would go to. He was a cop and very funny. So I saw a lot of different things there. It was nice, because it was probably the best hobby shop in the city. It was very small, and it was very high quality.

Q: What was your family background?

MATTIA: My father was born in Italy; he came over when he was twenty-seven, in 1925 or thereabouts. And my mother was born here. She was pretty much a housemother and wife. She was an only child. My father seemed to spend a lot of his energy vacillating between trying to fit into America and trying to maintain his Italian heritage. And they were very, very supportive. There were a lot of creative people in my family, but not in any sophisticated kind of way, you know, a lot of carpenters, a lot of people who worked with wood in the family, a couple of uncles and my father.

Q: Did many of his siblings come over too?

MATTIA: He and his brother and sister, three of them. My father was the youngest of the three. When it was time to choose a college, I was sort of going the Catholic college route just because I thought that was the path. I had no other alternatives or ideas. It was my hobby shop family, the people that owned the hobby shop, that suggested or planted the idea that maybe I should look into an art college.

Q: Was your mother involved with the crafts at all? What did she do?

MATTIA: My mother made a lot of little dolls, and she was an incredible cook, not a fancy cook but a sort of domestic kind of household menu, some Italian dishes, some American things. But they were both very good with their hands. They made a lot of things. My father made a lot of furniture. He was actually a carpenter, but I think he apprenticed to the village woodworker in Calabrito in Italy; he did everything from barrels to furniture. My parents are older. My father must have been nearly fifty when I was born. And my mom maybe forty-one.

Q: You said that there were other relatives who were involved in carpentry and making things. Were your family members in general particularly supportive?

MATTIA: They were very, very supportive, although my father was in shock at the thought of my going into a woodworking career or direction. In fact, I can remember he and my uncle, his brother, who he was very close to, I can remember the two of them sitting down and

trying to talk me into going into jewelry. My uncle was inventorying things, counting on his fingers. He said, "You're going to need a shop, a half-acre shop. You're always going to be dirty; you're always going to be tired, and you're not going to make a lot of money." And he said, "If you go into jewelry, you get to wear a suit; you can carry around a half a year's inventory in a briefcase; you'll have a small shop, and you'll make money!" He was a hundred percent right! That's why I say they were incredibly supportive. The only place my parents weren't supportive was sports. My father was dead set against sports. He was really frightened about me getting too interested in football or baseball; consequently I didn't get interested in any of them.

Q: Did you have any art in elementary school?

MATTIA: We had a very old nun who used to come in one day a week, and one week she taught music and the next week she taught art. And we drew—usually for art we drew religious articles. [*Laughter*] That was it.

Q: So when you got into it, you did go to art school?

MATTIA: Yeah. I went to Philadelphia College of Art.

Q: Steered there by the people in the hobby shop?

MATTIA: Well, a little bit by that and also, when we were in high school we used to venture down below Market Street to Pine Street. It was sort of a beatnik area at the time, so it was very attractive and interesting. Then when it came time to pick a college, we went down, a couple of friends and myself, and started to get a catalog and look into it. It just became more and more intriguing. One, it was a college; there was a college degree involved; there were so many unusual and different kinds of directions you could pursue. I went in thinking that I would probably go into industrial design [ID] even though I didn't quite know what it was. Of everything they listed as options that sounded like a good one! I made things out of wood all the time. Even when I was in the freshman foundation program, a lot of the projects we ended up working out in wood. I say "we" because sometimes we did team projects. And a lot of times my dad would even help with those things. I'm amazed at my father. I can never quite figure out whether he's just really brilliant or he's just really passive. I can't quite tell. He's got a kind of zen about him that way.

Q: What else did you study in college? Did you have a major?

MATTIA: At the time the crafts program was called the dimensional design department, which I thought sounded a lot better. I still think the crafts word is a difficult one. I was going to go into ID by now; I had figured out that they designed toasters. I can remember many times

staring at our toaster at home trying to think if I could really get into this! [*Laughter*] I was pretty naive when I went into school. And I guess I wandered into the wood shop in my sophomore year one day.

Q: Was there a regular foundation program?

MATTIA: I was pre-foundation. Foundation came in the year or two after, so I had a lot of courses. I had color and design and painting and drawing and anatomy, that whole thing. I still am a little bit undecided as to whether that's a better route or not. I'm not convinced I totally believe in the foundation design approach, but I understand why they do it. Unfortunately, I'm not sure that a lot of decisions aren't made for purely business reasons first and other reasons later. It is a lot easier to have a couple of teachers teaching a composite foundation course than to have one guy teaching anatomy, one guy teaching color, and one mechanical drawing.

Q: Did you have many other academic subjects as well as arts courses?

MATTIA: Minimal. We had just the list of what we had to take in order to meet the degree requirements. A lot of art history, which I had a terrible time with 'til I found film history and sailed through the rest of my art history credits. What else? I think we had one science course, a couple of humanities, English, economics taught by a guy with a baggy blue suit and dandruff. We also had a basic science and engineering course that was offered through the ID department, team taught by three of my favorite faculty members. It was a great course—though it was probably technically a studio course.

Q: How did you see your relationship to artists before you got to art school?

MATTIA: I had no conception of them at all. I had never met any. I didn't have an art teacher as a role model; I didn't know any artists. This sounds kind of silly, but I think even when I would be running around in the art museum, I never really thought about an artist making this stuff. Probably in the Rodin Museum, I was sort of aware that somebody had made these things. And even there it's probably the closest I ever got to that. It was such an intimate little museum. It really is a tiny little place, and it's really beautifully set. And there weren't any guards. It wasn't the kind of thing where you'd always be worrying about someone looking over your shoulder, if you're touching something or if you're making too much noise or if we were running around. Because we literally used to play for hours; we'd play tag. But in the Rodin you were really left alone a lot more. So maybe that had a little bit to do with it. Maybe it was one person, maybe it was the classical forms. I don't know.

Q: Was there a point at which you were aware of kind of a turning point, in which you decided, "Now I am going to become an artist," or "Now I am an artist"?

MATTIA: No. I went in for my interview for undergraduate school with a three-piece suit and a portfolio that me and two of my buddies had done in my basement.

Q: How did you know enough to have a portfolio?

MATTIA: We went through the catalog like a cookbook. You know, a collage, we had to look up a collage, we didn't know what it was. I remember that the registrar at the time was a real dapper guy, bow tie, really a funny fellow. And it became clear to us that we didn't really have to do a portfolio; in lieu of a portfolio we could have gone to summer school because that's what he suggested we do. So we ended up in a six-week summer program. And it was really the best thing in the world for me, because I always think of it as sort of taking me from a three-piece suit and banlon shirts to dungarees. I did all my adjusting there, and I might not have succeeded if I didn't do it that way. I think it was a really important transitional thing for me. The place wasn't full of people; most of the people there were like me. They may have had some creative talent, a lot of it or a little bit of it, but nobody had come out of very intense high school art programs. So I think that was a great thing. And I remember that I met some people there, too. I met some sophomores who were around; some of them are friends still, although I don't see them as much now, but Billy Bernstein and Katie, ceramic and glass people who were a couple. They were the first real couple that I met. They had a house and they seemed to be living the life of art students becoming artists. You know, there was a lot of work in the house that had been done by friends that I knew or had met. They were really good at taking people in. I think a lot of my education happened right there.

Q: What were your aspirations at this point?

MATTIA: To be a good art student, I think. I don't think I was really thinking about what I was going to do when I got out. I think I was trying to figure out how to succeed inside of that setting. I was very motivated to work, and I was really excited about the different classes and projects. I wasn't great in everything. I wasn't great in anything probably, but I have a funny sort of perception when I look back on it now because I really was very green. Well, I stayed there for undergraduate, and then after undergraduate school I stayed in Philly two more years and I rented studio space from my two teachers, Dan Jackson and Bob Worth. That was a nice situation too, Ed Zucca and I did it with

Dan Jackson; we did a couple of jobs together, and we made some things on our own.

Q: And by this time you were in furniture, in wood?

MATTIA: Yes. That happened probably in the second half of sophomore year. I stumbled in the wood shop right before a crit, saw all the furniture, and I think immediately just said, "Oh shit, this is it. You know, this is much better than toasters." And I do remember always thinking that I would not go into painting or sculpture. I had this image of black turtleneck and a beret. And it was like I couldn't quite see myself pulling it off.

Q: How have your aspirations changed from that point?

MATTIA: I guess somewhere along the line—I'm not aware of a transition happening, but I think probably as we got more deeply involved in the furniture making and the education and we saw more visiting artists, and we started to see that some people were teaching, that teachers were teaching and making work, and some people they'd bring in were just working, you started to get a sense that this is like a business. I mean, how am I going to be able to fit into this? Am I going to be able to have a shop and make things for a living? Or will I maybe be thinking about teaching? Or maybe I'd rather pump gas or drive a cab and make things on the side. That September, after that first summer, I mean, I was real aware of other freshman who showed up who were really good painters, really good. They were the ones that I saw. And I realized that wow, there's a whole other world. There were people who had a lot of very good training and were way ahead of where I was and comfortable in fields that I wasn't comfortable in. And my paintings, I still have them, and my father still has them in his basement.

Q: So two years you stayed on after undergraduate in Philadelphia, then what happened?

MATTIA: Well, then we started talking about grad school. And I know for me it was really important to find someplace where I could continue my furniture involvement. And the other thing was to get out of Philly. My whole education had basically been on Broad Street in Philadelphia. Grade school was just off of Broad Street; high school was on Broad Street; Philadelphia College of Art [PCA] was on Broad Street. I was really becoming aware that the city was getting pretty oppressively neurotic at that time with a lot of potentially illicit kinds of activities all over the place. And the Vietnam War was on, and I was fighting to beat the draft.

Q: Where did you go to get out?

MATTIA: Rhode Island School of Design [RISD]. It turned out to be a logical path for me because some of the people I knew from PCA had gone off to RISD. It was wonderful. It worked really well for me. It got me out of that city; it got me out of potentially a lot of trouble I could have gotten into. I went up with Jonathan Bonner and Jacque Lineott from PCA. We all moved in together in Providence in a big apartment, and I stayed two years. I had a good time with Tage Frid because he didn't have too many students coming into his program from strong undergraduate programs. He's a very territorial egotistical kind of person in terms of other people's influences and that sort of thing. He really had to make it pretty clear that we came up there and we didn't "know beans about making furniture." But I think he was tickled to have Jonathan and me come in with full portfolios, tool boxes full of tools; I mean, we were really different from what he was used to. And he expanded his grad program at that point. He opened up a room and made some more space and made a little bit of a bigger commitment. Hank Gilpin was there as an elective student. He had taken two electives. (I'm faced with this now. This is the kind of student I'm dealing with. You know, it's hard to get the fully qualified undergraduate student because times have changed and the business has gotten more competitive.) But Hank was there, and he had taken two elective courses. He had an undergraduate degree, he had come into RISD as a photographer straight from Viet Nam—that's what Frid did, he would take grads who had strong undergraduate degrees, but not necessarily in furniture. He thought the commitment was there. And he was usually right.

Q: Did you have any mentors or role models at this stage?

MATTIA: I had a lot of mentors and role models. I think at that stage I was sort of a mentor to some of the other people in the program. I know Hank really looked up to Jonathan and me because we had something he didn't have. We had four years of undergraduate experience and portfolios and a backlog of pieces of furniture we had been through or made. I had some mentors; some of them still are mentors for me, I guess, or influence me. But they weren't really furniture people.

Q: In what way did they influence you?

MATTIA: Just their motivation, their productivity, their ability, their talent. That kind of thing. Dan Dailey's always been like that for me. His work isn't my favorite thing about him, although I like his work, some of his pieces more than others, but he's always been someone who whenever I'm around him it's kind of like a little shot of adrenalin because he's always working on a huge scale. Now that I think about it, Dan was actually in undergraduate school when I was at PCA, too,

so he was always a year ahead of me. He went off to RISD before us. He was incredibly productive at whatever it was he was doing. And Ed Zucca was a year ahead of me. Dan Jackson was pretty much of a role model although he was a very, very intense personality. He tended to be kind of a dark personality. And I saw that in terms of him being a role model and was worried about it. I didn't know there was another kind of alternative because my perception of Philadelphia at the time was basically that it was a very neurotic and dark climate. When I went off to grad school I think I was trying to get out of Philly because I was still living at home—or too close to home. But I don't think I really knew that. I think I just sort of thought that was part of being an artist, that sort of neurotic driven approach. When I got to RISD, with Frid I realized that there was a whole different kind of thing. I mean, Frid was like a bon vivant kind of guy—he had a gourmet club, and he loved to have a good time. He doesn't have a particularly humorous approach in his work, but he is a very funny man. He's very entertaining, very gregarious. It was really like coming out into the sunshine or something. It was unbelievably good for me to get away.

Q: What happened after graduate school?

MATTIA: There was no 'after graduate school.' Our grad thesis show had just opened and Frid came in, and he said, "Listen, there's a job in Virginia, at Virginia Commonwealth University." And he said, "One of those guys who teaches down there was up here. He saw the show, and he saw this woodwork in the show, and I guess they're looking for somebody." And he said, "Maybe you guys ought to apply," to me and another student, one of my partners, Roger Bergen. I think it was Jack Earle who had come up to RISD and saw the show, and they were in a deadlock about a new teacher for the wood studio. And Frid was very good about handling it in a nice, fair way. He just said, "I'll write you both recommendations, may the best man win," da da da and he just encouraged us all to do it. Hank didn't want to do it. Hank knew what he wanted to do. Hank had just bought an old church in Lincoln and was ready to set up business and pretty much start in Frid's footsteps. I mean, Frid really loved Hank. And Hank had a real no-nonsense kind of approach that Frid could identify with. And Frid farmed work to him, like kitchens that people were calling Frid for went right to Hank. But, I applied for this job, and I got the job. And I left Providence straight for Virginia. I mean, I worked for Frid for the summer, which was a nice experience. I saw another side of him. I saw him at home and his family and Emma and the farm and the shop and the spread. And it was nice. He was not a particularly driven artist. He never really exerted a strong

influence through his work. Nothing like Dan Jackson or many of the other artists I saw, but he was a strong personality. Not so much a role model, but it was sort of his nature that he was really very inspiring, a catalyst.

Q: Let's stop for a second. Let's go over the career path. So you got to Virginia.

MATTIA: Virginia Commonwealth University. Big state school. Twenty-five thousand students. For three years I taught woodworking. It was a nice job because they had a nice little wood shop. The two people before me had been sympathetic with my education, so the machinery was just what I needed. They had a good program. The previous teacher was kind of a wacky guy, sort of a sculptor-furniture maker-painter. Joe Distefano was his name. And he had only been there a year, and then he kind of took off spiritually. He flew the coop so to speak. And before him was Alan Lazarus, who might have been a classmate of Dan Jackson's or Bob Worth's at RIT [Rochester Institute of Technology]. He was still in the area working, and I got to go meet him and talk to him a little bit about the school and that sort of thing. It was an easy, easy adjustment. I had a partner to teach with who was sort of a nonentity in a way. He was in a way a good partner for me because I think I am an only-child kind of person. I don't work that easily with partners although I have had good experiences working with partners. This guy always would support me, but he wouldn't do anything. And he didn't really make furniture. But I think what was good was that he didn't really pose any threat or obstacle to my plans. I worked right at school. I had a studio in school. I had a lot of beginning level students and a very small number of majors, but I had good majors. And they had a little money to spend, not a lot, but I don't remember grappling for every little piece of paper or every piece of sandpaper. It was fun, I really liked it a lot down there. I hated Virginia; I hated Richmond for a year and a half. So much so I had a big dog I had gotten when I was working for Frid, a big black sort of lab-looking dog. He looked like a big black Irish setter; Butch was his name. I would take him out for a walk in the park, and I'd get into heated monologues with people about how awful it was in Virginia. And then I remember at about a year and a half, I must have woken up one morning completely brainwashed because all of a sudden I loved Virginia. I don't remember ever making a slow transition. I just loved it. It's a wonderful state! There's an ocean and mountains, and it snows on the north side of the street and not on the south. And Rosanne and I had been carrying on a relationship via the mailman back and forth. She would come down on holidays, and she was still finishing up

at RISD. We had met when I was in my last year of grad school. It was really a nice situation.

Q: So what happened after Virginia?

MATTIA: I heard about the Program in Artisanry opening in Boston. I had known about it, it had opened the year before. Then in 1976 Dan Jackson was teaching there, my old teacher. I'd heard that he was trying to commute and teach, and I think he was really overextending himself, and he was in a fragile situation anyway. So I heard he was not going to continue teaching there, and the position was going to open. And Jere Osgood was there. Krenov had been the first teacher, but he only lasted about one semester. In that time he managed to really alienate every single person there, except for half the students. He had polarized the students completely. So, they brought Jere in; Neil Hoffman was the director. He had been the assistant director at RIT. I think he was at a real brilliant stage. It was a real ripe time for him. So I applied for that job, and I got it. I was really pretty excited, I knew I was in a good, solid school, a major program, you know like PCA or RIT or RISD.

Q: How long was the program in Boston?

MATTIA: It was 1976 when I moved up there. I remember I taught three summer programs that summer. I taught six weeks at Boston University, three weeks at Peters Valley, and three weeks at Penland, or something like that. And I was burnt. And then we moved in the middle of it all or something. It was really hard. We left for Swain.

Q: And essentially you've been with the program ever since, following it from place to place. Shifting the subject slightly, do you think the contemporary art or art craft world is competitive?

MATTIA: Yes. It's competitive in a lot of ways. I think there are only so many slots to show in, and there's easily ten times that number of people looking to show. And I think that there are only so many grants to get. In some ways it'd be nice to think of the grant thing as purely being like a lottery, which a lot of people say it is. But I don't think that it is. I think that a lot of it has to do with who knows who. I don't think it's polluted, I just think there's no denying that if you're known, you have some edge. It may be to your disadvantage, too. And I think there are only so many clients buying big pieces of furniture, especially at the upper end of the one-of-a-kind market. The only thing I would add to that previous question is that I don't think the craft world has ever been as competitive as the fine arts world or as cutthroat or as backbiting. Although I do think that as the numbers increase it'll be inevitable that that'll start to increase too. And I think some fields are more hostilely competitive than other fields. You know, glass is a little bit hotter than

fibers or wood. That's my take on it. I mean, it may not really be the case, but it seems like some of the fields are still sort of warmer and friendlier to each other. Although I can see as the activity has increased in the furniture field in the last five to seven years maybe that it's getting a little bit more edgy competitively. But it's still a pretty nice, small world.

Q: What do you think are the expectations of the artists and artist crafts-people?

MATTIA: I think it would be easier to answer that question ten years ago. There was a kind of universal lifestyle goal that everyone was trying to create. And there was a villainous kind of role to stay away from. But as things have changed and as the business aspect has become more competitive, the objectives change, I guess, or the goals change. I think that all of a sudden we're in the world of the high pressure, success-oriented artists or art world. And it didn't used to be that way. I mean, I think before we were all looking for a quieter lifestyle, sort of self-controlled and centered.

Q: Do you think the goals are more or less realistic today than ten years ago?

MATTIA: I think that the goals were very realistic ten years ago; it was a very realistic goal to turn away from the corporate world or the business world to settle into a more culturally and spiritually rewarding kind of a lifestyle, a place where you could make a living, work for yourself, be completely or predominantly in control of the product you made and the materials you procured to make it and the marketing. I think today's goals are also realistic. I just think they're much more dominated by dollars and business success. I also think that there's a polarity in the art world that we're dealing with now. Ten years ago when we were pursuing a more common lifestyle and products, everyone was in agreement about what that meant. And now I think there is a much more eclectic or divergent set of objectives and goals. One person's end goal is radically different from the next person, even though they're both trying to succeed.

Q: It boils down a lot to different definitions of success also.

MATTIA: Yes, and I think that is what I see in the students a lot. Not only different definitions of success, but different definitions of what's right and of validity in the content of the work that people are trying to do. I'm not sure it was completely healthy when we were so united in our vision aesthetically and philosophically. But I don't think that it was a narrow time. I just think that it was a product of the time. It was easy to see what you didn't want to be and what you did want to do. Then there

was room for individual expression, but there was sort of a common set of commandments or something. Now I think the commandments are more buck oriented—I mean, the universality, the common thread is the success of a business. The content of the work is all over the board, and I don't think that eclecticism is bad. Maybe it's a sign of change, I just think it's very, very different and harder to teach in, harder to work in, harder to succeed in. I never before had students making selection processes between what you show them, between either your own work or the work of the artists you bring in. I mean, they quickly figure out, "That's not for me, that is for me, this is not for me, that's for me"; it's alarming.

Q: Have you ever been a judge in any artist competitions?

MATTIA: Yes. I've been on panels. I was on a Dairy Barn jury—they were all craft—usually craft or furniture competitions—in most cases they were craft. And I was usually one of three or four people on the jury. I was on a public arts jury for the Massachusetts Arts Council.

Q: Have they been more for awards for artists or for entry into shows and exhibitions?

MATTIA: A little bit of both. I think I would rather be curating a show than saying yes or no, giving this or that the gold star in the contest of someone else's theme or exhibition concept. I like the award end of it because I find it difficult. I think the craft world is pretty small, but I also find it really exciting. I do find that as weird as those situations are, they're generally pretty fair. I think there's no getting around the fact that people know people, but I don't think that necessarily is a guarantee. People are pretty upright, pretty forthright about speaking their minds. If somebody's supporting someone and someone else feels that the work isn't strong, it doesn't go unsaid; you hear it.

Q: Describe the period in which you first received professional recognition.

MATTIA: I guess for me if professional recognition means making money, I don't know. When I was an undergraduate, I was really pretty fortunate in a couple of shows. There was a really wonderful show in Philadelphia that I still think is a great model. It was a show that they did every three years, and it was a combination of invited and jurored work, in the crafts. They called it "The Craftsman Shows." There was a group in Philadelphia called PCPC [Professional Council of Philadelphia Craftsmen]. And they sponsored these exhibitions triannually—1967, 1970, and 1973. I was in the 1970 and 1973 exhibitions. And I saw 1967 just around when I started majoring in school. And they were really good shows for me on all levels, eye openers. I graduated from PCA in

1969—I won first prize in Craftsman '70 and first and second prizes in Craftsman '73. I was really pretty excited about that. Then I was included in a show at the Philadelphia Museum of Art in 1970 or 1971. It was called the Peace Show. Cristo had wrapped the central staircase of the museum, and there was a whole bunch of people. I had a piece in it, and I was pretty tickled, although I was still so naive that I didn't quite know what to do with it all. Being hired is kind of the first sign of professional recognition as a teacher.

Q: Have you received any other professional recognition as a teacher? Other than being hired?

MATTIA: Well, they haven't fired me yet. So, a couple of promotions. I never get any awards for teaching. I've never thought of myself as an awardable kind of teacher! [*Laughs*]

Q: What art-related organizations have you been associated with?

MATTIA: I've been on a number of boards. I'm on the Haystack board, and I was on the Renwick Collectors Alliance for two years. Some of them are active positions, and some of them aren't really. I'm on the Advisory Board of the Wood Turners Society. (On that one I think I do the least, although my name's on the stationery!) At Haystack, I feel like I don't do enough; that's an active board position.

Q: It seems to me that you work both as an independent artist and as a teacher. Do you feel that either one of those is more important than the other?

MATTIA: I think that probably ultimately my own work as an artist is more important. Although I find that easier to say than to actually do. You know, sometimes I find it hard to separate them. I always find it hard to juggle them both at once. I mean, there have been some times when I feel like both plates are spinning at the same RPM. But most of the time one is tumbling while the other is spinning well. And occasionally they're both dead. [*Laughs*] Broken. Let me put it that way. They're both broken sometimes.

Q: Who are your peers?

MATTIA: I have a lot of peers in the furniture field, and then a number of people across media in the crafts world, and some sculptors and not too many painters. I don't know too many painters. I wish I did know some more painters. My peers are mostly people who I have maintained some kind of connection with over the years. They're not necessarily people I work with at the school I teach at or in the city I live in.

Q: Whose opinions do you rely on?

MATTIA: Well, nobody's. [*Laughs*] I don't know. I wish I relied on my own opinions. I'm such an undecided kind of person; I wish I had a few

more people whose opinions I really could solidly rely on. Because I certainly every now and then have some questions I'd just like a good solid opinion on! [*Laughs*] But I rely on my wife Rosanne's opinions, in certain areas only. Some of my peers who are friends, some of my friends who happen to be peers also, their opinions. I guess I'm the kind of person who juggles opinions. You know, I take a little bit from one person and a little bit from another, and then I try to piece it all together into an opinion.

Q: Do you serve as a mentor now?

MATTIA: If I do, when I think I am, I find out I'm not. And when I don't think I am, I'm told I am. So, just the other day Rosanne told me that a person who recently got out of school, really looked up to me and looked up to my work and where I am at this particular point and that sort of thing. I don't see that at all. I really don't. This person happens to be a pretty confident sort of wisecracking person. You know, very competent in his work, talented, and good designer and builder. If anything, I see a certain kind of wisecracking relationship.

Q: What kinds of professional safety nets do you have?

MATTIA: Well, I guess to me somehow I feel like the relationship of my teaching and my work are kind of a mutual safety net in that each one supports the other in a way. And when I'm having trouble in my teaching, or with my own work, the other thing is what I can bolster myself up on. And at occasional times when both things are down, broken, that might be a time when I would look for something else. And I wouldn't know where I would look then. I would look to myself, or into my family. But I wouldn't consider those professional safety nets.

Q: Can you describe the gatekeepers at different stages of your career, those who let you in or those who barred the way?

MATTIA: The very first impression that I would take on that question would be the big museum guys are the ones I always think of as the gatekeepers. Because I certainly think that there were times in my career when I found one of those people to be sort of barring my entrance and at other times when I found them to be incredibly helpful to me. And when I felt like I was being barred, I was angry and frustrated. And mostly angry with the system. I think sometimes I trust that system and sometimes I don't. Generally speaking it tends to work pretty well. I think there are people who don't get into the tree house who belong there, or who are better than it. But maybe it's just a function of the whole system and there are certainly misuses of it.

Q: How would you describe the major turning points in your career?

MATTIA: I would describe them as being fairly traumatic. [*Laughs*]
Starting teaching at Boston University was a real major turning point
in my teaching career. I think when the program left there and went to
Swain and Jere Osgood and I split ways, that was kind of a major point.
I think in my own work a real major point for me was in 1985 when I
did a show with Helen Drutt with a whole bunch of new and different
work for me. She hadn't opened in New York yet. I think that was a real
major point for me. I think having a child has been a major turning point
in my career, both teaching and working.

Q: How would you describe your relationship to money throughout your
career?

MATTIA: I guess because of the way I've worked or have been working
I have never really been in terrible money crisis kind of situations. You
know, the teaching jobs I've been in have always been fairly secure. At
this point in my life right now I'm probably a little overextended. I
mean, now I have a child, and we have a big house, and we've got other
property we're dealing with and that sort of thing. So now I feel like
I'm more worried and concerned about money. But up until now it's
been okay. We've had leaner times. When my work is not selling well
things get kind of lean. But when I'm managing to keep some work
moving in and out of the shop, my teaching going along, then things
are usually okay.

Q: What kind of emphasis do you think the art world puts on the market-
place today?

MATTIA: I think the whole art world is so money-marketing-business
oriented, commercially oriented that it's culturally damaging. There was
a time when it used to be respectable to not sell your work. Not
necessarily that it was glorified, but it was totally respectable to be a
productive artist who didn't sell well. Now I don't think that's true at
all. I think there are people who you'll find whose work is very
powerful; it's okay and they don't sell it. But I don't think you're seeing
them anymore. The galleries don't want to—can't afford to show
them—I think in the sixties and the seventies we had a much healthier
outlook on money. I mean, I think that you could have it and be okay,
and you could not have it and you could be okay. I think that in the late
seventies and through the eighties it's not okay not to have money. I
think you've got to have money. I think it's a product of too many MBA's
coming out of Harvard. I think they've got their noses in too many damn
things. I think they have their fingers in education and the marketing of
the work and even in the making of it. I just think that it's become too
mercantile. Maybe it has to be; I'm not sure, but I don't believe it has

to be. I think it's happening totally at the expense of ethics and morals, philosophies, content, and integrity. Culturally I think we're killing ourselves.

Q: Changing the subject slightly, have you ever received a grant?

MATTIA: Yes.

Q: How did it affect your career?

MATTIA: It was great. It was a milestone in my career that I forgot to mention. It was great.

Q: What was it?

MATTIA: I've received a couple of them. The bigger one was fifteen thousand; it was NEA. Then I received a seven-five from the Mass Council. But the money was great, although I have to say it happened at a time in my life when we were in a transition from Boston to a new home and a new studio, and I bought a new piece of equipment, I bought some new tools, and I made these new pieces. But we went from a meager studio to a much better studio, for both my wife and I. But, I think that those grants were really like a pat on the back. I think they really can make an artist feel acknowledged in some way. I know that they were really a big thing for me that way. I felt very good about that. And I also know they can be really devastating to people who don't get them. You know? They carry a lot of tonnage!

Q: What kind of control do you think you've had over artists' careers?

MATTIA: I don't think I've had any control over anybody's career. I think I've had some influence, and I feel really very fortunate to be able to say that. I think I've worked with some really talented people as students who now have very good productive careers. I think I've also helped to encourage people at different points in terms of shows or in some way. But I don't feel like I have any kind of control.

Q: How do you think this influence has been viewed?

MATTIA: I think that in almost all cases it's viewed as a good thing. Although I know of one particular person who views it as a kind of a self-centered, self-gratifying kind of power position, ego position or something. And I think that's unfortunate.

Q: What is your level of interaction with the public?

MATTIA: To me that talks about my retailing. My ability to promote and sell my work. I think of myself as a lousy salesperson. So, I had a very, very good time at the Armory for two years. Surprising, because I think in some ways I don't really know myself. I mean, I think of myself one way, then I'm surprised. I think of myself as being very reluctant socially. I don't particularly like to sell, do the retail work. You know, I hate to use that term; it's a totally commercial term. I generally don't

like commissions. You know, I like commissions because I like the challenge. You know you want something; you have special needs. I have a way I want to work; somehow we have to get together and get this to work. That's very challenging. When I make spec pieces it can be like working in a vacuum. But most of the time I find that it doesn't go that well for me. I find that I'm not comfortable enough in controlling the situation or in guiding the situation or covering my end of it. And a lot of times I end up saying yes when I mean no, or red when I mean blue. Or I overcompensate. So I find it a very awkward process. But at the Armory I thought it was really a nice situation. The audience was very good, and I really enjoyed the interaction. Plus once I managed to sell that first piece I needed to sell to get through the expenses I could relax. You know, once that's over, the pressure's off and you feel then you can smile.

Q: Do you think the kind of interaction you had has changed a lot throughout your career?

MATTIA: Yeah. I think that without knowing it I become increasingly more public because of whatever, my teaching position, the shows I do or something. I'm not conscious of it happening; I just am conscious of more and more stress or more and more activity or more and more responsibilities.

Q: How have you been affected by critical review?

MATTIA: There isn't any critical review in my field, so I don't get affected by it at all. I think sometimes there's a show and they don't describe my piece enough. That's not to say there aren't some really nicely written pieces or some really strong critical reviewing that's going on. But I don't think there's enough to call it activity. I think that's a sad thing, but it's just the way it is right now. We'll grow into it.

Q: How has your definition of success changed throughout the years?

MATTIA: I guess unfortunately a lot of my definition of success does probably have to do with sales and public recognition, in terms of collections and grants or coverage, publicity. I think that my definition of success at another time in my life was really based on the success of each individual piece I made.

Q: What's been your greatest satisfaction?

MATTIA: I think probably my family.

Q: And aside from your family, in your career?

MATTIA: I guess I would have to say that my greatest satisfaction comes from pieces of work, from finishing pieces of work that I feel are really important to me. And I don't make that much work that—I mean everything's pretty important to me, all the pieces that I make. But I

think some really mean more to me than others. I really feel like there is something bigger or better than me in the pieces I make; there's something that might last longer. It just goes outside of the human condition; it's something of itself. And when it works well, I feel very, very good about that. Even if I don't really totally like it. I mean, sometimes even those pieces mean a lot to me.

Q: What's been your greatest disappointment or frustration?

MATTIA: Well, I think lately my teaching situation is probably my greatest frustration and disappointment. Although I would probably say, maybe a bigger and deeper frustration or disappointment is when I am vacant in terms of ideas about the objects I want to make. I think some people find themselves at the edge of a black hole often in their work, and it's a very painful place to be. It's hard to to come out of it. Sometimes it takes the form of a big creative block and other times it's insecurity. But I think the best things come out of those times.

Q: What has been the effect of the marketplace on your work?

MATTIA: Oh, I don't know. I mean, I don't think it's had a bad effect. It's probably had a good effect for me. When I'm selling well it makes me feel more confident.

Q: Do you think there's been any effect of the marketplace on your teaching career in terms of numbers of students or quality of students or popularity of the department?

MATTIA: It's hard for me to tell that, because we were going through a very awkward transition right at the time that the field was at its hottest. So I feel like we missed really capitalizing on it or being able to use it as a barometer for what was going on. But now I'm in a school where it's cheaper, and we have a nice space and big machinery, and we're getting a lot of inquiries and a lot of applicants.

Q: How do you describe your occupation for the census?

MATTIA: Artist/teacher.

Q: Sounds good.

MATTIA: It's taken years! I mean, there were three or four years of artist. Even though no question I was probably making more money teaching, and I was spending more time at it if you added up the time over the year. But now just—artist/teacher.

Q: What advice would you give to a young artist entering the world of craft art?

MATTIA: Take as long as you possibly can with your education; don't rush it; don't accelerate it; don't shortcut it. Don't pander to the market, and that would be the last thing. And then between the two I would say, invest everything you can in finding out who you are and what your

personal approach and voice are all about. Don't define yourself or shape your point of view to the market. What is it they say? Build a better mouse trap and the world will beat a path to your door—I guess I still believe that's true.

Representative collections include: Corporate: Philip Morris Corporate Collection (New York, NY); Public: American Craft Museum (New York, NY), Museum of Fine Arts (Boston, MA), Rhode Island School of Design Museum (Providence, RI), Yale Gallery of Art (New Haven, CT).

Honors: Massachusetts Artists Foundation, Fellowship Award in Crafts, 1986; National Endowment for the Arts, Visual Artists Fellowship Grant, 1984.

NORMA MINKOWITZ

B. New York, New York, 1937. Attended High School of Music and Art, New York. BFA, Cooper Union Art School, 1958. Worked in textile design, freelance illustration. Began three-dimensional fiber sculpture in 1972; first one-person show, Silvermine Guild of Artists, 1972. Lives and works in Westport, Connecticut.

Q: Let's start by talking about your initial influences. Can you describe your family and your early childhood?

MINKOWITZ: Yes. Well I had a very supportive mother. I had a father who really never knew what I was doing but was always in some way supportive. I drew all the time as a child. I was very interested in fine pen and ink drawings and sketches. I was always doing something. My mother was always knitting and making sweaters. And consequently the two ideas merged. I was always crocheting around dolls and making sculptural forms. And she was always giving me scraps of yarns and threads. It was very exciting to me. The situation at home was generally a family-oriented kind of involvement where we would all sit around and listen to the radio, and everybody would do something. My father was a musician, and he would play the piano. And my mother and I would always work by hand or do things that were creative.

Q: Did you have brothers and sisters?

MINKOWITZ: I have a brother, and he was more musically inclined. And he was somewhat older for his years, and I was always somewhat

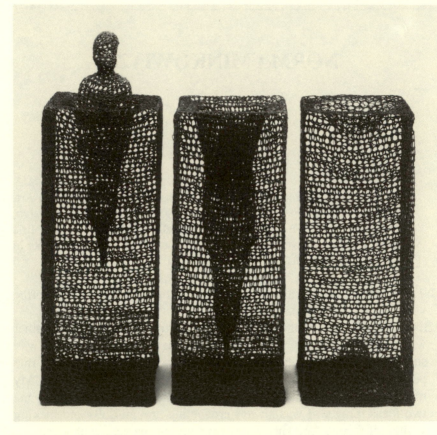

"Recycled" by Norma Minkowitz, 1989 (15″ x 5″ x 15″).

younger. So we really never did too much together. But he was very musical.

Q: He was an older brother?

MINKOWITZ: You know, I always looked much younger. When I was twelve, I looked like eight, and then he was twelve, he was like sixteen. He hung out with wild crowds, and I was always making things. So it was that kind of difference, really.

Q: Where did you grow up?

MINKOWITZ: I grew up in the Bronx, New York and was always really involved with the arts in high school and college. I went to Music and Art High School. My brother did as well, but he was a music student and I was an art student. And going to that school was really an excellent experience for a young person because you were introduced to so many different art forms. I remember at that time I wasn't interested in really pursuing fiber as an art form; I was interested in the traditional painting, sculpture, and graphics. I remember taking weaving courses and pottery combined with drawing and all the other traditional forms.

Q: How did the members of your family feel about your talent?

MINKOWITZ: Very supportive. I guess my dealings were mostly with my mother because my father, as a musician, was usually gone during the night, and he was always sleeping during the day because he worked in the evening. So my relationship was mostly with my mother, who never made me feel that I had to follow a traditional female role. It was interesting for that generation because she came from a generation where the women were always in the kitchen cooking and preparing and the men would eat and fall asleep immediately. She always made me feel that I could do whatever I want to do.

Q: Did your mother work outside the home?

MINKOWITZ: She did when times were hard when I was about sixteen. She got a job and was trained in putting jewelry parts together for a jewelry company. She did that for a few years. As a girl she also worked with her father. He was a manufacturer of neckties, and she had some experience with that. But she always wanted to pursue a singing career and that really never matured.

Q: What were your initial experiences with art?

MINKOWITZ: Well, it was basically just pursuing and experimenting and making things. And I think as a child that's the most important thing, not to be confined or restricted. When my children grew up I had so many friends who when their children would work would immediately say, "You have to clean up now." And I never ever told my children you have to clean up because I knew myself, you come

to a point where, you know, the next day you want to pursue something. And I think that's a really big mistake a lot of parents make by making their children more concerned about tidiness and cleanliness than their creative spirit. I think basically I just had my things out all the time and made things all the time. And I think that's really an important gift for your child.

Q: It sounds like the High School of Music and Art must have provided you with a lot of validation. But did you also encounter any resistances?

MINKOWITZ: No, I just remember never having any feelings of inadequacy. I always felt very confident about what I was doing. Although sometimes later in life when I look back, I would say, "How could I have done that?" But at the time I was doing it I always had a lot of encouragement, and I always did well in school. In Music and Art, I entered a competition for a scholarship with the Society of Illustrators in New York, and out of many, many students I was one of two selected, which was another validation of my drawing ability. I loved to draw—I wanted to be a book illustrator. And I find, it ties in with what I'm doing now in many ways.

Q: What art forms were particularly interesting to you in your early education and training?

MINKOWITZ: Specifically drawing, woodcutting. I liked detail, I liked repetition. I see that in my work now because my work has a very repetitious technique to it. The pen and ink drawings were similar, a lot of very fine lines that were tedious. And I guess I like that kind of process. At an early age I liked working with fibers and traditional stitching, the strokes of which were very similar to pen and ink drawings; it was free stitching. And I think there was a lot of similarity in that process.

Q: When did you know that you were an artist?

MINKOWITZ: I guess always. I always knew that I wanted to be an artist. I think success came later as far as what I'm doing now, but I always felt I was an artist. I always experienced a lot of satisfaction in expressing what I was feeling and what I saw other people involved with. And universal themes of life, death, and happy things, all kinds of expressions of life that I was always able to bring out in my work. I guess I always felt that.

Q: Was there a certain point where you decided, "I'm going to pursue a career as an artist"?

MINKOWITZ: More so when I was younger. When I was in high school. I went to Cooper Union, which was another fine school that helped me in confirming in my own mind that I wanted to be an artist. But then I

sort of dropped it after graduating college—I got married, and I didn't think of being anything for a while. Not because anyone told me that women don't generally pursue careers. I just, you know, my focus was on being a wife and a mother at that time. But once I started to have children I had this need to go back to create things. And I started experimenting at that time with fiber because perhaps it was an easier kind of method to work with, with small children. And I started experimenting, not really thinking that it would be an art form, thinking more in terms of a preoccupation during these very busy times with small children. And the work just started to evolve. I think once you're an artist you're really always an artist. And the work started to evolve into more sophisticated, more meaningful work. Whereas at the beginning perhaps it was a little more decorative. I was doing things for Armstrong Cork Company, for Coats & Clarks. I was doing things that one would get directions from a national magazine, the instructions in the back. And I didn't feel I was compromising myself because I was enjoying what I was doing. But then everything I learned at Cooper Union and Music and Art High School started to come back to me where all this could be an art form. The work started to become more sculptural and had more to say rather than just being a decoration. So I think probably in the late sixties—I got married in 1959, so probably 10 years later—I started to evolve into what I wanted. And this is what happened. [*Laughs*]

Q: You mentioned Cooper Union. Can you describe what Cooper Union is?

MINKOWITZ: Well, it's a very competitive school. I think in the art school they only accept a hundred people out of—I'm not sure of the statistics, but I think it's one out of ten students are accepted. And it's a couple days of extreme testing, some academic, some drawing, some various kinds of exercises in design. Then you're notified whether you're accepted or not. The school has always been a scholarship school, and there's no tuition. So you have to really work hard to get there. It was an excellent school. And it still—even today, which is amazing—is a scholarship school. At that time it was a three-year course. Now it's a four-year course.

Q: And what subjects were you studying?

MINKOWITZ: Mostly painting, graphics, photography, sculpture. Nothing in fiber at that time.

Q: Can you describe the importance of peers to you at this time in school?

MINKOWITZ: At school it wasn't competitive in any sense as far as the art work goes. It was mostly relationships and friendships. I think in art

school you really don't learn how to be an artist; you learn more how to teach yourself. I think it's more a process of finding yourself rather than becoming an artist immediately. The beginning of a long process of teaching yourself to see and to evaluate what you want to say and what you're trying to express in perhaps, new, fresh ways that's unique to yourself. I think that's what it prepares you for. I was kind of a loner in school. I had a couple of close friends, and everybody was really more involved with their own work and their own methods. I really never felt any kind of support group or that kind of situation. I just did what I wanted. And I think it was more friendships. They were more social rather than involved with the arts. But perhaps that was because of the type of person I was. I rarely stayed after school. The kids went to local restaurants, sat around and talked, and I usually just went home and worked. So I didn't have that kind of exchange that perhaps other students did.

Q: How about role models or mentors?

MINKOWITZ: There were some teachers that impressed me and that were very creative. I really didn't have anyone in particular. I had some old masters like Albert Durer, whose work I thought was fantastic—fine pen and ink drawings. And Michelangelo and Rembrandt. I was very interested in the sculptural and technical mastery of these artists. But there was no one contemporary that I was really following or excited about. I had a teacher in Cooper Union that I admired very much. His name was Stefano Cusumanu. And I remember when we were drawing he would make you feel that you have to go around the whole object and see all the sides. And I was interested in the three dimensional qualities of sculpture and the very structured forms of pen and ink drawing. I think he inspired me a great deal in the sense of sculptural forms and seeing. So that was one of my few teachers I remember.

Q: What qualities do you feel you needed most during that period? Physical stamina, mental discipline, something else?

MINKOWITZ: Self-confidence, I think. Not being afraid to do what you think. When I was teaching there were a lot of students who were really afraid to put on paper or with fiber or with shapes things that they were thinking because it gave them the feeling perhaps that they would be criticized or perhaps mocked. And I think to be an artist you have to have no shame or no [*Laughs*] self-consciousness. You just have to do what you're thinking—no matter what someone thinks. You have to feel free to do that. I think that really gave me the most freedom to explore, do what I wanted to do. It gets easier, though, when you get older. I think as you get older you don't care as much. People will say, "What's

that?" Or, "Ooh!" It's more that feeling—well, this is what I want to do or say. And you just do it.

Q: What materials were you working with and what was your relationship to those materials?

MINKOWITZ: Well, I worked with paint and woodcutting. I worked with linoleum block. We had some courses with clay. I didn't like the feel of that at all. I think the sense of the clay made me feel very uncomfortable. It was very dehydrating and unpleasant to touch. I think there're reasons why artists go into that direction and others who find a cleaner kind of material. I like the feel of fiber, but there're different kinds of fiber. Some fibers that are very thick and coarse I find unpleasant to work with too. And I guess that's just my personality. I like sort of delicate but structured kinds of materials. And maybe in some ways that's who I am. I've been told my work is somewhat feminine, yet it's structured and strong. So, maybe that's a combination of who I am. I'd like to think that anyway. [*Laughs*]

Q: Do you think your training during this Cooper Union period adequately prepared you for a career as an artist?

MINKOWITZ: Probably not. I wanted to be an illustrator and I think probably Cooper Union was wonderful in preparing me to draw and learn how to draw. Probably another school might have been better to follow the commercial direction, which at that time I was interested in. But now I'm no longer interested in that, so perhaps things worked out for the best. I found a different avenue, which was the fiber. I think schools really prepare you to experiment and to do different things that you haven't done before. But I don't know if they really prepare you that much for a profession. Maybe it's different now. When I got out of Cooper Union I worked in textile design for a while, which I had no experience in but learned on the job. It was designing patterns for fabrics. I did that for a couple of years. But I think the school only prepared me for that in the sense of aesthetics and colors and shapes and forms, but technically, I didn't know anything about repeats and printing, that kind of process.

Q: How did you get your first job?

MINKOWITZ: I had a friend who worked in textile design and she suggested I try. The jobs I had from Cooper Union were really not very artistic. I worked for Norcross Card Company. I wanted to really design cards and draw, but I had to start from scratch. So I was a scaler, which meant that I prepared squares (for other artists), which were to a thirty second of an inch accuracy in squareness. I did that for a while, and it drove me crazy. So I stopped. Then I freelanced and illustrated a couple

of technical books. One was a child's school dictionary, which had some scientific motifs. Then I did another book which was a dictionary for the same author. I remember that I did a hundred illustrations and charged a dollar each illustration. [*Laughs*] They were two inches by two inches. I had absolutely no idea what to charge, which we weren't prepared for in school either. So I got a hundred dollars for a hundred illustrations. I was so proud of myself. It was my first paying job, but it was a lesson.

Q: How did you get that?

MINKOWITZ: There was a sign on a bulletin board at Cooper Union. I still have the book, and it's kind of fun to look back on it. I was dating my husband at that time who was an engineering student at Cooper Union, and he was most helpful in the translation of the scientific part of this job. So he really deserved fifty dollars. [*Laughs*]

Q: When did you realize that maybe you could have gotten more money for your work?

MINKOWITZ: Probably twenty years later. I put it out of my mind. Then I remember I was commissioned. I had worked one summer in the garment industry separating different tags for different garment sizes. I was only sixteen then. Actually that was my first job. I was so good at drawing and doing sketches that this woman commissioned me to do a portrait of her children. I had to take a train to Bethpage, Long Island, and I charged fifty dollars for the portrait. I had to go there about eight times. So it was another one of my financial escapades. It wasn't very logical. I guess when you're in the arts or doing something with public exposure, you're looking for someone to like your work and approval. So I think this is part of it. You know, God, they want my work, or they want me to do something. And I think that's part of being exposed to the public eye. You want approval. And maybe that's why I did it. Of course now it's different. [*Laughs*] I'm older and wiser.

Q: Did you give yourself certain benchmarks for achievement?

MINKOWITZ: No. No, I just always wanted to be good at what I did and hopefully attain some kind of stature in my field and establish a name for myself and do something unique and different. And I think I'm doing that now. I'm in the process.

Q: Do you set goals now?

MINKOWITZ: Everytime I do something I just want it to be better than what I've done before. And my goal was to be in a New York gallery, which is happening now. And to show in prestigious shows that are museum quality and not be categorized as someone who perhaps does less than I want for myself. I think people like to put you in a category.

Some of my work pertains to vessels and containers, and I find myself being called a basket artist. I don't want to be called a basket artist; I want my work to be called sculptures. They do relate to baskets in the sense of containment, but in an abstract way. So right now I keep getting invitations to be in basketry shows. And some of them are very contemporary and very beautiful and very sculptured and I want to be in those. But I don't want to be categorized, pinpointed. Even though some of the titles of shows are "Basketry is an Art Form," "The New Basket," and it's geared more to sculpture. I still don't want to be put in a category.

Q: Have you joined any organizations as an artist?

MINKOWITZ: I did. When I first started I belonged to Artist Craftsmen of New York and the Society of Connecticut Craftsmen in Connecticut, but you sort of get away from that. It was a good vehicle for exhibiting and showing my early works, but I find I've grown and the organizations have basically accommodated newcomers and people who are just starting in the field. I keep up my membership because I feel it gave me a start, but I sort of just want to be by myself and pursue my own directions.

Q: In what way do you think that the shows are less?

MINKOWITZ: They're too crafty. And even though I work in a material that's a traditional craft material, I feel I want to be known as an artist, not a craftsperson. And I think within the crafts field there are many categories. There're people who want to be craftsmen and do production work and do shawls that are often very beautiful and have merit of their own, but I want to go beyond that. I want my work to make you think, to make you contemplate, to have a message, to have a statement. A lot of the work in traditional craft media is like that, but a lot isn't. And I think the shows tend to have work that's very homey and very . . . I don't know what word to use, but I guess cozy sometimes. I want it to be more than that. A lot of people working in craft material say well, they don't want their work on a pedestal; they want it to make you feel comfortable so you could touch it. But I don't feel that way. I want my work to be on a pedestal where someone might sit on a bench and look at it and think about it and perhaps see something in it that's personal to them. I think a lot of the craft shows are too mixed and are called decorative arts, crafts for the home. I want it to go beyond that. I'm not putting it down in any way, but that's not what I want for myself.

Q: So the organizations that are out there to belong to don't focus that way?

MINKOWITZ: Well, the American Craft Museum does. I think they have some spectacular shows and they have artists who work the way I do. There are many, many artists who are using the craft material as a vehicle

for their personal expression. But then, there are also artists who are doing beautiful production work. I think that's a different direction. I think that work is more for the home and it's work that's designed more for everyday use that's beautiful. Like a direction in beautiful stainless or beautiful dishes, the direction of feeling that things you have at home should be very beautiful and well-designed. So it's two different mentalities. And then the artists who are doing one-of-a-kind personal expressions, to me that's an art form. I think the American Craft Museum is doing a wonderful job.

Q: Are you active in any organizations today?

MINKOWITZ: In the American Craft Museum, I participate in many of the benefits, and my work has been in several exhibitions as well as benefits for the museum. And I'm in several shows that are traveling— they have a show now called Craft U.S.A., which is a spinoff from a show they had called Poetry of the Physical. It's traveling now; it's going all through Europe.

Q: Can you describe the period in which you first achieved professional recognition as an artist?

MINKOWITZ: I think probably in the seventies when the work started to become unique, different. It was an expression of materials that were used in a new way, I think. I'm working with fiber, and the fiber has become transparent, which was a new direction for me. And the forms that I've created have forms within them. I also went back to drawing by using pencil—actually drawing on the stiffened fibers. I've used paint. I think it's more a combination of what I loved to do when I was in college: the three-dimensional quality, some figurative forms, some abstract forms. I achieved a very quiet and peaceful way of expressing my thoughts. I don't think anyone else is working in that way right now. But this is something that evolved from me as a person and shows who I am through this expression.

Q: And what was the first professional recognition that you had?

MINKOWITZ: The most important thing at that time was being accepted in a show at the American Craft Museum. From that time on the work was mostly in national shows, juried shows. I won many awards. I won a National Endowment for the Arts in 1986, which was the biggest award I ever won. I've been asked to jury shows and been in numerous international catalogs. I showed in an international show in Japan, juried by an international jury. And I guess the shows that I'm in have become more selective and most of them are documented. My work is now in the permanent collection of the Renwick Gallery in Washington, the Metropolitan Museum of Art, and just recently the Erie Museum in Erie,

Pennsylvania has put together a show of contemporary basket forms. But in a situation like this I'm proud to be in the show because it's a very beautiful show and well put-together and traveling. So I guess every step has led to a more important show and a documented show. And now I'll be showing in New York, which is what I've been wanting to do.

Q: And what gallery is that?

MINKOWITZ: It's called the Bellas Artes Gallery. A gallery in Sante Fe, for which the name is more proper, perhaps, but the gallery has such a wonderful reputation that you want to keep the name. So that's going to be down on Broadway in Soho. And I think that's very, very good for my career at this point.

Q: How did you get the representation there?

MINKOWITZ: Actually that came from being asked to be in a show curated by Jack Lenor Larsen, who's an international figure in textile design himself and a past weaver. Every year he curates a show at Bellas Artes and picks about eight artists. In 1986 or 1987 I was in one of those shows, and the gallery liked my work very much and had me in a show the following year and then gave me a one-person show last year, which was what the article in *American Craft* was written about. It was a very successful show, and now they're pursuing their New York gallery, which is great.

Q: Have groups or institutions helped or hindered your progress as an artist?

MINKOWITZ: Well, they were helpful in the sense of exposing my work and publicity, and perhaps several times I won awards at annual shows and that was something I could put in my resumé. And I did a lot of teaching, which evolved from the relationship with the organizations. Basically I would say yes.

Q: How do you feel about unionization for artists?

MINKOWITZ: I have no feelings about it. I'm not very political. I never really thought about it, but I think as far as unions and organizations for artists' benefits, I'm somewhat in a different category because I really am doing this more for the love of my art than for money, I guess. My husband is supporting me very nicely so I have that added benefit of not having to worry about that. Although I'm doing very well with my work this year, but that's not my initial concern. I may be the exception.

Q: Getting back to peers again—moving up to the present. How would you describe your peers?

MINKOWITZ: Well, I have several acquaintances in the art world. I would say I don't really have close bonding friendships with anyone.

But we talk on the phone; we compare notes sometimes, and it's nice to know what other artists are doing. Sometimes other artists are experimenting with materials and techniques that affect the way I'm working, and we exchange ideas. Sometimes we arrange to show in a two-person show together perhaps where the work complements each other. So basically that's most of the association with my peers. Some of them live far away, so it's really a telephone type of relationship. I have one friend that I went to Cooper Union with who was a very fine painter, who evolved into ceramics. I keep in contact with her. She lives in Berkeley, California. And she's doing this very specialized kind of ceramic work with her husband as a partner—Eileen Richardson. And then there's another artist called Barbara Natoli-Witt. We were both cheerleaders at Cooper Union. A terrible team. I kept in contact with her because on and off we see each other's name. She's working with fiber as well, but she's doing a very specialized kind of jewelry. And it's quite beautiful. It's very detailed, very intricate. Those are probably the only two artists from school that I recall.

Q: Is there anyone that you speak to in your mind or when you're working?

MINKOWITZ: Not really, no. I think a lot of my work relates to my mother. A lot of the thoughts and feelings relate to her death. And I think that shows in my work. And sometimes the results are from that kind of feeling. Mortality. Being recycled. And seeing someone after their death. So I would say probably in the last few years most of my art work has related to her death. I think that's pretty common sometimes, digging deep inside yourself to find feelings that you have and had and perhaps feelings that you hadn't said or thoughts in that direction. I would say she's my biggest influence.

Q: Have your peers influenced your career in any way?

MINKOWITZ: No, I don't think so really. My family's been very supportive in that direction. But I can't think of a living artist who's really influenced my work. Maybe on a subconscious level. There're a lot of artists that I really admire. And you know, when I think of their work it's very different from what I'm doing; perhaps there are some similarities that I'm not aware of. But I do have some favorite artists. I don't really have that much contact with my peers except an occasional phone call or, if I see someone's work developing, in a sense maybe it makes me feel a little more competitive to drive myself a little harder, but not in any other sense.

Q: How would you describe your occupation versus your career?

MINKOWITZ: Occupation and career? Well, I guess the occupation part of it is being able to do what you really want to do and have the time to

do it. The career part I guess is driving yourself to do better and to expand and to experiment and to take chances. I guess occupation is what I do every day sitting here. And it's often tedious; it's often tiring; it's often fun. But it's just the doing of it. The career is the planning, the thinking, the goals and that sort of thing.

Q: What about your general job history from the time you began your career until now, and some of the freelance work that you've done?

MINKOWITZ: Well, my freelance career was not very long, probably two years. I was doing textile design and working for a big company called Cohn Hall Marx, which you kind of get lost in. It was a huge company. And I started off doing some colorings, which means that an artist does a design and then they give it to a colorist and they do the same design in three different color combinations. Then I sort of graduated to doing my own designs. Then I freelanced at home and did designs and brought them to studios and occasionally would sell them. That was probably— except for the two books I illustrated—my only art-oriented career job. When my children were very small I started doing commercial things and selling them to magazines like *McCall's* and *Woman's Day* and sending them on a consignment basis. They would look at it and decide whether they wanted to pursue it as an article. And then I showed in America House in New York—that used to be where the American Craft Museum is now. It was a retail outlet for artists working in craft media. I did decorative pillows, and wall hangings, and very saleable kind of craft-looking items. I did that for a while and realized I didn't want to do that. I wanted to pursue the sculptural direction. I think it was a very slow process where, you know, the three-dimensional pillow, which was used in a room setting for Armstrong Cork Company, started to become more sculptural. Like the pillow itself. First it was a square pillow, then it was a pillow in the shape of an animal form, and it just very slowly evolved into a free-standing sculpture. Then I had a one-person show in 1972 at the Silvermine Guild of Artists. And that was my first one-person show. And I had some very—I thought at that time—unusual wall pieces. I did one that was called "Icarus" and it was a male figure that was winged with stuffed forms going through the center of it with a great deal of stitchery that was similar to the fine pen and ink drawings that I was talking about earlier. And I did some free-standing white, sculptured forms that started to introduce the female form in crochet and stuffing. And it just slowly kept evolving 'til finally now these forms are open and have things happening within them, and they're transparent and I'm drawing on them and painting on them. It's a combination of my strengths, I think.

Q: Have you noticed a pattern or a progression over time again, on the career side?

MINKOWITZ: Well, I think there's a progression in the sense that you tend to repeat yourself in life. I find motifs that I did in the sixties coming out in a different way. I guess what you are inside is always there. The forms that are natural to a particular artist repeat themselves. I find I've done things that I had done earlier in a different way, but perhaps it's grown or evolved more in the sense of my expertise or my involvement with new ways of expressing myself. But I think it overlaps in a sense of who you are really.

Q: Can you describe gatekeepers at various stages in your career, those people who either let you in or bar the way as an artist?

MINKOWITZ: I've never really encountered gatekeepers except in the sense perhaps of entering a juried show and not getting your work in. But I think that's the same for most artists. I think sometimes your work is accepted and sometimes it isn't. Sometimes it's sought after and sometimes it isn't. But I've generally had success in my endeavors. You know, not right away. And I think if I didn't it was my own fault. Perhaps I was my own gatekeeper. You know, sometimes an artist might compromise a bit, and if I ever did I was always sorry afterwards: like changing my thoughts about a piece because the shape wasn't coming out exactly the way I want it to and compromising, and most of those pieces ended up in the garbage. I think you could be your own gate- keeper by keeping yourself back by not taking chances, by not growing, by not trying something new. I think sometimes artists find a way that's good for them, and it's successful, and they never take another chance in their life. You don't grow that way. I think that's your own restriction, really.

Q: Has anyone ever tried to influence your work, such as a gallery owner?

MINKOWITZ: Not really. The gallery I'm working with now is pretty free to let me do whatever I want. I think sometimes you influence yourself by saying, for example, the figurative work is selling so well. But if you're an artist you can't do that. Sometimes a client has said, "Oh, I like the abstract things much better," but if I do a figurative piece, other people say, "Well, I like the figurative things better." So it's just having to do what you feel and what you want to do without any influence. I think that's the biggest gatekeeper, holding yourself back by being influenced by what other people say. I don't even care to do commissions for that reason. Because I think that could be an influence. Although to some artists that's a challenge.

Q: Have you been approached much for commissions?

MINKOWITZ: For a while I did a couple of commissions when I was involved with wearable art for a number of years. I was doing things that were wearable art forms that could hang on a wall as well. And I did a couple of commissions, but most of the time you were asked to do it because they saw something else. And then you start doing something you've already done and the excitement of the creative process is lost because you've already done it. So for that reason I don't like to do that.

Q: Were there discrepancies between your career aspirations and your actual career opportunities?

MINKOWITZ: I don't think so. I think I'm where I want to be right now. I mean, I want to grow and I want to do a lot more, but I think everything that I've done has really progressed at a good pace for myself. I think I'm at the point now where I really know where I want to go and how I want to pursue it. So in that sense it's progressing the way I want it to.

Q: And has it always been that way for you?

MINKOWITZ: Pretty much for me. I've never really had any big obstacles or rejections. I've had disappointments, which were my own doing, probably.

Q: What would you describe as *the* or *a* major turning point in your career?

MINKOWITZ: Probably the new direction of the transparent sculptures. It was like an awakening, finding a way that I could express the thoughts and feelings that I want to in a way that seemed to be a perfect vehicle for me. I think I probably did my first transparent sculpture in 1980. Everything from that point on has been uphill as far as my career's gone.

Q: What has been your relationship to money throughout your career?

MIINKOWITZ: Well, like any other artist, I love to sell my work. And the prices have escalated in the past few years. But I never worked for the money. Again, it might be my economic situation which might be different. I did some teaching earlier, and I did some lecturing in my earlier stages. I was anxious to get paid and make some money. I guess the only aspect of making money that was important to me was as a sign of being successful or people wanting your work. I think that was more personal than economic. It was a way of confirming what I was doing.

Q: How have the costs of supporting your art changed?

MINKOWITZ: Not much. I think the materials that I use basically are very inexpensive. Most of my costs really come in photography and having slides and proper photographs taken of the work and in shipping and basically the involvement of getting your work to and from a show. I think slides and good photographs are very important because that's what your work is often judged by. The cost of my materials has always

been minimal. In the past few years I've had expenses in having boxes made to ship the work because they were being damaged in transit. So now I have wooden crates made, which is an expense. And of course it costs more to ship because they're heavier, but at least it protects the work. But if as far as materials and threads and paints, that's not really a big expense like some artists have casting and maquettes.

Q: You talked about slides and photographs. Can you describe that process of learning?

MINKOWITZ: Well, mainly if you send bad slides to a show you're rejected [*Laughs*]. If you send good slides and you seek out a photographer who has a sense of the material you're using, the way a piece should be placed, the light and the importance of the piece, your work is seen in a different light. If you're published, to have a bad picture published is depressing. You want something to be proud of, that you could show. And competitions like the National Endowment for the Arts, if you send in your best slides at least you know that you have a chance. But if you send in poor slides your work is automatically rejected. I know, I've been a juror in many shows. With poor slides you just can't tell, so you have to eliminate the work just for that reason. But everybody's been rejected, and everybody's had poor photos. That's part of it. Rejection is healthy. You know, I think if you keep getting your work into everything, you lose that drive to better yourself. And as disappointing as it was in my early years not getting into a show, there were other times where, you know, the work was accepted and given an award. So either way it's good and it's important.

Q: You mentioned awards. How would you say that grants, awards, competitions, emergency funds, any of those things have affected your career?

MINKOWITZ: Well, I think the NEA grant was probably the most important award, and it's the highest compliment. You're being juried by your peers. It's very competitive, and there're different levels of grants. I won one of the highest, which was very rewarding because I had never really pursued a grant. You know, I frankly felt a little guilty because I really didn't need to have the money where I'm sure there were other artists who needed it. But I found the more I exhibited with artists of a certain level, they all had NEA grants and I think that was very impressive. And I thought, you know, if I could get a grant I would like to have that on my resumé. Of course I used the money very nicely for my work, and it was nice to be able to use my own money for my boxes and my photographs and things of that nature. So it was rewarding to me in more ways than one.

Q: Was there a particular time in your career that the money would have been most helpful?

MINKOWITZ: Sure, early on. [*Laughs*] I mean, I always sold, but it was very minimal at the beginning, a couple thousand a year maybe, that's it.

Q: Would you say that the NEA grant, I mean, aside from the sense of validation and the peer group it put you in, would you say that it's actually enhanced your career?

MINKOWITZ: Definitely. Because it gives you a tremendous feeling of worth and self-esteem and accomplishment. That's one of the characteristics that encourages you to push harder and work harder, because you've received such an important award.

Q: I just want to backtrack to something you mentioned before. You said that you had done some teaching and lecturing. When did you do that?

MINKOWITZ: Probably beginning in the early seventies to the eighties I did some lecturing and taught at Arrowmount School of Crafts, Brookfield Craft Center, Eastern Connecticut State University in Connecticut. I did a small slide presentation at Yale University, and I did a workshop at South Dakota State University. It was about women in the arts.

Q: What did you teach?

MINKOWITZ: Well, it's very hard to teach in a craft-oriented material because you start teaching the basics of crochet and you really don't get into the art of the object because first you have to teach the technical skills. So often if the students were more advanced and already knew how to crochet or do fiber techniques we would basically pursue a sculptural direction, experimentation of materials and shapes and forms. It's basically a traditional art class but using fiber materials and found objects sometimes, combining them and using any material the student would want to work with. I usually lectured on my own work showing slides of the progression of my work and the meaning of some of the forms, and people always want to know a little bit about technique.

Q: Do you still do that?

MINKOWITZ: I don't really like to, no. I've stopped. In 1987 I did a presentation at the Brockton Art Museum on my work, and that was the last time I did it. I just really want to work all the time. I find teaching at times very enjoyable, but you know, I just sit there all the time wanting to work myself, so I stopped. But it was interesting.

Q: What have been the importance of physical location and workspace at different stages in your career?

MINKOWITZ: I basically was able to work anywhere I lived. I always needed a big room with all my supplies in it, but often find an intimate

corner to work, as I'm doing in this house. Being near New York is important more now than before. I find myself going in much more often to see gallery shows and look at different artists' work. I think it's interesting. You know, I never did that before. I used to just work in my own little shell, but I like to see what's going on, not just in fiber, in all media.

Q: What kind of control do you think that you exert over your own destiny as an artist?

MINKOWITZ: It's hard to say. I think motivation and, as I said before, taking chances and experimenting really do create a vehicle for pushing yourself and going beyond your limits. I think that's basically the strength of it.

Q: How have you interacted with the public over the span of your career?

MINKOWITZ: Mostly I guess through presentations and teaching and I've met several collectors who've bought my work. And it was interesting to go to their homes and see their collections. Some of them have invited me to see the other artists they collect. And we've started collecting ourselves, other artists' work, which is very, very rewarding, I think. To have a group of other artists' work that you can display in your home and really enjoy being with. That's important.

Q: What are your own criteria for success as an artist?

MINKOWITZ: Basically doing what you want to do. Following your star. Experimenting. Motivating yourself. Not giving up. I always wanted to be in quality shows and have my work documented and catalogued. I guess to some artists just working and getting the work done is enough, which is basically the most important aspect of it. But I don't know anyone who could say they don't want recognition. And I think some sort of recognition is very important to motivate yourself just to continue. I don't think I could be happy if I just made hundreds of pieces and put them in the room. I'd be happy doing it, but I think every artist needs some kind of approval. And I think everybody in life does to an extent.

Q: Your criteria—would you say that they're the same that other artists have?

MINKOWITZ: I think it may vary a little bit. I think some artists find a great deal of satisfaction in teaching. And I've heard many artists say that they love teaching because it stimulates them. They get excited by ideas. Not that they're copying them, but they get stimulated by other people's ideas. But you can get stimulated that way just by reading or going to shows, which is what I like to do. Just to see what other people are doing. And often it's surprising because there's so much similarity.

You go to a show and artists have similar themes and similar feelings and fears and, and it's a human experience to have the same kind of feelings often. But I think the success is to express it in a unique personal way that no one's done before.

Q: Do you have a number of central ideas that you keep working on throughout your career?

MINKOWITZ: My themes are fairly universal themes that I'm sure, are prevalent in many, many artists' works. In my situation it's containment, death, recycling, mortality. They're all universal themes and fears that you see in Woody Allen's movies, his fear of death. I think everyone's afraid of dying, but I think it's expressed in different ways. My work also deals with traps and cages. I think about the human experience. People are often trapped in their jobs, trapped in their marriages, and my vessels are really metaphors for these kinds of experiences. And I think I'm expressing it in my own very personal way, which is what makes an artist's work different.

Q: Are there particular periods of work that you feel more satisfied with than others?

MINKOWITZ: The newer period. This last three years, I think, is the period that most satisfies me. Everything I want to say is coming. And I struggled for a long time. The work was heavier and stuffed and more pillow-like and I wanted to get away from this baroque feeling of detail and texture and simplify and modify and have the forms simple and pure. Where the earlier work of the sixties was a birth of the direction in fiber art. And fiber was used to the most detailed, the most textured or most baroque kind of feelings. The artist was experimenting with multi-techniques and heavy threads and thin threads and everything was similar to the flower children, jeans designs. Everything was very detailed, and it was just too much.

Q: What are your feelings about critical review of your work?

MINKOWITZ: Well, I like when it's good. [*Laughs*] But you learn that not every critic has the same sensibility, the same feeling. There're people who're going to like your work and people who aren't going to like your work. Now I don't think it would bother me. I think maybe it would make me think or motivate me in a different way. But if it's not a good review and it makes you think about what the reviewer said, it's fine. Naturally, you hope it's good and that your work is admired, but it's never always going to be that way. Just have to accept that like a Broadway play. Someone's going to love it and someone's going to hate it. I think if it's a bad review, I think people who read the article often, fortunately for the artist, remember the artist's name. I've read many

reviews that weren't so great, and then when I see that artist's work again, I don't always remember what was written, but I remember the artist's name. So I think in a very small sense, it's publicity. If I see a photograph of someone's work in the *New York Times* I often remember that artist's work and I don't always remember what was written about it. And I think you form your own opinions, too. I think publicity is better when it's good, but publicity could be okay if it's not perfect. You know, if it tears you apart then it's not too good.

Q: You mentioned that you read reviews. Where do you read them?

MINKOWITZ: *Art News*; I read the *New York Times*; I read the *American Craft*. If I'm following a certain artist's work I admire and he's having a show, I try to read what's said about it to see, you know, if it fits in with my feelings or if it opens up a new direction for me to have more insight into the work. I think that's important. One person sees something totally different from another person. You might look at a piece of artwork and not understand it at all and then read a review and it might enlighten you, which often happens.

Q: How satisfied are you with your career?

MINKOWITZ: Well you know, you always want to do better. You always want the work to have more meaning. Good things have been happening in the past few years, but I don't think I'm ever satisfied. I think to be successful you can't be satisfied. You always have to want more or better. Sometimes I do a piece and I really feel good about it; then in a week, I have different feelings about it. But I don't think you should want to be satisfied. I think if I'm satisfied it's the end [*Laughs*]. It's like what else can I do? But like a performance, in any media you always think you can do better or strive to do better. I think that's what makes you plunge forward, really.

Q: How about the other side of the coin? What about frustrations? And resistances to professional development versus artistic development?

MINKOWITZ: Well, I think it's frustrating to work hard on something and it's not coming out exactly the way you want it. And I think it's frustrating to search out, for instance in my work, ways of stiffening the work and not finding the right thing. And it's constant experimentation. Or sometimes you have technical problems with buildup of materials that you have to start scraping or pulling off. So I think in a technical sense, there are setbacks, and often, being categorized. People are always trying to find a name to call your work, and why not just call it art? It's like you're looking for something just for the sake of having it sound different. I think work should be judged on what it is, not what materials you're using. But the basic frustration has been, is it craft or

is it art? I find that very frustrating. I don't even want to think about it anymore. You know, they call you a craftsperson or they call you an artist, or fiber artist, that's frustrating. People try to categorize you and you just want to do your art and do your work and have meaning and not find these little names for your work. So that's a little frustrating. I just don't like the word "craftsperson." The connotation is of hand-icrafts, and I think that's not really the best name for the whole movement. In fact, I was at a conference at the American Craft Museum, and Patterson Sims, who's a past curator of the Whitney, said "The first thing you have to do is change the name 'crafts' because it has such a poor connotation." I mean, what do you call it? I guess they feel they have to differentiate because of the materials, but artwork is crossing over into so many boundaries. And the materials are so mixed that I think an artist should just be judged on the value of his work, not what the materials are. That's my biggest frustration. I mean, Rauschenberg's most famous painting has a quilt in it with a pillow, and it's in the Museum of Modern Art. And you know, he's not a craftsperson because he started out as a painter. I think one of the problems is people who started out as weavers are called craftspeople and people who started out as painters or sculptors are called artists. I started out as a painter and a sculptor, and I don't really want to be categorized as a craftsperson. I want to be just categorized by my merit not the material. And I'm sure a lot of other artists feel the same way. But you know, as I said before, I think there are artists who want to be craftspeople, and that's fine. It's not putting it on a lower level; it's different.

Q: Can you give me an example of your greatest satisfaction and your greatest disappointment?

MINKOWITZ: I guess one of my greatest satisfactions was the NEA grant and getting into the exhibition called "Fiber Revolutions." It was a major exhibition that was in the Milwaukee Art Museum with very distin-guished jurors, and I was very excited to get into that because I had just started my new direction with the open meshlike sculptures. Also the grant came at the same time. It was I guess my greatest satisfaction. And I guess my greatest disappointment is in work that I'm not happy with. Or not getting into shows that I would like to be in.

Q: What has been the effect of the marketplace on your work?

MINKOWITZ: Well, this last year I have sold more than I ever sold before. I don't know if it's the new gallery or in combination with the growth of my work or the fact that collectors are more interested in textile art or fiber art or art. But I find that museums and collectors are very interested in my work right now. And I think it's a trend in general that

people are turning from monumental sculptures and huge paintings to maybe more intimate types of artwork. I think the work in general has a lot more meaning. It's not only about process. It's more about messages and . . . meaning, really. There are some objects that are just beautiful objects that people want to collect, but I think the whole direction of artists working in craft media is going to a more fine arts mentality. And also, I think the scale of a lot of the work is more collectible. It's easier to display and have more pieces of. I think not many collectors have enormous spaces to have huge works. I think the work is on an equal level with the bigger works, it's just easier to collect.

Q: How has your relationship to your materials changed from your early training to now?

MINKOWITZ: Well, my early training was painting and graphics and sculpture, and it's changed; it went in the sixties and seventies to solely fiber, and now I think I'm happier because it's going back and combining the paint and the drawing and the sculpture. And I've evolved into the things that are most important to me. And I'm able to combine that in the work I'm doing now. So that's worked.

Q: How have your absolute basic requirements for being able to do your work changed since your early career?

MINKOWITZ: I just have more time to work. It really hasn't changed that much. My goals are pretty much the same. To do basically what I want to do and try to do it in a special way.

Q: What one major point do you think you would make to young artists about a career in fiber arts?

MINKOWITZ: To pursue your goal. To be inspired by other artists but not imitate other artists. I think many young artists may have mentors or may have work that really excites them. And from some of the shows that I've juried I've seen a lot of work that was very derivative of successful artists' work. If you're inspired by another artist's work you should use it as a stepping stone to your own work and not try to duplicate that; I see that very often when I jury. And I think, in terms of being successful, you should search for a way of expressing what you want to say in a unique personal way, and not fall back on someone else's work. And I think just perseverance and experimentation and not getting into a rut where you never grow; where you just keep doing the same thing over and over. I think you have to experiment and try new things and see what's going on.

Q: Is there anything that you wish someone had said to you at a certain point?

MINKOWITZ: Yeah, at times I think it would have been helpful if someone would have said "That's terrible." [*Laughs*] You know, I always really was encouraged.

Q: But would you have believed them?

MINKOWITZ: Probably not.

Representative collections include: Private collections: Jack Lenor Larsen, New York; Corporate: Condec Corporation (Greenwich, CT); Public: American Craft Museum (New York, NY), Erie Art Museum (Erie, PA), Housatonic Community College Museum of Art (Bridgeport, CT), Josephus Daniels Foundation (Raleigh, NC), Massachusetts Institute of Technology (Cambridge, MA), Metropolitan Museum of Art (New York, NY), Renwick Gallery, Smithsonian Institute (Washington, DC), Wadsworth Atheneum (Hartford, CT).

Professional affiliations: Represented by Bellas Artes Gallery (New York, NY and Santa Fe, NM).

Honors: NEA Visual Arts Fellowship Grant, 1986; "ArtQuest '86," 1st Place Winner, Fiber; "Visual Reservoirs," Monterey Peninsula Museum of Art (CA) 1st Place Winner, 1985; "The Figure: New Form/New Function," Arrowmount School of Arts & Crafts Award, 1983; Women in Design International Competition, Certificate for Outstanding Achievement, 1981; Purchase Award, Mordecai Square Historical Society, 1978; "Fiber Structures," Convergence Fiber Studio Award, 1976; Marietta College Crafts National, Judges Award, 1976; American National Contemporary Art and Craft, Slide Competition, 1975.

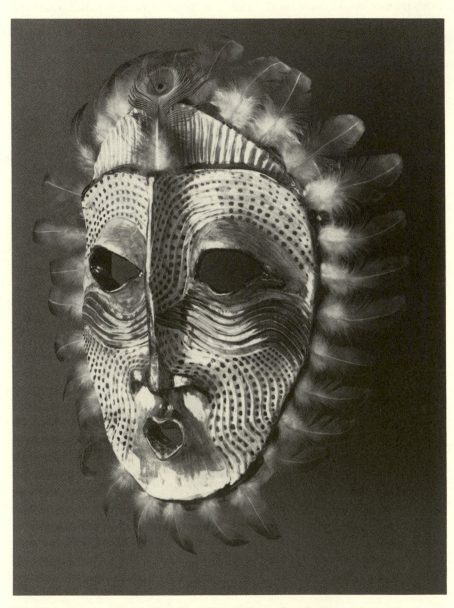

"She Who Watches" by Lillian Pitt, 1989 (10″ x 14″ x 4″; clay, anagama fired, and mixed feathers). Photo by Dennis Maxwell/Lightplay.

LILLIAN PITT

B. Warm Springs Indian Reservation, Oregon, 1943, Warm Springs-Wasco-Yakima Tribe. Associate Degree, Mt. Hood Community College, 1981. Lives and works in Portland, Oregon. Exhibits internationally.

Q: Would you describe your family and early childhood?

PITT: My family, they were great fun. They had a sense of humor and were very supportive in everything we did. I'm the middle child with an older sister and a younger brother. And we were considered kind of wild kids 'cause Mom and Dad let us do everything we wanted to do other than creating harm for ourselves or others. We lived on the reservation in Warm Springs, Oregon. We had the hills and horses and everything that was there right at hand. So if we wanted to go ride horses, we'd go ride horses; if we wanted to go swimming, we'd go swimming, Mom and Dad knowing that we were going to be home for dinner when we got hungry. It was more or less learning at our own pace, and Mom was a real traditional sort of Indian. She believed in the Washat services, which is a special native American religion. Dad was a Presbyterian and sang in the choir, and Mom would go to all the churches because she liked seeing the people. We would tag along and were always with Mom and Dad. They didn't have any babysitters. We were always together. Since Dad wasn't traditional, he wanted us to always speak correctly, to carry ourselves well because he didn't want us to be just regular reservation Indians (as stereotype Indians viewed by non-Indians). He wanted us to

learn, get out of there, and contribute. And Mom always said, "Well, whatever you do, do the best you can, then follow your heart." Those were the best words, I still remember them. I'm not totally secure, sometimes I doubt that what I'm doing is the right thing, and when I think back about what they said, it keeps me going.

Q: Did either of your parents do any crafts at home?

PITT: Well, Dad painted fun things and did a lot of drawing for us. He was real good at drawing. And Mom did beadwork. She made moccasins and coin purses and cute little pins that she always loved making. This was when her hands were better. She was older when she had us so arthritis set in; she couldn't do it too long. And her aunt, my great-aunt— we called her Grandma Mollie—tried to teach me how to do the twining of the cornhusk bags, and apparently I wasn't very good because she threw up her arms and left. [*Laughs*] So I never did learn how to make the cornhusk bags, and I've always wanted to learn how to make the baskets. Mom showed me how to do beadwork, but I didn't seem to have the patience for that. Dad always would be drawing fun things for us, drawing cartoon characters on our rain slickers and that type of thing. And my Uncle Johnny worked in charcoal, but he had always been supportive of my sister and was teaching her drawing. I was always just the tag-along, the one who wouldn't be taught because my sister was older and she got the most attention. So I never did think about art when I was growing up. Or even thinking of myself as artistic, although I loved looking at beautiful things. My sister still does painting, but she doesn't do it full-time and does it just when she feels like it. She's not committed; it's not what she plans on doing. And my brother is interested in sculpture but hasn't pursued it.

Q: When you were watching your family and your mother was doing the beadwork and your father the drawing, were these just part of everyday life? Were they considered art? And was art considered something special and different? Or part of everyday life?

PITT: It was part of everyday life because in our culture, in Warm Springs—there's really no one word for art. In fact when Mom was older she would forget what we were doing for a living. She had some little strokes, and she said, "What do you do?" I said, "Well Mom, I make art." And she said, "What's art?" And—gee, that's a loaded question. And I said, "Well Mom, I make pretty things. I make things that people put on their wall." And she said, "Oh well, that's good. You must do the best you can" and, I thought, well, there really is no word for art.

Q: How did the members of your family feel about the talent that you had even then?

PITT: Well, I don't know if I displayed any artistic talent. I was kind of a rowdy kid.

Q: What educational experiences provided you with early validation or resistances?

PITT: Throughout high school—I graduated from high school in '61 and those were the days that there wasn't much support for the arts. Be a typist, be a secretary, get married, find-a-husband-to-take-care-of-you type thing. And so there was always that resistance of teachers accepting artistic endeavors. I knew I didn't want to follow that; I didn't want to get married. I knew there was something else out there. So there wasn't any support for the arts. I think even now there really isn't much support for the arts or people choosing the arts as a career. Although there's less push on marriage, there's not that support. In a small town like Madras, Oregon or a reservation like Warm Springs they want you to "get a real job".

Q: Did you have any art in grade school?

PITT: No, I didn't. Well, just the normal amount of art, and I enjoyed it. There wasn't any focus on it. I never did take art in high school either because I figured my sister would. She was always the one given all the art materials. What really got me going was just looking at flowers. Mother Nature, more or less, and I would get spring fever. I remember this back from a tiny child; I would go out and get this terrible spring fever and just go lay on the ground and look at the flowers. And then seeing the drawings that my uncle had done was really wonderful. They were charcoal portraits. I thought it would be so nice to be able to draw faces. So that kind of stuck with me. I love going to museums and looking at the art there. A lot of which I didn't understand, but I knew someday maybe I might.

Q: When did you become an artist?

PITT: Actually it was in 1981. I had always done embroidery and needle-point but had never done my own designs. And I didn't want to do beadwork because that was too time-consuming and slow for me. I just wasn't very patient. So I took a ceramics class at Mt. Hood Community College and it was love at first touch. It smelled good, it felt good, and it was just magical. I loved doing that. I didn't know anything about ceramics, so I just hung out in the library to find out all about ceramics. And being really engrossed in the teacups of Japan and the wonderful books on ceramics. We had *The Mudpie Dilemma*, Tom Coleman's book, M. C. Richards' *Centering*. I just read as much as I could and focused on ceramics and just loved it, always knowing that it was a hobby type thing or something to do, because I didn't know anything

about it. So I did not think of ceramics as a career. Because my back is bad, I couldn't throw at the wheel anymore. Vance Perry was the instructor then. And he said hand-build, and I didn't know how to hand-build either. He said, "Well, just take some clay home." So I did. I brought home twelve pounds of clay on the bus; I didn't even drive then. I lugged some clay home and was sitting in my living-room wondering what to do with this bag of clay, and then I looked up. I have some Northwest coast masks. And I thought "Geez, I'll make me a mask." And it was just magic, you know. Just total magic. I made the worst mask you had ever seen. And by the time I did get it finished I didn't know how I was going to fire it! I told Vance "I want color— how'm I going to get color?" He said, "Well raku fire it," and I said "What's that?" He spelled it for me and said, "Go look that up in the library." And all those nice teapots I'd been looking at were raku fired and I thought, things are just falling into place and so I did raku fire the mask. At the end of the term, we had our critique session and Vance said, "Well, if you work hard, if you're really lucky, you might be able to have a show, or sell a piece or two." And I thought, "Oh, what a silly notion," that just made me chuckle. So then I went on to Portland State and was accepted in the undergraduate program in social work. But then I went back to Vance and I said, "Well Vance, how do I do this?" meaning making art. I said, "Maybe I'll give this one summer." He said, "Well, there's about ten steps to the firing process. And I'll help you." He helped me, and I never did go to Portland State.

Q: Was there any particular point at which you suddenly felt you moved from being a hobbyist and being very interested and a learner into recognizing yourself as an artist?

PITT: Well, it happened that fall. I still don't know whether I'm an artist or not. But, I had seven pieces by then and had terrible pictures of them. I didn't know anything about photographing my work. So I had Polaroid pictures, and R. C. Gorman was in town at a gallery, and I thought, "Gee, I'm going to go look at this artist." I've always liked him because he was a Native American artist, and we all have a sense of pride if there's a fellow Native American artist doing good. And so I went to the opening and had my pictures with me. I started talking to him. He was asking me questions to which I had to make instant answers, I mean snap decisions. And he said, "Well, what do you do?" I said, "Well, I'm an artist." And he said, "Well, what do you make?" And I said, "I make masks." [*Laughs*] And he said, "Do you have pictures?" And you know, my heart was just booming because I don't call attention to myself and I'm usually really laid-back and shy. It was really hard being so forward.

I showed him my pictures. He said, "Well, do you sell them?" "Yes." And he said, "For how much? And you know, he had to just drill me with these questions, because I didn't know what I was doing. I was so afraid. And I said, "Well, this one's a hundred dollars and that one's a hundred and ten because I like it more." [*Laughter*] Well he bought two. He said, "Your work is good. I'd like to buy the two." I just about fell over. He said, "You should show your work here." (It was at the Westwood Gallery.) "I'll talk to the gallery owner for you." And he did. And I just didn't know what to do. The gallery owner had said, "Bring your work in next week" and all I had were seven pieces and R. C. Gorman got two of them. So that was five. I took the five, and the gallery bought two pieces. And that's when I figured well, I guess this is what I'm going to do. It was just magic, just happened like that. And so I told Vance, "Well Vance, maybe I'll give it a little longer. What step are we on with the raku firing?" And he said, "Well, I think we're on step five. Just keep working at it." So I'm still working at it. He's still helping me and it's been nine years.

Q: Where did you go after high school and what kinds of subjects interested you?

PITT: I left home the day after high school and had no idea what I was going to do with myself. I had applied for college at Marylhurst and was rejected because my vocabulary was too low and that was what they looked at. I thought I don't ever want to do anything like laboring over increasing my vocabulary. I was doing the laundry at Hawthorne and saw a beauty school across the street so I thought I'd go to beauty school. So I went to beauty school and that was really fun 'cause it was doing something with my hands—and creating. I was an excellent student because I just loved what I was doing and loved learning. I was learning balance and symmetry and how to move the hair and do all that challenging stuff. I like the hairstyle and the haircutting the best of all. Then my back was still bad so I started having a series of back problems and eventually surgery. So I quit hairstyling. I went to get my license as a hairstyling instructor. I went to Toronto to this fancy hairstyling school and that was great fun. I'd never been on a plane before. All these challenges came and then I became an instructor and had to quit that.

Q: Who were your peers at this point?

PITT: Having always been kind of a loner, at beauty school there were just a few people that were good friends. We were all supportive, and we were all wanting to do well. I didn't seem to have much patience for those that were just there—passing time away. There were all these

energetic people, and we always supported each other and studied together, and we were always there for each other. (The same with going through the mental health program.) I still see the same people. And there were only just a couple of people that I became close to. We still see each other and talk to each other and support each other, and, although I'm in a different field, we know what each other's talking about, and it's nice having that mutual support. I'm always wanting to inform and, and it never bothered me to ask for help. I've always had support.

Q: Did you have any particular role models or mentors at this point in time?

PITT: Well, my teachers in beauty school and also at the community college, and all the teachers who were out there—I really admired them for doing what they were doing. They didn't have to do that. I realized they made choices, and I like people who make these kind of choices. Then I started finding out about who knew what in the art; I would try to find a way to be friends with them and then they would share and be supportive. So it was always reaching out.

Q: Did any of these role models or mentors or peers relate back to your Indian heritage particularly?

PITT: Other than my family, not really. Because when I was in the sixth grade we moved from the reservation to Madras, so I was a little distant from the extended family. The elders were always there and always behaving the way they were supposed to behave. They still are role models for me. Although it's kind of sad—a lot of them are dying. I'm running out of elders.

Q: What qualities do you feel you needed most during this period?

PITT: Perseverance and patience and a willingness to risk. I needed that because it's always been scary because I don't really have a sound education base behind me. So I'm always intimidated by those that have gone through the education process. So I had to fight that feeling, you know, and I think life offers a lot! Life is a big classroom itself. [*Laughs*] I think I've done well.

Q: In working with the various materials, at first in beauty school, then as a teacher, and as you discovered clay, how would you describe your relationship to the materials?

PITT: Oh, I'd say with the malleability of the hair and pushing it in its wet form just to create different looks, different forms. And the same with the clay. Just moving it around and its malleability. Being forgiving, I can start over. And then being unforgiving when I'm too harsh and, and the same thing with hair. It's always that direct contact with my hands.

It was nice not having my clay talk back. [*Laughter*] Telling me what to do. [*Laughs*] And be unsatisfied with what I do. I mean, my clay had total acceptance or rejection. You know, it was one or the other.

Q: Do you think your training during this post-high school period adequately prepared you for a career as an artist?

PITT: Well, the hairdressing and dealing with people that are sometimes a little cantankerous and of all ages kind of helped. And always working towards a satisfactory solution. And then with the mental health program—we had to take group sessions and private counseling sessions where we were able to learn about ourselves and accept ourselves. And so that was kind of a self-healing, intense two-year program. And group counseling and interviewing skills have helped. I probably couldn't have done what I'm doing now without that background.

Q: Did you have any help with business skills?

PITT: None. I'm still learning and I'm still deficient at that. And I'm still looking for help.

Q: Once you'd moved into clay or even earlier, did you give yourself any particular benchmarks for where you wanted to be?

PITT: No, I've always felt guilty about that, thinking I'm somewhat lax because I don't have these goals. Once in a while I have these little private things. Like saying well I'd like to have galleries in this area and in that area and I'd like to be in such and such a collection. Or it would be nice to be in a museum. And everything I've really wished for has happened, so you have to be careful what you wish for.

Q: What were the first organizations you joined as an artist?

PITT: Oh, the American Craft Council in about '83. Getting the *American Craft* magazine and finding out what's going on. You know, it took me a couple of years to find out what's going on. And then I joined the Oregon Potters Association. Just having that sense of kinship, you know, is nice, although I never attended the meetings. But I'm a terrible joiner and a terrible go-to-meeting person. As I got more confidence I joined the Native American Arts Council and was their advisor to the executive board. And that was big learning experience. It's a little umbrella group, a subsidiary to support the Native art collection at the museum. That was where I was the most active. And Local 14 Lake Oswego Arts and Crafts League liked me mostly because I sold a lot during their art show. They have a sale every October, and I submitted my work and was accepted. And each year I sold work. Apparently I met their selling criteria so I was asked to be a member.

Q: And is that still going strong?

PITT: Uh-huh. And doing just great. They're making me work now, forcing me to be a part of it.

Q: Have any of these groups or institutions that you've belonged to helped or hindered your progress as an artist?

PITT: Belonging to the ATLATL. It's a national Native American art service organization. And they have helped groups like Women of Sweet Grass Cedar and Sage, which had a national touring show of women's art—both contemporary and traditional. It just seemed they have helped a group of women artists show their work all over. They also helped with getting some of these shows toured. It's for both men and women, and both traditional and contemporary art. They're a networking organization too. That really helps because a lot of us women keep in touch. We're always networking for shows and different things that are going on. It's a really good organization. As with Local 14 and the Native American Arts Council it just helped me get to know everybody. But no one has hindered me in any way.

Q: Describe the period in which you first achieved professional recognition as an artist.

PITT: It was when I was accepted at a show at the Gresham City Hall in 1982. Right at the beginning. And although I had been in other shows, it still made me feel good. Then I was showing in Seattle and was there during Native American Art Council's big convention. And so a lot of the Native American speakers—the artist speakers, came into town and went to the Sacred Circle Gallery and saw my work and fell in love with it. Jaune Quick-To-See Smith asked me to show with her group of women—Women of Sweet Grass Cedar and Sage, which was to tour the United States. So I had my first piece touring in that. That was really a good feeling. The hard part was having to write a statement about my work [*Laughs*] because I still didn't know, really, what was going on and really didn't know why I was doing what I was doing.

Q: Do you have strong feelings about showing with Native American groups, and are you interested also in showing in non-Native American galleries or non-focused Native American galleries, as being an artist in your own right not just defined by your background? Do those issues come up for you?

PITT: All the time. All the time. And although I don't ever want to refuse showing in a Native American group show or in a Native American gallery, I would submit slides to different galleries and they would reject me on the basis that it is Native American, or suggest I try Native American focused galleries such as Quintana. That happens all the time, and I don't know whether it has to be addressed. Even when I take other

Native American artists who are very contemporary, whose work does not fit in Native American focused galleries like Quintana's to contemporary galleries (there are two really good galleries in town), they say, "Well, why don't you try Quintana's?" That really makes me mad because these artists should not be pigeonholed like that and should be given a chance. There are some artists now like James Lavador, who is showing, you know, at different galleries in his own right, not being known as a "Native American artist." It's a big problem and it's reversing now to the point where there's a lot of tokenism going on with the jurying committees and things that need minority representation. I seem to be the token Native American artist in Portland because I'm the most visible. So I'm being constantly bombarded to be on juries, to fill a minority quota on such and such a committee. I don't resent it, but I know what's going on. It doesn't really make me feel that good. I'd rather be chosen because of my work or my skills. I've refused to send some of the things because as I said, I'm not an administrator. And I said maybe another Native American can fill your bill. I feel like it's a big commitment too when things are going on, such as a call for slides. I call up and I say, "Have you contacted Native Americans for this art?", and they say "No." Or I'm always calling to see if they have a minority on their jury. So it goes both ways. It's tokenism, and it's me being active and making sure they're doing what it is I think they should be doing. But when talking to other women of color who are non-Natives— they're getting the same treatment, and they're kind of getting tired of it, too. I feel the sense of responsibility that if I don't do it, that the quality's going to be lessened. Because I know what's going on in the Portland art scene, and so I do an awful lot of that type of stuff, whether I want to or not. Just because I'm the only one around that will do it. It's very important. But it takes me away from my work.

Q: Who are the group you rely on now as your peers?

PITT: Other artists. Other Native American and non-Native American artists. I always know where they are, what they're doing, and we're always calling each other and supporting each other. They're always saying, "You can do it, you can do it, don't give up, you can get it done, we know you." When I received the Governor's Art Award everyone was there that was supportive, and it was just wonderful because I was able to thank all of them at one time. I feel like I'm part of a weaving and they're the other components, and we all make this wonderful fabric—that I'm a project of my community. So we're always there for each other. I don't feel like it's anything I've done on my own. There are people like you that have been nice to me since the onset, and things

like that that I'll never forget. So I'll never get a fat head because I know how hard it is. I've worked hard and a lot of people have helped me.

Q: Describe the gatekeepers at various stages in your career—those who let you in or those who barred the way for you as an artist.

PITT: Well, those who let me in, I think, were all the Native American type galleries who welcomed me because my work was different and innovative, and they were always supportive. And then the other Native American artists that were in influential positions that could call me in to be part of their group show, like Jean Lamarr. They were always opening the door for an opportunity to either show my work or go and give presentations to increase awareness of my work. And those that have hampered it are those that say, "Well, your work doesn't suit us because it's Native American; it should be in a Native American-focused gallery." And people that don't understand that it's a new art form, it should be labeled as such. Because I use feathers, that makes it Native American, and I use beads. Those that aren't willing to take a risk on my work, and I imagine people are still grappling with where to put me. You know, I'll always call myself a ceramic artist, a potter.

Q: Were there any particular individuals who worked as gatekeepers in your life?

PITT: Well, people like Jaune Quick-To-See Smith, a Native American artist that lives in Santa Fe, and of course, R. C. Gorman who first bought my work and wrote letters of introduction so I could get some grants. And he got me into other galleries. And the people at the Heard Museum. And then I have collectors of my work, like Bunnie Ray, who bought—I think she had twenty-two pieces, which was just amazing. She kept my phone bill paid for years and years. I mean, this lady was wonderful. And so just with her financial support I was able to keep going until I was able to sell a few pieces to make my own contacts.

Q: What are the discrepancies between your career aspirations and your actual career opportunities?

PITT: I don't think there are any other than just showing my work as mainstream art. I was accepted at the American Craft Museum for their Bewitched By Craft auction for one year, then rejected the second year. But I know there'll always be opportunities. And I don't worry about what it is I'm going to be doing so much because things happen all the time anyway that keep me busy.

Q: What would you describe as the major turning points in your career?

PITT: I think when I got accepted at the Heard Museum and in the Third Biennial of Contemporary Art. It wasn't a crafts show, it was an art show. And I think the Governor's Award has been really a major

acceptance by my state, although I think some of it might be political too. But that's okay. It still makes my people at home proud. You know, it makes the young kids proud and I can accept that. And ten years from now, who's going to know that there was a little bit of tokenism. And so that has helped my career, but has also increased my level of responsibilities to my community.

Q: What has been your relationship to money throughout your career?

PITT: I don't ever worry about it. And I feel like there's a big flaw in my personality because I don't worry about it. I know things always work out, and it's feast or famine with my work, depending on the shows. I've never given it much thought. It's not why I do my work. Money is not the main purpose. I like to have my phone bill paid and to pay all my utilities and clothes bills, but it's not my main purpose for creating.

Q: How have the costs of supporting your art changed since the beginning?

PITT: Oh my, by just presenting this professional appearance, and increasing my visibility by making brochures and getting my pinback cards, all those marketing tools to look really slick. Having to change my sense of aesthetics and marketing value is expensive.

Q: How have grants, awards, and competitions affected your career?

PITT: I got two Metropolitan Arts Commission grants and that really did help. They helped me show my work and then another one helped me go and do things I wouldn't have done before. They bought me some time. I was able to do a one-woman show and then was given the money so I could make a brochure and the money for mailings. And the competitions—I don't think I've done many of those here in Portland. You know, I've never been accepted in Art Quake and the Biennial. I've always been rejected. And also for the Oregon Arts Commission fellowship—I've applied I think three times and been rejected. I don't know, if I tried again I might get accepted but only because of my name, the familiarity of my work, and I'm Native American. You know, I feel like if I went ahead and applied, I would get it. And some artist who really needs it might not get it because of me.

Q: Has there been a particular time in your career where such money from an award would have been particularly helpful?

PITT: When I was first starting out I didn't have any galleries. It was still a trial period, but I really wanted it to work. And I had no other income, that part was really scary because it was tight and everything was so insecure. But then I didn't have the astronomical phone bills either. You know, I didn't have a studio to take care of then and even this last month has been really tight because I was focusing on my one-woman show

at Kahnecta with thirty-eight pieces. So I pulled all my pieces from all the galleries, so no one had anything to sell. So there was no paycheck coming. If I could just get enough money to keep me going for another month, it would really help. And that's usually when something comes up. Like I sold thirty-six pins, and so that'll take care of the phone bill for this month until I start getting my wages from Kahnecta. I sold eight major pieces there. I'm so pleased, and to special people, too. One lady, pregnant—she and her husband drove all the way from Seattle—she had her little wad of money, excuse me, her big wad of money and bought two pieces. She had saved a thousand dollars in cash and was hanging onto it between her hands like a child buying candy. They picked out their piece, I took it off the wall and let them take it home. And they got back in their car and drove back to Seattle. Isn't that something? That's over 700 miles. I was so overwhelmed with that.

Q: Have you ever received emergency funds?

PITT: No. Other than from my mother when she was alive. [*Laughs*] I call that the Pitt Foundation.

Q: What has been the importance of the physical location and workspace at different stages of your career?

PITT: It's always been at my home; I've never tried a studio away from my home. I like it because I can work whenever I want to. And I can work solo, which I really enjoy doing. It's hard for me to work with other artists in their space and try to develop my territory. I'm not good at that. So having my studio space behind the house here really does help. Although it's too small. I'd like a barn. Just a big barn. Portland's good because I'm close to everything. I'm close to the galleries and to the museums, although I don't get to them that often. But I would rather be here than any other place; I don't see myself moving.

Q: What kind of control do you think you exert over your destiny as an artist?

PITT: Absolutely zero. I don't even have any control as a person, as a human being [*Laughs*]. I think there are forces working that I don't know about. Somebody has a plan for me, but they're not letting me in on it, so I just have faith and keep going.

Q: What are your criteria for success as an artist?

PITT: I would say after a commitment is made to the gallery you need to follow through, keeping in touch with your gallery, letting them know you've got new things, and keeping them abreast of what you're doing. And if you're going to have a show at such and such a time, have your work there early. That is one of the most important things—following

through. And getting your work there on time, if not early and giving information with your work on anything important. A lot of the galleries seem frustrated when there's not enough information.

Q: Do you have a number of central ideas you keep working on?

PITT: It's mostly dealing with people and animal images and this concern I have with the earth; those are always my issues, whether I'm working in clay or not. All I know is when I do finish a piece there's good interaction between my piece and me.

Q: Are there particular periods of work that you feel more satisfied with than others?

PITT: Yes. I've really had some hot times. Really where I'm on a roll, and I just love it. Just when things are so easy, it just comes out very smooth and clean. Work is effortless and I'm not struggling. Then there are times when I'm frustrated and angry. Then I have to quit that and go someplace quiet and grit my teeth.

Q: What are your feelings about critical review of your work?

PITT: Oh, I don't care. It doesn't bother me. I know how I feel, and I've never worried about what other people think about me or my work. I know what I'm doing and I feel good about it. Sometimes, I really worry about my work. [*Laughs*] Of course I like people to like my work. You know, we all like those positive strokes, but if a person doesn't like my work then that's okay. You know, we all can't please everybody.

Q: How satisfied are you with your career as an artist?

PITT: Oh, I'm just a blessed person. I'm just totally blessed. I'm so lucky, and I'm totally satisfied. I couldn't be happier with what I'm doing.

Q: What have been the major frustrations in your professional development?

PITT: Having to quit when I'm really on a roll.

Q: What would you describe as the greatest satisfaction in your career?

PITT: Seeing little kids looking at my masks and feeling really good about it because they're so totally amused. Seeing the joy that they have when they look at my work, even if they start laughing and pointing fingers; it's just a feeling that can't be duplicated.

Q: And the greatest disappointment?

PITT: When I put twenty-six pieces in the Anagama kiln and five pieces turn out.

Q: What has been the effect of the marketplace on your work?

PITT: It's been very positive, but then again, that's been to a targeted group of buyers. And some real big buyers have come across that collect ceramics. I'm really happy that I have that acceptance from that type of community.

Q: How has your relationship to the materials you use changed from the beginning until now?

PITT: I started with total ignorance and a lot of confidence and now, as I know more, I realize that I don't know enough. I'll never know enough about my materials. And I have a great amount of respect for my clay.

Q: How have your absolute basic requirements for being able to do your work changed since your early career?

PITT: Well, I demand more of myself. I demand better work. I demand better materials. I demand more of those around me, that they've got to expect more of me. It's been good for me; I've really changed, by expecting more out of myself.

Q: What one major point would you make to young artists about a career in art or in the craft forms of art?

PITT: Oh, just what my mother told me. Do the best you can, follow your heart, and I think when you maintain that sense of integrity towards yourself and following what it is you really love to do. Even if one thing might sell more that you hate making it's not worth it. Do what it is you love doing and people will eventually see that. They'll see that love in the end results of what it is you're doing. And trust yourself. Trust your integrity, to follow your intuition.

Representative collections include: Private: R. C. Gorman, Eleanor and William Ray, Joan Mannheimer; Public: Art in Public Places, Washington State Arts Commission (Seattle, WA), Bonneville Power Administration (Portland, OR), Burke Museum (Seattle, WA), Heard Museum (Phoenix, AZ), Indian Arts and Crafts Board (Washington, DC), Yakima Cultural Heritage Museum (Toppenish, WA).

Commissions: Grand Prize for Northwest Women's Studies Association Portland-Sapporo Sister City Association, 5 masks given to city of Sapporo, Japan.

Professional affiliations: ATLATL (Native American art service organization), American Crafts Council, Lake Oswego Arts and Crafts Guild (Local 14), (Lake Oswego, OR), Native Arts Council, Portland Art Museum (Portland, OR), Oregon Potters' Association.

Honors: Governor's Award for the Arts (Portland, OR) 1990; Purchase Award, Metropolitan Arts Commission (Portland, OR) 1988; Participant: Artist Promotion Project of American Indian Contemporary Arts Gallery (San Francisco, CA) 1985; City of Gresham, OR, Purchase Award, 1983.

_____ *Nine*

JOYCE SCOTT

B. Baltimore, Maryland, 1949. BFA, Maryland Institute College of Art, Baltimore, MD, 1970. Additional studies at Rochester Institute of Technology, Rochester, NY, The New Theatre Institute, Baltimore, MD, Haystack Mountain School of Crafts, Deer Isle, ME, and in Japanese traditional and contemporary theatre techniques, traditional Navaho rug weaving, and Native American beadwork. MFA, Crafts, Instituto Allende, San Miguel Allende, Mexico, 1971. Lives and works in Baltimore, MD, in both performing and visual arts, exhibits and performs nationally.

Q: Would you describe your family and early childhood?
SCOTT: My parents were from the Carolinas. My father's from North Carolina, and my mother's from South Carolina, and I was born and raised in Baltimore, Maryland. For me, the family environment was very much having two people from farther south, with southern ideas and an older way of doing things, be very happy about having a kid who was modern. My father has four other children from two other marriages, so I'm my mother's only child, and I have an older brother, sister, and a younger brother, sister. And at one point, my older brother and sister, for a short time, lived with us. I want to say that when I say "two parents" from an older school having a modern daughter, a modern child, I mean that, neither of my parents got very far in school. In fact, both of them probably went to around the sixth grade, when I was young. They both tried to do other things. My father pursued more education

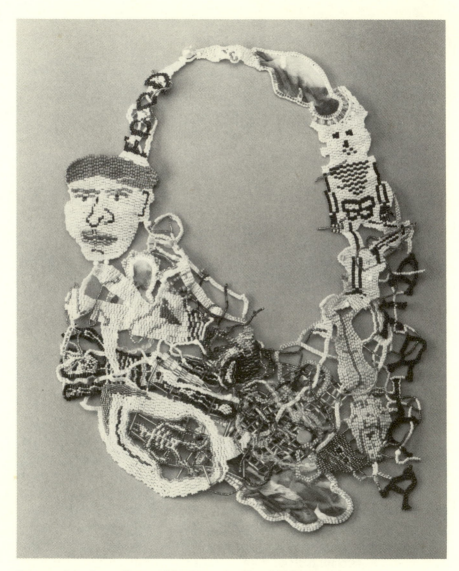

"Hunger" by Joyce Scott, 1991. Photo by Kanui Takeno.

after that, but they were . . . field hands; they were sharecroppers; they picked cotton and tobacco and rice, other crops; they cleared land; they went from plantation to plantation, area to area, and they never got a chance to really study in school. And they both resent it, and they both have a real hunger and yearning for it. Therefore, they imbued in me this impulse. I have a real respect for knowledge, and they have a real respect for knowledge, and they also really like the idea that I was pursuant of it. And I was very much someone who persevered for it. My younger life was basking in the freedom to do those things and having parents who were very supportive of that because they didn't have it. My mother's an artist, a nationally exhibited quilt artist. From my very first breath from her, prenatally, when I was in her womb, I was surrounded by that from her, this love of art, the knowledge of creation, the heat, those sparks you get when you are really involved in a conversation with material. My father, on the other hand, being a true Scottish lad, really wanted to make a buck. Later on in life, I asked him, because he never seemed to be able to reconcile himself to the fact that I was an artist and a successful one, in the sense that I was doing what I wanted to do and was getting some acclaim for it, acclaim which does not equate to big bucks. So my mother's name is Caldwell, and my father's name is Scott, and I make jokes about it because, of course, slave owners not only colonized, but they had children with slaves and freedmen, freedwomen. My father is very much directed to making money and being successful. But in later years, I asked him, "Dad, what did you really want to be as a young man?" And he said he always wanted to be a leader of men. He always wanted to be a leader and felt as if he really couldn't because of his shortcomings that he had as someone who wasn't academically trained. So it made sense to me that he really had to push himself to own property or to have in that way because he couldn't have what he needed in other ways. What he taught me, though, was self-sufficiency. I mean, I'm very much a dreamer on one side of my brain and also very much a pragmatist on the other. I was very lucky to have two parents who were both dreamers. My father dreams, but he's one of those closet dreamers; he's cloaked in those mysteries. My mother is more vocal about what her dreams are. So, actually my childhood was a very fertile place. I had cousins who are the age of my parents. You know, southern families have lots and lots of children, and then their children have children young, so my Uncle Waully, or Wyatt, which is his real name, Cousin Lucille, they're in their sixties now; Waully's actually closer to my mother's age; he's around seventy-four, and they would take care of me while my mother was at

work. So I had a real extended family in that sense, too. And they all cooked, and fished, and loved me. I mean, evidently I was an easy kid. So I had a really good time, an extended family, some close friends. I also lived in a neighborhood across the street from the projects! But still, the projects didn't mean what they mean now. There was strife and trouble there, but it still was a place where your other friends lived, and I know some people had problems because the projects meant you didn't have as much money, supposedly, (as if we had any money across the street). But I had good friends there. It was a very small neighborhood. I lived a block from my elementary school, which meant I could walk there and back. I was a latchkey child, so the lady on the first floor would make sure I got into my apartment, and I did my homework, and I had myriad, myriad things to do: dolls and games and the T.V. I'd call my mom, when I got home. My mother was a maid, a housekeeper, a caterer, a cook. You name it, she did that kind of work. My father worked with Bethlehem Steel. He worked as a crane operator and all kinds of things. You know, they moved you around until you found your forte, whatever your forte was. And my Uncle Waully, or Wyatt, he worked at Beth-lehem Steel, and his wife did ironing and she had foster children, and that was one way. So their foster kids, became my, in a sense, foster cousins, and we still see each other once or twice a year, maybe. And she has an older son, David, who's a photographer as well, and I still see them.

Q: What were your initial experiences with art?

SCOTT: I don't have the slightest idea. But what I do remember was that, by the time I had memory, I was targeted as an artist. I went to what was called a demonstration school. They have different names for them now. It's experimental schools. You see, a college would use us as a demon-stration school. They would come in and try out all their new stuff on us. And so I was always getting something new and different. We were guinea pigs, actually (Guinea, meaning a country in Africa). I had good teachers, and they realized how artistic I was. And so they targeted that in me. The difference also is that since these young teachers and student teachers were very interested in doing different things, art wasn't a separate commodity for me. So we would learn to read and write with art and music. It wasn't so separate. My beginning things were like making doll clothes with my mom.

Q: Did she work on her quilts at home while you were little?

SCOTT: For a long while she stopped making quilts. I mean, she started again when I was older. I think she started at forty-five. So by that time I was in my twenties. I should say avidly in the seventies. She worked

on and off before that. But she would sew with me for doll clothes; she always decorated everything in the house, everything. So the pillow-cases had some kind of decoration and the towels in the bathroom had something sewn on them. Teachers—I worked a lot with teachers in school.

Q: So would you say that throughout school, from the very beginning, you kept getting validation back from the teachers? Was this from your fellow students as well?

SCOTT: Yes, I have a photo of my class and we held up our artwork. What I didn't say to you was when I say I was a latchkey kid, I don't want it to sound like from the age of six I let myself into my apartment. I went to nursery school. After I stayed with my cousins for a while. I went to nursery school. And there was a lady named Mrs. Austin who would have drawing class, and they'd always yell at me 'cause I refused to eat squash. As I got older, my mother had an agreement with her that I would stay there for x amount of time after public school. I was older than some of the other kids, but I was also still at this school. And she allowed me to draw and do all kinds of things. Lots and lots of things.

Q: Was there any particular art form that interested you more than others when you were in the early grade school years?

SCOTT: Well, it's a mixture. I know I drew a lot. I mean, those are the kinds of easy things one does because that's the materials you have. But I remember being a flashy dresser even then. My mother would always give me that real look of chagrin when I'd leave the house. My father would be adamant about it. "I mean, you can't let her out like that." I remember wearing a hoop skirt to school once. My mother said don't do it. And I walked to school in my little skirt, and I remembered then being in school not being able to sit down 'cause that skirt went up to my head. See, that was the lesson that I learned. So dressing was all for a while. And jewelry—I always had stuff hanging—in junior high school I always had things hanging out of my head, and off my head, and once the principal asked me, "Why are you wearing these things?" He didn't like it because it looked gypsy-like during that period. This was just before the 1960s happened. So I think body adornment was always something very interesting to me.

Q: When did you become an artist?

SCOTT: I was always an artist.

Q: How did you know?

SCOTT: It was always the form that I communicated in best. It was something that people understood. And, when my teachers or academics

understood that, they would target me and say, "You do art very well. You should do this. Try that."

Q: Did you stay there on through high school? All in the same neighborhood?

SCOTT: My junior high school was not so far. It was an adventure for me 'cause I'd have to take the bus. Public bus, not a school bus. And for a kid, it was sort of far, but it wasn't that far, you know, in retrospect. And I was with a lot of my same friends. And it was very new—it was a new element. It was a junior high school. There was only one white kid there, a Jewish boy from Germany. The rest were all black kids. But it was a new building, and everybody was happy about it being crisp and clean and new and ours. So I didn't get ragtag until many years later.

Q: What about high school?

SCOTT: I went far away from my neighborhood. Baltimore used to have two boys' schools and two girls' schools that were sort of vying with each other. Eastern High School was the girls' school and City College was the boys' school. But they both had very high academic standards. And I was shy so I was happy I could go to a girls' school. But it was my first time where I really, really was in an integrated setting. In fact, the students of color were in the minority. And it was the time when I could actually also go across the street and study with boys in special classes. They had a really intense art curriculum there. And that's what I studied. But you could have an intense music curriculum or a science one. Then the other schools were Western—and that was a girls' school, and Polytechnic was the boys' school. And their strength was science, English, things like that. So Eastern was far away. It was my first brush with consistently being with people my age who were not the same race. There was always the insurance man or the guy who owned a store or the rent man or the guy who collected on your furniture or whatever. I was always surrounded by older people who weren't the same color or the same ethnic group or the same religion, and I never had any problems. Going to high school I didn't have many problems. It was my first strike with having friends my own age who weren't of the same race. But it was also just a continuation of art for me because then I was tracked into an art discipline.

Q: Where did you go after high school?

SCOTT: I won a scholarship at a college called the Maryland Institute College of Art in Baltimore, a four-year school. I got my Bachelor's degree in education. But during my student teaching I realized this was not the right thing for me to do because the thirteen-year-olds were tongue-kissing in the hallway and they obviously knew more about life

than I did. Aside from that, there was lots of systemic stuff that I didn't want to do yet. Keeping grades, lesson plans. I did it, but I also found that the things that I wanted to do were not easily accepted in school. So after that I went to graduate school in Mexico. I didn't plan to go to graduate school in Mexico. Some friends were going to Mexico and said, "Let's go down for a month." I went, started hanging out, got accepted in this school and decided to stay for a year: Instituto Allende in San Miguel Allende, which is in Guanajuato, Mexico. At that time, San Miguel, which is like a national monument city, had a lot of writers from Canada and England and the United States. The school had an intensive Spanish/English section and an intensive visual arts section. I did a lot of weaving, a lot of clay, a lot of jewelry-making, some dying of fabrics. It was wonderful experience. I always thought I should go there.

Q: How would you describe your current art forms and how you began to specialize in them?

SCOTT: Well, I really felt that I was going to be a painter 'cause that's basically what I was taught to do in school. But when I was in undergraduate school it was painfully obvious that a painter is not what I wanted to be or should be. Because I was doing my undergraduate work in education, it afforded me to experiment in a lot of things. And more and more I realized I was looking for something that was not like cooking, easy cleanup, and that it gave me the ability to do a lot of things at once. Easily. More and more. I'd worked as a weaver for years. And working on a loom was difficult for me. So I started crocheting, but something about it wasn't translucent enough. I don't know exactly how I veered into beads. Because I worked in beads—as the bead worker when I was very young with the Girl Scouts, until I was forced to leave the Girl Scouts 'cause I didn't turn in my cookie money. And I felt that I shouldn't turn in the cookie money 'cause I thought it was an inequitable split, that I should be on the street in those dopey uniforms selling all these cookies and I didn't get a good split of the money. Anyway, I kept looking for something that was tactile. That I could feel. That was serpentine. That I didn't have to wait for it to dry. That I didn't have to wait for it to cool off. That didn't stink. That wasn't toxic. That had light shooting through it, or not, if I wanted to. That had an intrinsic color and texture. Something that I could carry with me. Something that I could build into something giant or make it so, so small that it was mysterious. Something that mesmerized you, that you could not stay away from. And beads, more and more, became the media for me. Oh, I work in a lot of other things, but beads seemed to just creep into

whatever else I do. The beads are like working with liquid color. It's like Matisse talking about cutting into color when he used colored papers to make those collages. Something existed for him already. It's having light pass through. It's having shadows that are colored fall all on a surface. It's my being able to almost see through something, but not. It's my being able to be a beader and actually transform these little circles of light—the word "bead" in old English means "to pray"—transform these little circles of light into some kind of matrix, be it flat or sculptural, and still have light pass through it. So beads became more and more the thing for me to do. Also, when I have a dirty studio that only means that my floor is covered with these glistening aspects, in contrast to the other stuff that I used to put all over the floor. And I get to work with opacity. I get to work with something that's slow-drying so I am disciplined. I must wait. I don't know what it's going to look like because things that are wet are different from when they're dry. And that's real interesting for me. But there's always some kind of secret hidden in it. Beads or a couple of layers of glass or mirrors or some words that I put in there or something. You know, it has to be as interesting for me to make as it is for me to look at, or I don't want to do it. So that's why I chose those mediums. I still sometimes work with fabric. Fabric's pretty amazing. It is also harking back to my inheritance from my mother, in the sense that she taught me how to sew. She passed me that needle as a rite to passage. So I still work with that. I like almost anything that allows me to puncture it, sew into it, drag threads through it, unite it with some other medium. But beads have been now in the forefront of what I do.

Q: How does that tie to your performance work?

SCOTT: Is that some kind of joke? Tie, thread? Excuse me? Is this some kind of metaphor for something else? How is it related, tied to the performance art? Well, when you do things in your studio it's, for me, a very solemn and mantra-like state. And what you put into, breathe into, shape into that artwork has intrinsic values and it exists in and of itself. I like the idea that I can come into a gallery and not know what I'm looking at and make up stuff. That's fabulous for me. Or know what I'm looking at and wonder why it's happening in that manner. The other part about that is—and especially when you deal with social and political kinds of ideas like I do—is that sometimes people have so much freedom that they're thinking the exact opposite of what you wanted them to hear or see or feel. That's fine too. But if you have a message that you really want out and you don't want them to be reading stuff forever—I mean, I know my personality is that unless the artwork is

just amazing, I'm not going to stand there and read it. I mean, I've been in front of these things and I've just read for days 'cause that piece hit me. And the ones that didn't, I really didn't care what you had written. Even though maybe I should, I'm not going to do it. So theatre reared its ugly head because it allowed me to say exactly what I wanted to say and because I can write and sing and perform, and it allows me to say it in a manner that's going to get you watching me. You don't have to agree, but I have the ability to get you to listen to me. And so it gets these things out of me. I was also looking for a legitimate place to act out. How long are you going to act out in the Safeway or the Acme? How much shtick can I do on potatoes or carrots or whatever? I was really looking for a place for me to work on that part of myself that was very, very performance, act-out, crazy-oriented.

Q: Did the acting start back during the college period or did that evolve later?

SCOTT: It evolved later because I can tell you the only thing I remember doing when I was seventeen years old, I was an arts counselor at an art camp that had theatre, dance, music, and the visual arts. And you know, I did a little performing then, but I don't remember ever being in lots of class plays. Not in college. Post-college, yes. But it was always something that you've got to say, you've got to do. It was a way, also, to get me out of the real solitude, the loneliness of a studio. 'Cause the kind of work that I choose to do I basically do on my own. My mother and I may work in the same room, but it's still very . . . tunneled. I don't think I'd like to work in a sweatshop or anything where I had to be with four thousand other machines.

Q: During the period when you were doing your graduate work and just after that, could you describe the importance of peers to you?

SCOTT: Well, I've always needed friends. And of course I think of peers in the sense that they're people in the same profession or occupation. Peers are important because they're people who understand what you're talking about. There're people who know when you don't want to talk to them. They understand what the time in the studio means. I've been on the road a lot for the last three years, and I've had friends who were concerned about me because I've been away so much. There are others who also understood because I've been away so much. There's a knowledge implicit in that kind of peer.

Q: Were there particular role models or mentors?

SCOTT: Art Smith. I'm wearing one of Art Smith's rings. One of the first African-American jewelers to own a shop in this country on Fourth Street in the Village. I could appear in New York at any time. I'd just

call him at any hour and say, "You know, Art, I . . ." "Where are you?"
"I don't even have any . . ." "Come on over." And we'd talk a lot about
art. How to make it. What the system is. He was my jewelry teacher at
one point at Haystack Mountain School of Crafts. We did one collabora-
tive piece together. He was just very much New York. Old school New
York, you know.

Q: What qualities did you feel you needed most during this period of
graduate school, postgraduate school, after that?

SCOTT: I think it was just that I had a real desire and a real stripe to be
the best me I could be and to do that in a way that made the most sense,
which was through art. So I seldom pursued other occupations that
weren't art-oriented. In fact, I've never had a job that wasn't art-
directed. I'd make jewelry, I'd make something to make more money,
but I knew that my quest—that brass ring—the yellow brick road was
not only leading me to art, but those bricks were of art. And that's what
I had to step on. I did not get away from that. You asked me what I
needed—I needed perseverance; I needed real trust in myself. And when
things got shaky, I went to places or people who showed me that
self-trust and belief was very important. I had to have real trust in my
ethnicity. I had to know it was all right to be an African-American
woman who was progressive and leading that road, getting me to—to
artness. It's very difficult in a world that talks about all the isms—
racism, sexism, artism—not to fall off the road so much, or if you do,
to get back up, or if you fall in a ditch that's next to the road you get out
of the ditch.

Q: Do you think as you pursued this path—the yellow brick road—that
your training during college and the graduate school helped prepare you
adequately?

SCOTT: Unequivocally. Well, you see I don't think school prepares you
a hundred percent for anything so I don't think that training could
prepare me adequately. Once again, we live in a world where having
academic knowledge, being in school is respected and deemed impor-
tant, deemed beyond important; a necessity. I'm real frightened for all
these kids who are not going to school now or who can't read. So just
my having perseverance to stay in school prepared me.

Q: When you were working in this early stage, did you give yourself
certain benchmarks for achievement?

SCOTT: I'm sure I did all that. I mean, young people do that. Old people
do that. People do that. I knew that I wanted to have a certain amount
of something by the age of forty. I think when I was very young I saw
marriage and children. But I knew by the age of twenty-eight or

twenty-seven, I would have no children because I physically couldn't have them. Marriage has and has not been right up front for me. So I knew I needed to achieve what I needed in my own life by a certain age because then I was going to have to also be at a point in my life when I could start recouping some kind of financial stuff from that. So that I wouldn't be one more seventy-year-old artist who's still doing artist-in-residencies in elementary school, not because she had something fabulous to give the kids, but because she had no money to live on. Now that could happen to me, but it won't be because I didn't try. Not to have some kind of financial footing. Let me also add being a woman of color in the art world who does performance and who does art about political and social stuff, how that can narrow your opportunities sometimes. Sometimes it's in vogue for me to be all these wonderful things. So I'm on the seesaw—all artists are on seesaws. I believe I'm on another kind of specific seesaw. I have to figure out a way to make this work for me and I'm too old to be a waitress. Now we know I wouldn't be anyway. I mean, I wouldn't want to, which means I wouldn't be a good one so I'm not going to do it. So I got to be pragmatic about this, too.

Q: What were the first organizations you joined as an artist?

SCOTT: I don't join organizations generally. At one point I was in Maryland Crafts Council, and I just rejoined that because they're just becoming active again. The basic reason I'm rejoining it is 'cause I think 1993 is going to be the Year of the Crafts, and I'd like to be in some way helpful. I'm a member of something called the Baltimore Theatre Consortium, which is a group of alternative performance people in Baltimore. And we thought "strength in numbers." I'm a member of the NAACP. And I'm a member of something else.

Q: American Craft Council?

SCOTT: No. I might join them, but at one point I didn't because I never saw any people of color in the magazine so I never saw any reason to support it. I can honestly say to you that at one point I just never saw me in it. So I never saw any reason to send in twenty dollars or fifty or whatever. Even though they were working for arts and craftsmen, I didn't see it. And when I go to Wintermarket—that's the only fair that I go to 'cause it's in my city—I still see four hundred, five hundred artists, maybe out of that I saw three African-American artists. There are more Asians this year.

Q: Describe the period in which you first achieved professional recognition as an artist.

SCOTT: I've been getting recognition since I was in graduate school because I made good jewelry, but that was really local. Then it started

to get better and better in my early and mid-twenties. And I was always doing something very experimental. I think I'm at a point now where at the age of forty-one, maybe the last five years I've been starting to get some real play. People have started to really look at some of the stuff because I'm one of the few people who's doing bead work that's not only decorative in some senses, but that has some underpinnings that deal with societal problems. There are some people who're doing that, and I'm one of them.

Q: Have there been groups or institutions whose services have either helped you or hindered you?

SCOTT: Everybody helps me. Because you know, when you go to a place and you feel you're excluded, it either makes you want to get in there or it makes you find another way to do what you want to do. So I'm helped. I will go to the Renwick or the Smithsonian. They're always very interesting to me, and this is changing now—the Smithsonian Institution's just now opening a new space that's showing new work. You can go to all institutions—the American Masters—you don't see many black painters, and they exist. The Baltimore Museum of Art actually has a collection of African-American artists. I'm in the collection. It's small, but at one point, I think maybe in the forties and fifties, they were collecting. I went to all these places. The Walters Art Gallery in Baltimore, which is actually a museum. It's very old. And they have a really great collection. And I actually eventually curated for them, as a guest curator—an African show. They have an Egyptian collection that's wonderful, but aside from the Egyptian collection, they don't have many African works. I used to go there as a very young child and just go and stay a few hours. Now I am curating for them, or I have curated for them. I mean, I can go on and on and on. When you asked me earlier about who are my heroes and mentors I looked up and I told you it was ethnic groups. I didn't especially look for institutions to do that to me. At an early age I started to travel. And so if I wanted to know about weaving, I would go to school, but they could only tell me about the technique of weaving and about maybe how modern people dealt with weaving, or how you deal with it also in a business sense, wanting to be an artist. But I'd rather go to Guatemala and go to Quezaltenango and sit with the people who are weaving. And that gave me some other ideas about weaving cause I come from a very blue-collar background. I just did a press conference in Washington. It was about artists getting together and really beginning to work to be a real force to redirect people's ideas about art and artists. So that the NEA can exist and so that people like Helms won't have control over something that either

they do or do not understand, or if they understand it, they still wish to control it or abolish it. Consequently, there's a real call for artists to become more politically aware and that's very smart to me. I don't believe that any of this stuff about artists being inarticulate or irresponsible necessarily is true, since most artists are your cousins, your brothers and sisters who make art. We don't come from Mars.

Q: And are not separated from society.

SCOTT: Well many of us are. Some of that's by choice; some of that's because society says you're weird and wants to separate you. But I don't have to do it just because society says that's what you're supposed to do.

Q: How would you describe the group you rely on as your peers?

SCOTT: My peer group is variegated. Some of them are artists, some aren't. Some of them are my age, some are younger, some are older. They're just people who are highly directed and working at what they want to do. So a lot of them are artists, but it's very mixed.

Q: How have your peers influenced your career?

SCOTT: They've been supportive. Been very supportive not only of saying "yeah, you're right" or "you should slow down and think about it," but also when I don't know how to do things I can ask them and they'll tell me.

Q: How would you describe your occupation? And is this different from your career?

SCOTT: No, my occupation and career, they're both the same thing. See, we're talking about my life here; I don't go home and unmask and become, you know, Barbie Doll or something. When I go home it's the same person.

Q: Could you go over your general job history from the time you began until now?

SCOTT: Age sixteen I was a shampoo girl in a beauty salon. I also, around that age—sixteen or seventeen—was a camp counselor in an art camp called Camp Neyati. And so I would work with visual and performing artists there. Young kids like myself. After that I was a shampoo girl again. I didn't have a lot of jobs while in college. I worked basically in the summer. When I got out of college, I went to graduate school. I sang in nightclubs in Mexico to help make money. When I came home I got one job as a drug counselor. There's no telling how many people I sent back to drug abuse through my counseling method. Actually I used art as a modality. We painted murals, we did a lot of stuff with art. I promised myself after doing that job for a year that I would never work for anyone consistently but myself again. So for the last sixteen or

seventeen years I've been self-employed. By that I mean I take jobs working in schools or something, but I am my own boss.

Q: Do you see particular patterns or progressions over that period of time?

SCOTT: Oh, sure, how much more self-aware I am. When I was younger I was maybe a little more scatalogical and tried everything. My artwork had everything in it. I'm much more singularly directed. I'm calmer and truer to what my ideals are, and they show in my artwork. I just think that's how a persona generally evolves. I'm more mature and wiser about certain things now.

Q: Describe the gatekeepers at various stages in your career—those who let you in or those who barred the way for you as an artist.

SCOTT: Maybe I haven't experienced life so much like that. Because I don't know about people who haven't let me in. I think it's more or less systems than people. Of course systems are comprised of people. But I basically had people who said "Yeah, go try this, do that." Scholars, people who were the heads of departments. As I say, I've worked for myself basically so I might get into some kind of program like Diverse Works at Maryland Art Place that each summer has a time for you to develop your own performance. And that was a gate in the sense that each time I do it, it'll open up one more door to my finding about how to perform. But I haven't had many who said no to me, and those who said no were sometimes helping and those who were doing it for maniacal reasons—I'd just open another door or I actually walked past them. Life is like that. A lot of times you just go through the door. And you cut a new door.

Q: What, if any, are the discrepancies between your career aspirations and your actual career opportunities?

SCOTT: I'm not making enough money. The career opportunities—I don't know from opportunities. I get the feeling that possibly if I were working in a different medium with my skills, that I would have had a big show someplace by now at this age. So many times I think if I weighed 110 pounds, didn't have these gaps between my teeth, and wasn't in this ethnic group, I would be doing a one-woman show on Broadway. Now that's not something I'm necessarily looking for, but that is a reality. As a fat black woman who looks as I do, there're all kinds of things that are closed to me. That's why I write my own work. That's why I'm doing this Honey Chile Milk where we're writing our own work. And that's why I work with my partner Kay Lawal and the Thunder Thigh Revue, because we create our own vehicle. Don't wait for that to happen because it may not happen.

Q: What would you describe as the major turning point in your career?

SCOTT: I don't know if I had any. I say that because there's more of the major turning points in me, and I don't know if I've had career turning points. I think I might have had evolutionary points in my career, but there have been more major turning points in me. Then the career just maybe followed. I had a hysterectomy, I think, in 1978. That closed up the ability to have children, which meant that the ideas about why one marries or about having children or having to make a certain kind of lifestyle 'cause you would have to have certain money for kids or whatever, that changed for me. It also meant that I had to redirect who I would give this knowledge to. I couldn't give it to my own offspring, so I really would have to teach because I do believe it's my responsibility to share. I mean, I have too much not to share it in some way. That's why theatre's very important. It's a communication. It's a communicative skill. It's a sharing proposition. When I turned forty-one, I realized that age was insignificant if you had health. I was looking forward to turning forty 'cause I was always told that that's when an actual singer's voice becomes like drop dead. They're right. I'm just evolving, I think.

Q: What has been your relationship to money throughout your career?

SCOTT: I haven't had much of it. That's what my relationship's been—not having seen it.

Q: How have the costs of supporting your art changed over time?

SCOTT: Costs more to do it now. I'm shrewder about it, but it costs more. I mean, I'm doing theatre; I'm on the road—I have to stay someplace. There are certain things I don't settle for. I'm not supposed to settle. Human beings don't have to settle. Some of us do. Thank God I'm not a bag lady. Well, I'm a designer bag lady, but thank God, I'm not on the street. I could be. I mean, my education doesn't guarantee me anything except maybe self-knowledge. And a lot of us don't have that.

Q: How have grants and awards and competitions affected your career?

SCOTT: I seldom do anything in competition.

Q: Have you received other awards or grants?

SCOTT: I get grants, and I assume there's competition. The three that I've gotten have been very helpful in the sense that it meant that I could do less of one kind of work and have more freedom to do others. I'm a worker so I don't think there was ever a time where I was so destitute that it would have saved my life. 'Cause really if I ever got that destitute I could sweep floors. Not well. But I could still sweep them.

Q: What has been the importance of physical location and workspace at different stages of your career?

SCOTT: Always been the same. I always need a comfortable space. I needed larger and larger space. I needed more and more to know that

the space was mine. I bought a house sixteen and one-half, seventeen years ago and that freed me. And then I could destroy it if I wanted to. But I can tell you my mother and I always had a real relationship with our landlord. We didn't move many times. And they were always real supportive of me, Little Joyce, the artist. And so we just always had a house where we could do things.

Q: What kind of control do you think you exert over your own destiny as an artist?

SCOTT: I exert a lot. Not a hundred percent but I exert a lot because I have self-esteem and self-concern. I believe it's my responsibility to show that artwork. I don't believe all artists have that responsibility, nor do they want to show their work or have a need to do work on things that are really concrete like social or political situations, environment issues. But I do. And that sometimes shuts me out of places. That doesn't mean I don't or shouldn't do it.

Q: How have you interacted with the public over the span of your career?

SCOTT: You know, I've taught a variety of things, done crafts fairs, lectures. I do a lot of public stuff. I still do some things for free. Always. I mean, that's a very common social African/African-American thing to do. Once again, 'cause they're not separate. An artist isn't separate from the community.

Q: What are your own criteria for success as an artist?

SCOTT: Being true to myself. Now I know that sounds just like pie in the sky, but that's it for me.

Q: Would you use the same criteria for other artists?

SCOTT: I don't know if I can lay it on anybody else because maybe being a liar to yourself is what makes you work the best. Which in some way, I guess, is being true to yourself, but I can't lay anything on anyone else. I can look at the artwork and think the art's untrue. But that's a judgment that I make or don't make. But I don't think I should tell anybody how to do or be or make your own work unless it impedes me from doing mine. I think humans have to realize that we're all the same species. Consequently it doesn't matter how tall you are, what your skin tone is, whether you're a man or a woman; we're all the same thing. If we weren't the same species we wouldn't procreate. I mean, to me it's like real bedrock stuff, okay? A lot of stuff that we make up are artificial things that we do. I don't know why humans have to do it, but we do artificial things that make us believe women are weird, blacks are weird, white, brown, green, short, tall, men, women. I believe that we have to see that we're all of the same species. And so my work consistently talks about, "I am you." When I realize that you're a human being too, there's

certain shit that I could never do to you. But as long as I can say you're a white woman and a white woman means that you came from under a rock in Ireland, as long as I can make up stuff like that, then I can separate myself far enough from you that I can just lay stuff on you. But when I see that you're another human being like me, that seeing you is seeing myself, then maybe I cannot do shit to you. Or if I'm doing it to you then I'm really masochistic and crazier than I ever thought. That there's appraisal. That kind of stuff. All kinds of stuff about just realizing how beautiful and wonderful we are. And how when you don't do that then you end up thinking you're ugly and do horrible things to yourself.

Q: Are there particular periods of work that you feel more satisfied with than others?

SCOTT: Yeah. I did something in 1977; and 1979 was a very strong breakthrough period for me 'cause I was really working materials well and was working thematically really well. Then 1984 right up to now has been very profitable, visually and performance-oriented.

Q: What are your feelings about critical review of your work?

SCOTT: I think some of it's on the mark, some of it isn't. I'm glad there are people who critique 'cause sometimes it makes me more insightful. I sometimes wish the critics knew more about what they were doing reviewing. 'Cause sometimes I read stuff and it's just like technically wrong. Or a viewer who's a critic will say that they wonder what this is about. Well, they can call me up and ask me and get that kind of insight from me. I think it would make for a better reading and better opinions on their part.

Q: How satisfied are you with your career as an artist?

SCOTT: I don't want to be satisfied 'cause then I think I'd lay back. I'm satisfied in the sense that I know that I'm doing what I ought to be doing. Sometimes I get a little freaked because I believe that there's no reason why the art world should be any different from the rest of the world. Consequently it's rife with all the problems that everybody else has. So it's not possible for me to be comfortable within it when the world is filled with so many problems.

Q: What have been the major frustrations in your professional development?

SCOTT: I want things faster than I get them. Want people to understand me. I'm pretty articulate, so when they don't understand me I know that it's probably something that comes out of me or between the two of us. Just to harken back to what I just said—working within a system that's racist, sexist, whatever "ist" means that there's just certain things that probably are not going to happen within my lifetime or are not going to

be easy for me to achieve because of it. Now see, I'm not the only one, so I 'm pissed that everybody's having the problem too. It's not just me saying, "And it's me and my life and I'm always . . ."—no, it's everybody. That's how screwed up this is.

Q: What are the greatest satisfactions in your career?

SCOTT: I'm the one. I'm success or failure for myself. When I embrace what I'm doing and others embrace me then I know that I'm right on the mark. The fact that I'm continuing something that my mother, her parents, my great-grandparents, my great-great grandparents who were slaves, my ancestors—primordial ones who were in Africa—the fact that I am still pushing that makes me very happy and very proud and that I have a touch with it. Having a touch with my past, I think, makes me really close to the person I want to be right now and gives me hope for myself in the future. Makes me want to strive. Makes me want to have a future. My having one means that I'll be able to share and give to others.

Q: What's been the greatest disappointment?

SCOTT: That I haven't been able to make overt change in the world. That within my lifetime things haven't changed any faster or for the better. See, all that directly relates to artwork. It's not like oh, we'll have a better world and then I won't do art anymore. It's like it hasn't gotten any better so it directly relates to how I make art, what I make as artwork. And there'll be generations to come after me who're going to have to deal with the same shit. Okay, I could use a variety of other words, but that's not what I mean. That is disheartening for me.

Q: What has been the effect of the marketplace on your work?

SCOTT: [*Laughs*] I told you earlier—I don't have any money. And the fact is that I haven't gotten any of it. When I say any of it, I mean substantial money. That's what I mean. Of course, I'm living. And because I make almost everything that I need—back to the slavery way of thinking. Slaves—they knew how to pick up a berry. Now, I don't know how to necessarily pick this berry up. I think I would figure it out, but I know how to take that last piece of fabric and make something. I can make shoes if I need to. I control that kind of stuff around me. But you know, I don't have money to go out and do unlimited projects.

Q: Have you had to alter your work to please the marketplace?

SCOTT: Not necessarily to please the marketplace. I've had to alter my work in ways that don't please me. If I want to do a city of beads, I can't afford to do it. And because this may not be what's happening in people's heads, then I maybe can't get funding to do it. Or because I'm so pissed about it, I won't pursue funding to get it.

Q: Has your relationship to your materials changed from early on 'til now?

SCOTT: Yeah, by forcing the materials. I'm learning more and more to follow their lead and to do, I call it, some of it, automatic writing. Allow it to tell me what to do. So I am trying in my life to be more submissive to lots of things. And I 'm trying to be more submissive to the artwork so I allow it to become its best self.

Q: How have your absolute requirements for being able to do your work changed since you started?

SCOTT: I don't think they have changed. I always need a comfortable real place for me to work where I really have control over it. And I always had to feel that I was making artwork that I was proud, happy, involved with. And I shouldn't say "proud" 'cause I made things that I've really been disgusted by, and they maybe didn't get out of the house, out of the studio, but I really had to make them. They haven't changed very much.

Q: What major point would you make for a young artist considering a career in crafts?

SCOTT: I basically could talk about what it is for me and what it is for me is my being the truest realest self for me. Knowing myself through my art. A lot of my art should be a way of breathing. Real therapy. The real life of me. When you are that involved with what you do it not only is like your breath, your blood, but it's almost armor when you need it. It's a smile when you need it. It's everything. I have devoted it all. I jump into this sea of art with both feet, with little knowledge, actually, of swimming. And I have taken leaps of faith. Art is a big leap of faith in this world. And you can do it. You can do it. I mean, you just have to commit to it. I'm not an art star. I don't wish to do art so I can make a lot of money and be known by a lot of people. Although I do think it's necessary for me not to be a pauper. And I do think, in a world where African-American artists, women or men, have a hard time getting quality publications consistently, I think it's real important for me to have—to push as hard as I can to make sure that what I say, what I do, even if it's the most grandiose pap in the world, should be written down somewhere so kids who are like me, like I was at the age of eight, didn't see the same six African-American artists for their entire life in every book. And the exact same artwork. You'd think they only did one piece of artwork, and there were six of them. Yeah, and that's why I think I've been much more ethnically-oriented than I was art-oriented, artist-oriented. Because countries had zillions and zillions of artists who were doing fabulous things and I could just look to the art for it. I didn't look for a star or a person for it. 'Cause the name isn't as important as the

work. That's the other thing. I'm not looking to be famous. I'm looking for the work to be famous. One day I won't perform anymore, but I want to keep writing. Maybe direct. And let the work go on. But this is what I have to do now because it's therapeutically what I have to do now. Plus it's the way that I learn about theatre and the way I learn about art. But eventually I probably won't do this. Be too old anyway. You know?

Q: Probably not. It's hard to imagine you being too old for anything.

SCOTT: I think you're absolutely right. That goes for all the young men who are editing this. [*Laughter*]

Q: Which there won't be any.

SCOTT: Damn! Forget it, girl.

Representative collections include: Public: Benjamin Banneker Museum (Annapolis, MD), Baltimore Museum of Art (Baltimore, MD), Corning Museum of Glass (Corning, NY), Maryland Artists at Towson State (Towson, MD), Kruithaus Museum (Netherlands).

Professional affiliations: Represented by Esther Saks Gallery, Chicago, IL; Mobilia, Cambridge, MA; Susan Cummins Gallery, Mill Valley, CA.

Honors: National Printmaking Fellowship, Rutgers Center for Innovative Printmaking, 1990; NEA Fellowship Grant, 1989; Honorary Board, James Renwick Alliance, Smithsonian Institution, 1989 Artist in Residence; Pyramid Atlantic Grant, 1987; Maryland State Arts Council Fellowship Grant, 1981.

RUDOLF STAFFEL

B. San Antonio, Texas, 1911. Studied at School of the Art Institute in Chicago, 1931–33. Taught at the Tyler School of Art at Temple University, 1940–1978. Lives and works in Philadelphia, PA.

Q? Would you please describe your family in early childhood, while you were growing up?

STAFFEL: My family are second generation Germans, they probably came to Texas around 1880, toward the end of the Civil War, and they settled in San Antonio. There's still a Staffel homestead in the middle of the business district, in the courtyard of the Four Seasons Hotel now. I grew up very close to that area. My father was a hay, grain merchant selling food for chickens and cows. I did a lot of work in the store when I grew up, mixing cow food, chicken feed, and things like that. My mother was a musician, a pianist; I grew up more or less spending a lot of time underneath the piano while she practiced. And I fondly remember music thundering down on my head from crawling under the piano while she practiced most of the day or gave lessons.

Q: Brothers, sisters?

STAFFEL: I have a brother—he died just two months ago. And I have a sister. My sister still lives in San Antonio. My brother did live in Louisiana. And I moved; after going to art school at Chicago Art Institute, in 1930, and being more or less a drop-out from art school, by a circuitous route I finally arrived in Philadelphia about 1940, employed

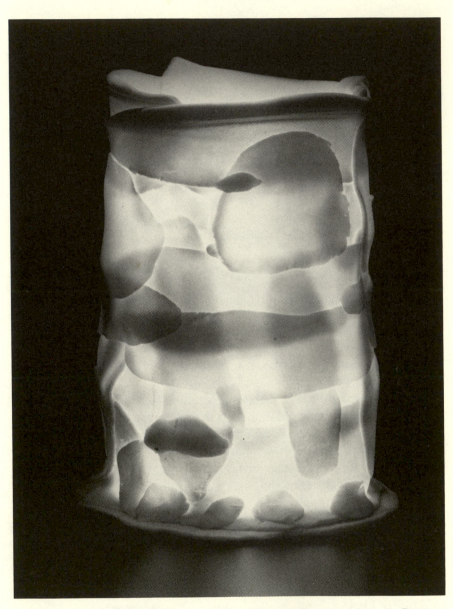

"Light Gatherer" bowl by Rudolf Staffel, 1988 (porcelain, translucent). Courtesy of the Helen Druit Galley. Photo by George Erml.

by Temple University, Tyler School of Art of Temple University, as an art teacher. In those days, I taught almost everything—ceramics, sculpture, drawing, painting. But it eventually narrowed and I came basically to teach ceramics. This was in the depths of the Depression when I first came to Philadelphia. When they hired a teacher, they wanted the teacher who could teach a multitude of things.

Q: How did the members of your family feel about your talent that led you to develop your art?

STAFFEL: My mother was very encouraging. In my family, the expenses were sort of split. My father's earnings went toward paying the mortgage, the food, and transportation bills, basic expenses; my mother's income went toward educating her children in various cultural pursuits. Mine happened to be art.

Q: What were your initial experiences with art?

STAFFEL: My initial experiences? Well, let's see, very early—I remember I was in grade school, so I must have been about ten years old—I had a strong urge to study painting. San Antonio used to be a place where a lot of refugees from Mexico settled during the days of the Mexican Revolution. Among them was a woman who was a painter of religious paintings. I saw her work stored in a barn and found out that she gave lessons, I asked my mother whether I could take lessons from her. My mother said yes. It turned out that she would only teach me pastels, which I hated because I just hated the smell of them. And I always thought I wanted a big, curving palette with a lot of paint on it. I wanted to be an artist, in the romantic notion that I had of being an artist, you know. Velvet curtains and a smock and a big, big palette. Mysterious.

Q: What educational experiences provided you with early validation and/or resistances to your art?

STAFFEL: I had an English teacher in high school, Miss Butler, who had a very powerful influence on my wanting to become something other than routine, or what I thought at that time would have been a routine kind of an occupation. I wanted to be something special, whether it was a sea captain, an artist, an explorer, or something. But Miss Butler wanted us to be something special, and we tried to meet her. Well, she motivated us. She was excellent at that, and she had a very powerful influence on my eventually choosing a career. Let's see, then I studied privately when I got out of high school with a wonderful Spanish artist named Xavier Gonzalez and his uncle, a traditional Spanish painter, named Jose Orpa. And then I also palled around with a group of Mexican artists in San Antonio. Later on, I applied to the Art Institute in Chicago

as an art student, and went to Chicago and stayed there several years. Then I dropped out and went to Mexico.

Q: Did you find any resistances to your work?

STAFFEL: No. No, the only resistances were my own inner conflicts about whether or not I was pursuing a career that I could succeed in or make a living in or survive in. My family would help me in any way that I seemed to want to go.

Q: What art forms particularly interested you in your early education and training?

STAFFEL: When I was at the Art Institute, I spent a lot of time in the galleries of the French Modern, which in those days in the 1930s was kind of avant garde. Van Gogh was one of the artists I admired a great deal and almost all of the French artists. I would roam the Chicago Art Institute looking for the French moderns. I remember Turner interested me a great deal, I think because of the atmospheric effects, which I still love. That atmospheric effect has a lot to do with light and translucency. Then I discovered, to me it was a discovery in any case, the Field Museum in Chicago, which is an anthropological museum, full of folk art, African, Mexican, and various ethnic art forms. I would spend a good deal of my time at the Field Museum. I had a feeling that to be an artist was to be an artist in whatever gave one visual pleasure. Wandering around the Field Museum and looking at all of their collections, which in those days were sort of just thrown into cases. Nowadays, they're carefully exhibited. But when I was there, you just had to walk around and peer into the cases and sort things out and sort of discover all of these things.

Q: When did you become an artist, or feel you were an artist? How did you know?

STAFFEL: Well, I was a student at the Art Institute, and I saw an exhibition of blown glass from Germany that simply blew my mind because of the vivid colors and the light passing through and the sun beams hitting this particular gallery at the Art Institute. I just lost my interest in painting. Not immediately, but my interest in painting sort of waned. I wanted to go to Germany and study glass. But a patron, who had once promised to send me to Germany if I wanted to study art there, lost his money during the Depression, so I couldn't go to Germany. But my family agreed to send me to Mexico where I could also work in a glass factory. But my sojourn in Mexico ended up so that I didn't learn glass-making; I spent most of my time in the anthropological museum in Mexico City. I found that walking around and drawing pots, from the various Mexican cultures—the Aztec, the Toltec—and I found that, well, I liked ceramics

as much as I like glass. So I found a potter near San Juan Teotihuacan who agreed to allow me to work with him. So I learned some of the basic ceramic things from him, including loading a donkey and taking the pots to the market, things like that.

Q: Is that when you began to specialize in your art form?

STAFFEL: I always thought I could do both, that I could be a painter and potter, and an enamelist, and a worker in lacquer. I was very fond of Mexican lacquer, carved lacquer, which I had done a lot of research in and learned how to do it. I always thought I could do both. But eventually, ceramics superseded everything else. I still draw and paint from time to time. But I don't actively exhibit that work.

Q: Where did you go after high school, and what subjects were you interested in?

STAFFEL: After high school, I went to the night classes of this Spanish painter, Xavier Gonzalez. I think what I wanted to find out is whether or not art suited me. And I felt that it did. Although I don't think I showed any particular proclivity. I was very doubtful. Nevertheless, I felt that art was something that I wanted to pursue. At least, I was quite certain of it.

Q: Could you describe the importance of peers to you in this time?

STAFFEL: After high school, I made friends with a group of Mexican artists in San Antonio. Now, in those days, in San Antonio, for an Anglo like myself to run around with Mexican artists or Mexicans was an odd thing; because San Antonio was in those days very racist. My family, for instance, didn't quite know what to make of it. They didn't forbid my associating with these artists, but they had some of the typical racist feelings that many people had in those days. They thought it was rather odd that I should find my main friends among the Mexican artists. Anyway, we had a sort of informal group; we had a studio that we could meet at. We hired models and drew. We set up still lifes and painted. We went on sketching trips to, for instance, a town near San Antonio called Castroville, which in those days was a sort of an abandoned town with a lot of abandoned houses. We would go spend a couple of days sleeping on some of these abandoned house porches and painting and drawing, landscaping. It was a bizarre pursuit for that particular time. Professional artists in those days would be painting blue bonnets and cactus scenes and Indians sleeping under a tree and that kind of stuff. And we hated that. We called it tourist junk. And it is tourist junk. We wanted the real gutsy, you know, we were lovers of Diego Rivera and the Mexican revolutionary artists, like Siqueiros and that bunch.

Q: How were your role models or your mentors influential at this time?

STAFFEL: Well, that whole Mexican atmosphere was extremely influential for we were politically kind of left-wing because of our interest in Rivera and Siqueiros and the Mexican Revolutionary art.

I remember going into the libraries and finding any book that had a Russian author, that sounded like a Russian name—I would read it. I was an avid reader, particularly of Russian literature, the whole bunch starting with Dostoyevsky.

Q: What qualities do you feel you needed most during this period? Physical stamina, mental discipline?

STAFFEL: I don't think I ever thought in terms of quality. I think I had a very romantic notion of what the profession of an artist would be. First of all, it would be a rather, well, mysterious, interesting, never dull kind of life. It would be beyond the nine-to-five kind of life that I thought I wanted to avoid. Also, it would always be meeting beautiful, fascinating, romantic people. I had a very idealistic notion that somehow or other a patron in a big fur coat would walk in the door and say, "Where have you been? We need your work."

Q: What materials were you working with during this period, and what was your relationship to that material?

STAFFEL: I finally became enamored of translucent watercolor. An artist I admired a great deal was John Marin. I would go out with my water-color paints, and sit down facing east, and do a picture. And then face west and do a picture. I deliberately avoided selecting an interesting subject. I found, oddly enough, that whenever I selected an interesting subject, I had an unsatisfactory result because my expectations were immediately elevated beyond a stage that I could attain or at least thought I could attain. But if I just accidentally looked at something, and found, discovered visual aspects of it spontaneously, that I seemed to have been doing my best work.

Q: Do you think your training during this period adequately prepared you for a career as an artist?

STAFFEL: Oh, yes, definitely. I think, in hindsight, it was wonderful training. It taught me to be very independent, for one thing. Essentially, I struck base with various associates and teachers from time to time, but I was mostly on my own, having my own experiences, and often being disappointed but occasionally being encouraged by this or that person. I had an exhibition in New Orleans, of paintings, that was very successful and actually led to my, oddly enough, getting a job going to New Orleans to teach ceramics about 1935.

Q: Did you give yourself certain benchmarks for achievement when you began your career?

STAFFEL: I think that's a kind of a 1970–80 kind of a concept of having goals and setting goals that comes from EST training, or Silva mind control, or these other more contemporary aspects. I just observed the people I ran around with, we always thought at any moment the dam would burst, and our whole career would shine, and we would be flying with great success, at any moment. It seemed to stretch out, year after year after year.

Q: Did you ever get discouraged?

STAFFEL: There was a time when I was discouraged, yes. For instance, I wanted very much to teach in a university setting; and yet, I didn't have what at that time, or even now, were the qualifications for a university teacher. Except that it's very possible, as it was then, very much so in the 1930s and early 1940s, to use your experiences as an equivalent, particularly in art departments. But not in academic departments. In most academic departments, you need certain degree qualifications to teach, but in some of the art departments, you needed equivalent experience. So, I never went to college, and I was very discouraged for a while thinking I'd never be able to find a university job. Time was passing. It was getting a little late to think about going to college. But as, as luck would have it, through various recommendations of friends, using I guess the old boy network, I finally landed a job at Temple University, Tyler School of Art at Temple University in Philadelphia, after having other teaching experiences prior to that. I was, I think, very fortunate in bumping into certain individuals, for instance, Xavier Gonzalez, who got me a job by his influence teaching at the Arts and Crafts Club in New Orleans, where I taught ceramics and drawing. I found that teaching was the best instructor; to teach something is to learn it as well. Then later on, to have bumped into a man named Boris Bly, who founded the Tyler School of Art at Temple University and seemed to like the kind of work that I was doing, and on what in today's terms would be very meager qualifications, offered me a job teaching at Tyler. So I remained at Tyler until I retired; I was at Tyler from 1940 until 1978.

Q: What were the first organizations you joined as a craftsperson? Which ones are you most active in today?

STAFFEL: I never was much of a joiner. I at one time belonged to the American Ceramic Society. And then the American Ceramic Society had a splinter group of ceramic artists who branched off and called themselves NCECA, National Council on Education of Ceramic Artists. And I belong to NCECA. I'm one of the honorary fellows of NCECA, which I'm very proud of. I belong to various museums. Other than that, I'm not much of a belonger.

Q: Can you describe the period in which you first achieved professional recognition as a craftsperson?

STAFFEL: Well, I started exhibiting work, ceramic work, quite actively in New Orleans. That would be in the years about 1934 to 1939 and 1940. Recognition was very satisfactory, that is, if recognition is any kind of a goal. By recognition, I mean, I was accepted in some professional exhibitions that I highly respected, like the exhibitions that originated in New York, the big crafts show that always originated in Syracuse, New York. The Everson Museum. In fact, one of my pieces from that period is in their collection. I was very lucky.

Q: Have groups or institutions whose services you have used helped or hindered your progress as an artist?

STAFFEL: The institutions that helped me as an artist were schools. There was the Witte Museum in San Antonio, for example, that gave me a great deal of encouragement by hiring me to teach what they called Saturday classes, talented children from the public school classes. I used to teach drawing. Then later on a school in New Orleans called the Arts and Crafts Club, which passed out of existence many years ago; but in the 1930s, it was a very active and quite unique school in that they taught with equal emphasis painting, sculpture, and ceramics, which was very rare for an art school in those days. And then, Temple University, at Tyler School of Art. I considered these schools more or less as patrons of the arts in that I was able to make a living and pursue my art work and have the satisfaction of teaching and being associated with people with a like mind. By being centers of teaching they obviously supported the arts.

Q: Have they offered you services, in the form of benefits like health insurance, credit?

STAFFEL: Well, in the early teaching days, health benefits was something unheard of. That didn't exist until I started teaching at Tyler School of Art in Philadelphia. I think maybe at the very end of the war, health and pension benefits began to come into existence.

Q: How do you feel about unionization for artists?

STAFFEL: I'm sympathetic to any kind of unionization. But I'm not particularly an activist, just a sympathizer and an observer and a supporter of any kind of union activity.

Q: How would you describe the group you rely on as your peers now? Who do you talk to in your mind—for friendship, aesthetic, artistic support—and have the members of this, or any peer group, remained the same since your youth?

STAFFEL: I guess I would classify myself somewhat as a loner in recent years since I don't particularly travel around with artists in my own field, although I'm friendly with a large group of them. My peer group is very diversified. I find that I'm just as intrigued by a painting exhibition or a folk art exhibition or rummaging around a junk shop or a thrift shop. And I can go into the craft museum, as I did just a little while ago, and be completely flabbergasted and intrigued with that exhibition called "The Art of Excess". I would call it the art of fantasy. It was a very joyful experience and very happy to see a peer group like Mark Burns and Lucero and several new people I'd never seen before. Their work is unbelievably joyful and fun to look at. Intriguing, I would say. I will jump from there to the Museum of Modern Art, and I guess I'll be intrigued by something there, equally so, as I was by walking down 52nd Street. There was a person selling what looked like reproductions of African folk art. They looked like reproductions that were excellently made, and I was thinking, boy . . . I got ideas from this.

Q: How have your peers influenced your career?

STAFFEL: I know that my peers have influenced my career, and it's very hard to say exactly at what point they have influenced my career. It's very hard to put my finger on that point. I would say that the totality of that work, of the peer group that I am most familiar with, has strongly influenced me, and certainly encouraged me in every way that I can think of. But the whole scene does very much influence me, the whole crafts scene: the activities of NCECA, the Craft Council, the NEA, and all of the exhibiting groups.

Q: How would you describe your occupation and is this different from your career?

STAFFEL: Well, the dreams or the aspirations I had as a youngster certainly have been fulfilled, even though I don't know that I have the consciousness of that, day to day, it's not a day-to-day revelation to me. It's just a routine life for me now—that of being an artist. But I have today the kind of success that would have been an unbelievable dream in my younger years. I'm secure in my daily life and meeting my daily needs. I have all the time in the world to do whatever I like. At the time I retired, I really didn't want to retire. My university at that time had compulsory retirement. I enjoyed teaching so much that I simply didn't want to retire. But I did retire, and in hindsight, I'm very glad that I did. I wish I'd retired sooner or at the first available opportunity, anyway.

Q: Do you see a pattern or a progression within your career over time?

STAFFEL: The pattern that I seem to see is that my work may be becoming more spontaneous, somewhat more daring. By daring I mean, working to the outer limits of the potential of the materials and the techniques that I use. I see a progression in that. Now, I've always thought it's a little bit backward. To learn something and very rapidly, and in depth, there's nothing that gives learning more impetus than teaching. For example, in ceramics, in just a matter of a month or two one is in contact with beginners who do odd unexpected things through inadvertence, through their inexperience, which leaves them open to all kinds of possibilities. But as an observer, and their teacher, it leaves me open to all kinds of possibilities. As an example of how things, by inadvertence occur with beginners, one time I told a student her clay was too soft. So I pointed to a table that had a huge plaster bed on top of it. I said, "Well spread your clay out on that plaster." And she misunderstood, because at the bottom of that table, on the floor, was a bag of plaster of paris. And she dipped her hand into the bag and sprinkled plaster of paris in her clay. And, and you know, to mix plaster with clay is a famous no-no, because it causes all kinds of problems. But if you mix powdered plaster with wet clay, you can get some very interesting results. Now, later on a graduate student who had noticed some of those things finally said, "Let's see what happens with this clay that has the plaster mixed in with it." And some very interesting results happened. And then we pointed this out. We were having a discussion with a graduate ceramics student, who was looking for a subject for a thesis. And she did some research in mixing plaster of paris with clay, and getting interesting, porcelain-like results that opened all kinds of doors for her in her later research. It's those things that happen in teaching, that happen very frequently. It makes teaching very fascinating. Of course, a lot of it's routine, and often quite boring, particularly after you've been teaching for fifty years. But things happen quite often that are fascinating.

Q: Can you describe the gatekeepers at various stages in your career—those who let you in or those who barred the way for you as an artist?

STAFFEL: I can't think of anyone who barred my way in any kind of way. I can think of many people who opened gates for me. If there were any obstructions, they were entirely within myself, not in other people. When I was younger, I had many doubts and conflicts, which I think . . . well, I don't know if they stood in my way or not. But I thought they were there in any case. I had many doubts and conflicts about whether I was pursuing the right course or not. An occasional compliment, or occasional encouragement was eagerly, eagerly sought after, but never seemed to be enough. Like Christmas, it never seems to be enough.

Q: What were the discrepancies between your career aspirations and your actual career opportunities?

STAFFEL: Well, I think many professional artists dream of the kind of situation that may have existed in the old European academies, where the professor walks in whenever he pleases to a class. A class assistant will have taken the roll, and done all the routine setting up of the class. The professor walks in. He may or may not feel like talking to students that day. And he'd say, "Well, I think I'll come back next month, and if you want to see me I'll meet you then." There were a few teachers like that in the old days at the Art Institute, for example, and certainly at the European academies. The routine teaching and the routine handling of a class was always done by an assistant. So my feeling of being a teacher was, oh, boy, wouldn't it be wonderful to have a very light load, so that you could have a lot of time for your own pursuit, having, in other words, a Medici type of art patron.

Q: And did you, ultimately?

STAFFEL: No, I really didn't have. No. I think I earned my keep by being, I think, a good teacher who was always there.

Q: What would you describe as the major turning points in your career, up until this point?

STAFFEL: Well, major turning points were going to Mexico. And getting this opportunity to teach at the Arts and Crafts Club in New Orleans in 1935. And then later being offered a job teaching at the Silvermine School of Art in Connecticut one summer session, where I met someone who introduced me to Boris Bly in Philadelphia who eventually hired me to teach at the Tyler School of Temple University. And strangely enough, during the war years I enlisted in the glider program, and I learned to fly small airplanes and things like that, which gave me an enormous boost in confidence, emotional confidence. Even though I chafed because I had to give up art for a while.

Q: What has been your relationship to money throughout your career?

STAFFEL: It was always a worry. I first started learning art from a professional standpoint right at the beginning of the Depression. So money seemed to be just impossible. If it wasn't for my family giving me a few bucks now and then and being able to borrow the family car for all the things I wanted to do and . . . oh, I don't know. Money was always a nightmarish fear; that is, the lack of money was a nightmarish fear. But I always managed to stay one paycheck ahead. I never was in actual want even though I was very anxious about money.

Q: How have the costs of supporting your art changed over time?

STAFFEL: Most of the teaching situations provided the use of the facilities as well. So the costs of doing my art work was built into the job situation as an unspoken benefit. It was traditional that all people who teach ceramics use the facilities of their particular teaching situation. However, in time that became a burden rather than a help. So almost all ceramic teachers that I know of now have their own private facilities and very rarely use school facilities. But when I first started teaching ceramics, that was the way to go, almost the only way to go.

Q: And now, since you're retired, do you find that it's a little more difficult?

STAFFEL: It's negligible. The cost of doing art work for me is negligible. That is, the basement and first floor of the building I own is my studio. I live on the second and third floor. Well, by negligible I mean it costs me roughly one-third the up-keep of my house, which isn't very much.

Q: How have grants, awards, competitions, or emergency funds affected your career? And was there a particular time in your career such money would have been most helpful?

STAFFEL: It would have been most helpful when I probably wasn't qualified to receive these things. It seems to go along with the old adage that when you need money, you don't have it. And when you have it—money's around when you least need it, in other words.

Q: I know you've received awards. Have you received grants or emergency funds?

STAFFEL: The university had grants that I received from time to time, sabbaticals, which are part of the grant system. And they've always been extremely welcome. Money and providing for money has always been somewhat of a burden for everybody who hasn't been born with a silver spoon or something like that. They've always been a way of lightening one's emotional attitude towards money. For instance, the grants, the university and NEA grants, were used to buy equipment that I kind of thought I would need.

Q: What have been the importance of physical location and workspace at different stages of your career?

STAFFEL: My first studio was in San Antonio when I came back from Mexico. I remember talking to my father about being able to work in what my father called a tool shed in the chicken yard. Most houses in San Antonio in those days had a backyard with chickens. People kept their own live chickens, which has disappeared today. Anyway, I was going to set up a studio in my father's tool shed. He said, "Well, why don't you build a little annex to it. You go to the bank, and borrow the money, and I'll guarantee it to the bank." So he and I went to the bank,

and we borrowed $250, and that was the cost of a 10-by-12 annex to the chicken coop, which was my studio. And then I found a junk kiln, set that up and built another kiln in the chicken yard. That was my first studio. It's still standing, by the way, although my family no longer owns the property. Then the next studio situation was the studio provided by the Arts and Crafts Club, which was in a magnificent old French Quarter building, a historical building. And that came with a live-in caretaker even; the caretaker lived downstairs. The ceramic studio was upstairs, and the kiln was in the slave quarters in the courtyard. It was gorgeous; still there, although now it's a residence. Then the next studio situation was the Tyler School of Art. And that had to be built from scratch. Let's see, there was a greenhouse on the property. We built the kiln in the potting shed, and the glass part of the greenhouse was the classroom. It turned out to be a wonderful place to have a ceramics studio. And then later on, Temple went through an enormous expansion in the 1970s, where they built a complete building for ceramics and sculpture and crafts with every modern convenience you could think of.

Q: What kind of control do you think you exert over your own destiny as an artist?

STAFFEL: Complete control. Absolute complete control. And, by destiny, I include health and every other aspect. I just read Norman Cousins' book called *Head First*. Everything comes from your own head, including health, and every bit of consciousness that we want to exert: to either be sick, or be healthy. I'm simplifying it, I know, a great deal.

Q: Have you interacted with the public over the span of your career?

STAFFEL: Yes. Giving workshops and talks on my own work, which I do a couple of times a year. I used to do it more often. But universities have cut back a great deal on traveling lecturers. Also, I've cut back on it; it takes a lot of energy to do it.

Q: What are your own criteria for success as an artist? And do you feel that these criteria are the same for others as for yourself?

STAFFEL: I think every artist has something within himself that spurs him on with or without success. And that's certainly true if you look at all the biographies of the artists. Some that are successful while they were alive; others who were failures while they were alive became successful later. I really don't know what success is. But there is something that keeps you working, beyond success. If you have it, I think you're just lucky.

Q: Do you have a number of central ideas you keep working on?

STAFFEL: Yes. In ceramics, I'm essentially interested in the vessel as a kind of a metaphor, as a container; one can be very idealistic about what

the container contains. It can contain anything from coffee to light or a soul, as the American Indians thought of containers. American Indians, when they buried a pot with a person, would break a little hole in the bottom of the pot to release the soul of the container.

Q: Let the dark out.

STAFFEL: Let the dark out, that's a good expression.

Q: Are there particular periods of work that you feel more satisfied with than others?

STAFFEL: I found that I'm a very poor judge of my work. I only see it after a lapse of time. Expectations cloud my seeing what my work might be at the time it comes out of the kiln. Most often, I'm disappointed. But, and sometimes in hindsight, I'm elated at some of the things that have come out of the kiln.

Q: What are your feelings about critical review of your work, critical dialogue?

STAFFEL: Sometimes there's a gnawing dissatisfaction when I think, what am I doing? I might be doing something that has just become a routine. And that triggers a kind of a fear that I don't want to do something that's just habitual. Most reviews that I've read, that other people have written about my work have been quite flattering. And sometimes I've thought, I really haven't become an artist until I can receive a devastating review, and can, you know, have that experience. In other words, I think if my work were a little more in depth, and maybe more profound, it might affect people in such a way that, they'd say, "Hell, I don't understand this work. This is trash; this is crap." So I think I really haven't made it 'til I receive a devastating review. Because most of the reviews of my work have been, somewhat flattering—not critical.

Q: How satisfied are you with your career as an artist?

STAFFEL: Well, I must say, I'm very happy with my career as an artist. I say that with somewhat tongue in cheek because I know that philosophically it's supposed to be dangerous to be satisfied. It leads to complacency, and the ideal of the young artist who now is an older person, the ideal was never to be complacent.

Q: What have been the major frustrations and/or resistances to your professional development?

STAFFEL: The frustrations I would call mostly process oriented, having a lot to do with technical things. When you open a kiln and everything is flattened out in a pancake and melted, that is very frustrating, extremely frustrating. And you can remember what efforts you've made, and all the pieces have melted. Also being rejected from a show is very frustrating.

Q: Were there satisfactions?

STAFFEL: Many. Satisfactions of the opposite. Opening a kiln, and everything is standing there, and glowing in unbelievable beauty. And being accepted in an exhibition. And even going further and selling a piece. Those are the satisfactions.

Q: What has been the effect of the marketplace on your work?

STAFFEL: It's been always very encouraging. And in recent years, much more encouraging than at any other time in my earlier career. Matter of fact, acceptance has been greatly increased since I've retired. I guess because I have more time to work at my art.

Q: How has your relationship to your materials changed from early training until now?

STAFFEL: Well, I've always loved the touch of clay. Even though just before I put my hands in wet clay, I have a slight shudder of, "I don't want to wet my hands." That's an unconscious itch, I don't want to wet my hands. But once they're wet and dirty, I love the touch of clay. And it's been that way for as long as I can remember. But what intrigues me a great deal is manipulating clay so that it can produce an imagined and projected result. Now, I usually don't succeed at these things, but the fun is in trying.

Q: How have your absolute basic requirements for being able to do your work changed since your early career?

STAFFEL: I felt I always wanted to make a living by teaching, that I didn't want to depend on my art work for a living. For example, I can't imagine anything more boring than to go out and find orders for dozens and dozens and dozens of certain types of ceramics, and then producing them, and always being tempted to digress, because an interesting possibility cropped up, but, no, you can't do that. You have to finish, you have to complete this order in order to make a living. Well, I've always wanted to really have my living depend on teaching and let the art work come as it may, in whatever direction I want. I wanted to be free to pursue whatever direction cropped up, in a serendipitous way, to seize the opportunity.

Q: What one major point would you make to young artists about a career in crafts?

STAFFEL: A career in crafts offers several possibilities, one of which is teaching. And another is that the crafts field is opening ever wider to a discerning public. The possibility of a living doing what you are most happy doing is becoming ever more a potential, but it's chancy. And persistence is an important prerequisite. And being happy at what you're doing. And pursuing it with a minimum of doubt. There's always going to be some doubt, but a minimum.

Q: Is there anything else you'd like to add on crafts training and prepara-
tion of careers for craft artists? Is there anything that you wish someone
had said to you when you were twenty-one, that with hindsight, would
be important?

STAFFEL: Everyone that I knew at that time was very encouraging in that,
I'm largely self-taught. I would go out to a place that made, for instance,
butter churns, near San Antonio, and I would get to be friendly with the
owner, who would say, "Hang around as much as you like. The throwers
are coming in tomorrow." In those days, there were itinerant throwers
that would come in, fill up a barn full of dry pots, you know, let them
dry. And then the owner would fire them in the kiln during the whole
winter season, or summer season. And then people would come and
pick up this fired pot, whereas, the itinerant potter would have moved
on to another pottery, filling up another barn with thrown pots. And so,
I was intrigued with all of that. I would say to students, be open. Don't
try to be too professional too early. By professional, I mean, for instance,
there was a time in art schools, not too long ago, when you would major
in ceramics, so you would cut yourself off from drawing and painting.
You wouldn't even bother to go to exhibitions of the other crafts and
other arts because you were gung-ho on your own major. But I think
that's shutting your mind off to all kinds of other potentials and
possibilities and experiences. In other words, my only advice is to be
persistent and open at the same time.

Representative collections include: Private: numerous private collections
throughout the United States and Europe; Public: Arkansas Art Center (Little
Rock, AR), American Craft Museum (New York, NY), Carnegie Institute
Museum of Art (Pittsburgh, PA), Denver Museum of Art (Denver, CO), Detroit
Institute of Art (Detroit, MI), Everson Museum of Art (Syracuse, NY), Honolulu
Academy of Art (Honolulu, HI), Hopkins Center and Carpenter Art Galleries
(Dartmouth College, NH), Los Angeles County Museum of Art (Los Angeles,
CA), Magee Rehabilitation Center (Philadelphia, PA), Montreal Museum of
Decorative Arts (Montreal, Canada), Museum of Fine Arts (Boston, MA),
Museum of Contemporary Art, Het Kruithaus, s'Hertogenbosch (The Nether-
lands), National Museum of History and Technology, Smithsonian Institution
(Washington, DC), Philadelphia Museum of Art (Philadelphia, PA), Renwick
Gallery, National Museum of American Art, Smithsonian Institution (Wash-
ington, DC), Shigaraki Museum of Ceramic Art (Shigaraki, Japan), St. Louis
Museum of Art (St. Louis, MO), Victoria and Albert Museum (London, England).

Honors: National Endowment for the Arts Craftsman's Fellowship, 1990;
Mayor's Art and Culture Award, Philadelphia, 1990; Pennsylvania Council on
the Arts Fellowship, 1986; Philadelphia Craft Show Award for Distinguished

Achievement in American Crafts, 1985; The Hazlett Memorial Award for Excellence in the Arts in Pennsylvania, Temple University, 1982; American Crafts Council Fellow, 1978; National Endowment for the Arts Craftsman's Fellowship, 1977.

BIBLIOGRAPHY

Abel, Marianne. "Iowa Crafts: Which Way to Grow?" *The Crafts Report*, October 1989.

American Clay Artists 1989. Catalogue for exhibition sponsored by the Clay Studio with the Port of History Museum. Philadelphia: June 1989.

American Craft 1988–89 Guide to Craft Galleries & Shops USA. New York: American Craft Council, 1988.

The Arts and Public Policy in the United States. American Assembly, Columbia University. New York: Prentice-Hall, 1984.

The Arts in the Economic Life of the City. Harvey S. Perloff, Director. American Council for the Arts. New York: 1979.

Bartow, Arthur. *The Director's Voice*. New York: Theatre Communications Group, 1988.

Becker, Howard S. *Art Worlds*. Berkeley: University of California Press, 1982.

Boris, Eileen. *Art and Labor*. Philadelphia: Temple University Press, 1986.

Brighton, Andrew, and Nicholas Pearson. *The Economic Situation of the Visual Artist*. London: Calouste Gulbenkian Foundation, 1985.

Cartlidge, Barbara. *Twentieth Century Jewelry*. New York: Harry N. Abrams, 1985.

Cheatwood, Derral. "The Private Muse in the Public World." In Kevin Mulcahy and C. Richard Swaim, eds. *Public Policy and the Arts*. Boulder: Westview Press, 1982 (pp. 91–108).

Clark, Garth. *American Ceramics: 1976 to the Present*. New York: Abbeville Press, 1987.

Constantine, Mildred, and Jack Lenor Larsen. *Beyond Craft: The Art Fabric*. New York: Van Nostrand Reinhold, 1983.

Craft Artist Membership Organizations 1978. Washington, DC: National Endowment for the Arts, 1978.

"Dance Education and Training in Britain." Calouste Gulbenkian Foundation. London: 1980.

Darling, Sharon. *Chicago Furniture: Art Craft and Industry: 1833–1983*. Chicago Historical Society. New York: W. W. Norton, 1984.

Davis, Virginia Irby. *Crafts: A Basic Survey*. Dubuque, Iowa: William Crown.

Diamonstein, Barbaralee. *Handmade in America*. New York: Abrams, 1983.

DiMaggio, Paul J. *Nonprofit Enterprise in the Arts: Studies in Mission and Constraint*. New York: Oxford University Press, 1986.

Dormer, Peter. *The New Ceramics: Trends and Traditions*. London: Thames and Hudson, 1986.

Duncan, Otis Dudley, David L. Featherman, and Beverly Duncan. *Socioeconomic Background and Achievement*. New York: Seminar Press, 1972.

Frantz, Susanne K. *Contemporary Glass: A World Survey from the Corning Museum of Glass*. New York: Harry N. Abrams, 1989.

Friedrich Becker. Catalog. Kunstverein fur die Rheinlande und Westfalen. Dusseldorf Grabbeplatz Kunsthalle. 1984.

"Going on Stage." Calouste Gulbenkian Foundation. London: 1975.

"Good as Gold: Alternative Materials in American Jewelry." Smithsonian Institution Traveling Exhibition Service. Washington, DC: 1981.

Griff, Mason. "The Recruitment of the Artist." In Robert N. Wilson, ed. *The Arts in Society*. New Jersey: Prentice-Hall, 1964, reprint 1969.

Harris, Neil. *The Artist in American Society: The Formative Years*. Chicago: University of Chicago Press, 1982.

Hauser, Arnold. *The Sociology of Art*. Chicago: University of Chicago Press, 1974.

Lavine, Sigmund A. *Handmade in America: The Heritage of Colonial Craftsmen*. New York: Dodd, Mead & Company, 1966.

London, Manuel, and Edward Mone. *Career Management and Survival in the Workplace*. San Francisco: Jossey-Bass Publishers, 1987.

London, Todd. *The Artistic Home*. New York: Theatre Communications Group, 1988.

Kaplan, Wendy. *The Art That is Life: The Arts and Crafts Movement in America, 1875–1920*. Boston: Museum of Fine Arts, 1987.

Krause, Elliott A. *The Sociology of Occupations*. Boston: Little Brown, 1971.

Lucie-Smith, Edward. *The Story of Craft: The Craftsman's Role in Society*. Ithaca: Cornell University Press, 1981.

Manhart, Marcia, and Tom Manhart, eds. *The Eloquent Object: The Evolution of American Art in Craft Since 1945*. Tulsa, OK: Philbrook Museum of Art, 1987.

Mayer, Barbara. *Contemporary American Craft Art: A Collector's Guide*. Salt Lake City: Gibbs M. Smith, 1988.

Meilach, Dona Z. *Woodworking: The New Wave*. New York: Crown Publishers, 1981.

Mishler, Elliott G. "Work Identity and Narrative: An Artist-Craftsman's Story." Craft Memo #9, n.p.: March 1989.

Pearson, Katherine. *American Crafts: A Source Book for the Home*. New York: Stewart, Tabori & Chang, 1983.

Perry, Louis. *Intellectual Life in America*. Chicago: University of Chicago Press, 1984.

Savran, David. *In Their Own Words*. New York: Theatre Communications Group, 1988.

"A Sourcebook of Arts Statistics: 1987." National Endowment for the Arts. Washington, DC: Westat, Inc., April 1988.

Smith, Paul J. *Craft Today: Poetry of the Physical*. American Craft Council. New York: Weidenfeld & Nicolson, 1986.

Stone, Michael A. *Contemporary American Woodworkers*. Layton, Utah: Gibbs M. Smith, 1986.

"Training Musicians." Calouste Gulbenkian Foundation. London: 1978.

Volpe, Tod M., and Beth Cathers. *Treasures of the American Arts and Crafts Movement: 1890–1920.* New York: Harry N. Abrams, 1988.

Williams, Christopher. *Craftsmen of Necessity.* New York: Random House, 1974.

Williams, Gerry, ed. *Apprenticeship In Crafts.* Goffstown, NH: Daniel Clark Books, 1981.

Wolff, Janet. *The Social Production of Art.* New York: St. Martins Press, 1981.

Yanagi, Soetsu. *The Unknown Craftsman: A Japanese Insight Into Beauty.* Tokyo: Kodansha International Ltd., 1972.

INDEX

University of Kansas, Department of
 Design, xxii
University of the Arts (Philadelphia), xxxi
Utopians, xix

Virginia Commonwealth University,
 106
Vocational schools, xx–xxi
Volunteer Lawyers for the Arts, xxxi
Voulkos, Peter, xxix, 4

Washington University, xxii

Webb, Aileen Osborn, xxvi, xxix
Wendell Castle School, xxxv
Wood, xxx, xxxiv
Woodman, George and Betty, 52
Wood Turners Society, 110
Work space, 15, 39, 57–58, 133–34,
 152, 169–70, 186–87
Works Progress Administration (WPA),
 xxv, xxxviii
Wright, Frank Lloyd, xxii, xxiv

Yanagi, Soetsu, xxviii

About the Research Center for Arts and Culture

The Research Center for Arts and Culture is both a service and a resource for arts institutions, policy and decision makers, funders, scholars, individual artists and managers. Committed to applied research in the disciplines of arts management and arts law, the Center provides the academic auspice so important for exploration, education, policy making, and action.

In addition to the vast resources of Columbia University, including the considerable cooperation and participation of the faculty, an advisory board of artists, administrators, and members of the legal and business professions offers continuous support to the Center, helping it to provide services and expertise. Collaboration and cooperation with service organizations, trade publishers, and arts institutions strengthen the Center's unique position and enable it to translate its findings into useful, practical forms.

About the Editor

JOAN JEFFRI is Director of the Research Center for Arts and Culture, which she founded in 1985 at Columbia University, Director of Columbia's Master's Degree Program in Arts Administration at Teachers College, and former Executive Editor of *The Journal of Arts Management and Law*. Her books include *Arts Money: Raising It, Saving It, and Earning It*; *ARTISTHELP*; *The Artist's Guide to Work-Related Human and Social Services*; and *The Emerging Arts: Management, Survival, and Growth*.